T. J. CLARK
HEAVEN ON EARTH

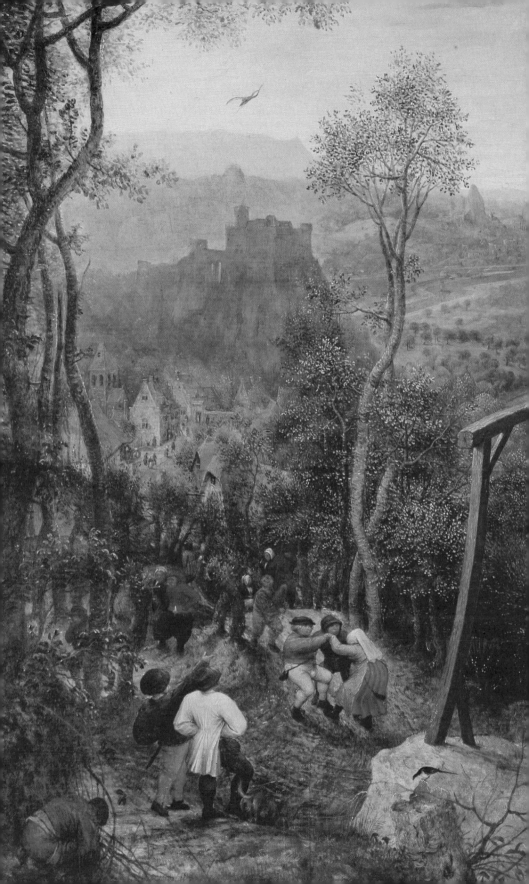

T. J. CLARK
HEAVEN ON EARTH

Painting and the
Life to Come

Thames & Hudson

TITLE PAGE Detail of fig. 38:
Pieter Bruegel the Elder, *Magpie
on the Gallows*, 1568, 45.9 × 50.8 cm
(18⅛ × 20 in.). Hessisches
Landesmuseum, Darmstadt.

Works are oil on panel or oil on canvas unless
otherwise specified.

Every reasonable effort has been made to trace rights
holders of material in this book. Thames & Hudson
will be glad to include any omissions in future editions.

Designed by Samuel Clark
www.bytheskydesign.com

First published in 2018 in the United States by
Thames & Hudson Inc., 500 Fifth Avenue, New York,
New York 10110

Library of Congress Control Number 2018932302

ISBN 978-0-500-02138-5

Printed in China by RR Donnelley

Contents

And I saw a new heaven and a new earth: for the first heaven and the first earth were passed away; and there was no more sea.

And I John saw the holy city, the new Jerusalem, coming down from God out of heaven, prepared as a bride adorned for her husband.

And I heard a great voice out of heaven saying, Behold, the tabernacle of God is with men, and he will dwell with them …

And God shall wipe away all tears from their eyes; and there shall be no more death, neither sorrow, nor crying, neither shall there be any more pain: for the former things are passed away.

Revelation 21: 1–4

You never enjoy the world aright, till the sea itself floweth in your veins, till you are clothed with the heavens, and crowned with the stars: and perceive yourself to be the sole heir of the whole world, and more than so, because men are in it who are every one sole heirs as well as you.

Thomas Traherne, *Centuries of Meditations*

Preface

It took a long time for me to understand that the elements of this book had a subject in common. What the artists whose pictures held me captive offered most deeply, I came to see, was a way of being earthbound – fully and only here in the world. This meant that the artists essentially set aside the question of belief and unbelief when they dealt with pagan or Christian themes, or looked at the question as one facet of an indelible human comedy; and that 'other worlds', though often vivid in their works, were entirely part of the same human round, built from humble or unregenerate materials; and that therefore their paintings seemed to offer the possibility of imagining (even making) the world otherwise without positing a future transformation scene where life would be raised to a higher power. This last refusal of the future seemed sanitary as the world all round began another cycle of 'end-time politics' and religious war. The Giotto chapter, embarked on later than the others, brought many things into focus.

Earlier, and sometimes very different, versions of the chapters on Bruegel, Poussin and Veronese had been given as lectures or seminars over the years. The *Land of Cockaigne* was first talked about in the Tanner lectures at Princeton University in 2002; the *Sacrament of Marriage* in the Watson Gordon lecture at Edinburgh University in 2005; the *Allegories of Love* as one of the Page-Barbour lectures at the University of Virginia in 2006; and *Joachim's Dream* at Concordia University and the University of Pennsylvania in 2014. A version of the Picasso chapter was first published in 2016 in *Campo cerrado: Arte y poder en la posguerra española* (Reina Sofia, Madrid). In all cases I presented the first form of my argument again more than once, and benefited enormously from listeners' and readers' responses.

Given the book's long gestation, any list of debts is bound to be arbitrary, but here are the people whose help and criticism stick in the mind: Kathy Adler, Bridget Alsdorf, Caroline Arscott, Stephen Bann, John Barrell, Iain Boal, Yve-Alain Bois, Manuel Borja-Villel, Cammy Brothers, Christopher Campbell, Stephen Campbell, Fiona Candlin, Jago Channell, Philip Cohen, Elizabeth Cowling (I have a fond memory of coming across her in front of Poussin's *Marriage*, checking that the cross really was on the ground), Todd Cronan, Andre Dombrowski, Hal Foster, Rita Felski, Michael Fried, Isabel Gass, Darcy Grigsby, Harriet Guest, Christa-Maria Lerm Hayes, Laura Jacobus, María Dolores Jiménez-Blanco, Krishan Kumar, Pablo Lafuente, Henrike Lange, Wendy Lesser, Nancy Locke, the late Tom Lubbock, Megan Luke, Joseph Matthews, Jeremy Melius, Andrew Miller, Andrew Moisey, Franco Moretti, Omri Moses, Lynda Nead, Donald Nicholson-Smith, Todd Olson, Rosario Peiró, the late Michael Podro, Jacqueline Rose, Mel and Sherie Scheer, Kaja Silverman, Howard Singerman, Carlotta Sorba (without whose help I would never have been allowed to stand for hours in front of *Joachim's Dream*), Daniel Spaulding, Richard Thomson, Samuel Titan and his team at *Editora 34*, Susan Watkins, Jonathan Weinberg, Marnin Young, and the editors at the *London Review of Books*.

At Thames & Hudson, my thanks to Roger Thorp, Samuel Clark, Sally Nicholls, Sam Wythe, Poppy David and the indefatigable Amber Husain.

The person who lived longest with this book is Anne Wagner. She looked with me at the pictures that instigated it, and the boundary line between her responses to them and mine disappeared long ago. As for her reading of the manuscript – well, only she and I will know how much the book owes to it.

Introduction

I felt as if I had been plunged into a sea of wine of thought, and must drink to drowning. But the first distinct impression which fixed itself on one was that of the entire superiority of Painting to Literature as a test, expression, and record of human intellect, and of the enormously greater quantity of Intellect which might be forced into a picture – and read there – compared with what might be expressed in words. I felt this strongly as I stood before the Paul Veronese. I felt assured that more of Man, more of awful and inconceivable intellect, went into the making of that picture than of a thousand poems.

Ruskin, *Diaries*[1]

This book is about what painting – or certain painters, Veronese among them – have had to say about a central strand of the religious and political imagination. That sentence will do as a brief announcement of what follows, but I am immediately unhappy with it, since the metaphor of 'having to say', as my epigraph from Ruskin is meant to suggest, goes contrary to one of the book's main arguments. Painting does not have anything to say. It would be foolish to deny that in many circumstances this has proved a limitation or worse. Powers of all sorts, religious, political and economic, have seized on the silence and seeming transparency of the visual image, and filled the silence with speech (or sub-speech) that appears to emanate from the image itself. But I am with Ruskin in thinking that a picture is not by its very nature ideology's mute servant, and has at its disposal kinds of intensity and disclosure, kinds of persuasiveness and simplicity, that make most feats of language by comparison seem abstract, or anxiously assertive,

or a mixture of both. Of course I step back from Ruskin's endearing wild claims for painting's total superiority. But at certain moments and on certain subjects – this is the book's essential proposal – painting's muteness gives it a peculiar advantage over the spoken or written word.

The advantage is twofold. It is not simply that in times of enforced orthodoxy (that is, most of the time) the 'openness' of the image can provide a space for the insubordinate, or at least the blessedly unserious. That is part of the story, certainly; we should never forget the Inquisitor's suspicions of Veronese and the painter's faux-naive replies: 'We painters take licences, like poets and madmen.'[2] I go on laughing in general at art history's efforts to pull all the great Nay-sayers and Yea-sayers of European art – the Bosches, the Goyas, the Blakes, the Bruegels, the van Goghs – back into the world of sanity and conformity. Even Bosch is a finger-wagging moralist, it turns out; even Blake no believer in his Proverbs of Hell. But the real question goes deeper. Let me state it in the abstract straight away, and then hope that the accounts of particular paintings in the body of the book will put flesh on the bones.

There are aspects of the human imagination – the attempts that individuals and societies go on making to give overall shape to earthly existence, and have time take on a trajectory and destination; the effort to have pain and powerlessness be bearable, and to answer the question of whether the coherence and fullness of a life in common ought to be seen as an entirely human possibility or as the foreshadowing (the gift, the vision) of a world to come – whose main established metaphors and images look to be indelible, however often they are subjected to the fires of disbelief. Criticism is impotent in the face of them, because it can immediately be characterized as the voice of Satan. This is because criticism *is* a voice, and because what it goes on trying to dismantle is not a set of propositions or 'beliefs' so much as an orientation, a way of showing and telling, a placing of oneself in space and time, a cry of rage and *dis*belief ('I could never have dreamt …') or exultation and

ekstasis. The idea of heaven on earth, in particular – of a future close to us in which 'former things are passed away' – will persist as long as the hellishness of the present demands it.

Painting's advantage, then, is that it can simultaneously tell and untell the story, not putting it into words. It can enter first of all, and wholeheartedly, into the scale, the urgency, the whole exalted logic of a certain vision of history. It can make the vision concrete, and therefore spellbinding: persuasive and imminent as never before. Heaven on earth, as we look at Giotto's or Veronese's representation of it, is a reality in comparison with which the present looks pallid, insubstantial. Ruskin's hyperbole makes sense in this context: he is not alone in having been touched, with unique force, by a great painting's mixture of the wished-for and the matter of fact.

What seems more difficult to decide is the effect of the mixture Ruskin is responding to. I am looking as I write at Veronese's *Crowning of the Virgin*, done for the high altar of the Ognissanti in Venice, particularly at the balance struck in the painting between higher and lower (therefore nearer and more vivid) levels of heaven; and also at Giotto's unequalled *Raising of Lazarus* (figs. 1 and 2). Here is what I feel to be the great fact about them both. The more luminous and fully materialized the vision of heaven, or of death defeated, in paintings of this kind, the more human and earthbound the vision becomes.

This is a matter of judgment – of experience of the real thing – and it is part of these painters' visionary achievement that the balance between heaven and earth should be delicate, ready always to tilt one way or another as we look. 'Spellbinding', for example, to take up a word used previously, clearly does Giotto and Veronese no more than justice. The spell is binding in both – the miracle of resurrection or transfiguration happens before our eyes – but (here's where the spell begins to turn back on itself) precisely because a familiar, and utterly worldly, array of things has been taken up into such an inspired, ingenious, well-calibrated play of form. (When Veronese said to the Inquisitor that he

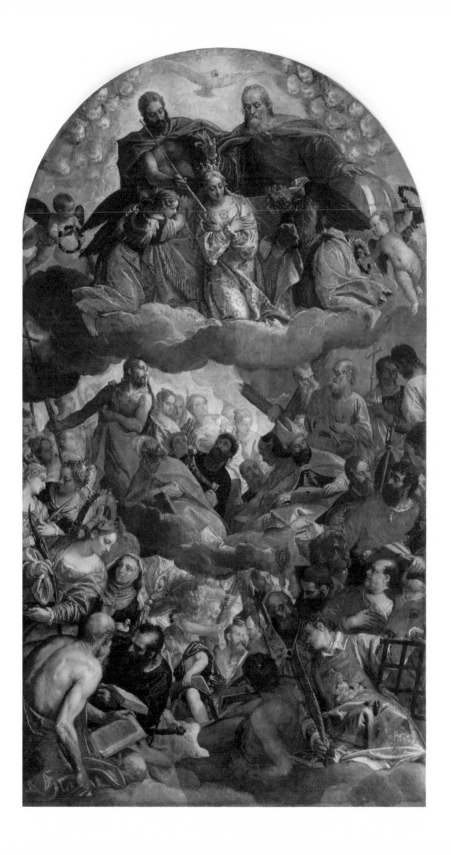

PREVIOUS PAGE 1. Paolo Veronese, *Crowning of the Virgin*, c.1586, 472 × 302 cm (185⅞ × 118⅞ in.). Galleria dell'Accademia, Venice.

BELOW 2. Giotto *Raising of Lazarus*, fresco, c.1303-5. Arena Chapel, Padua.

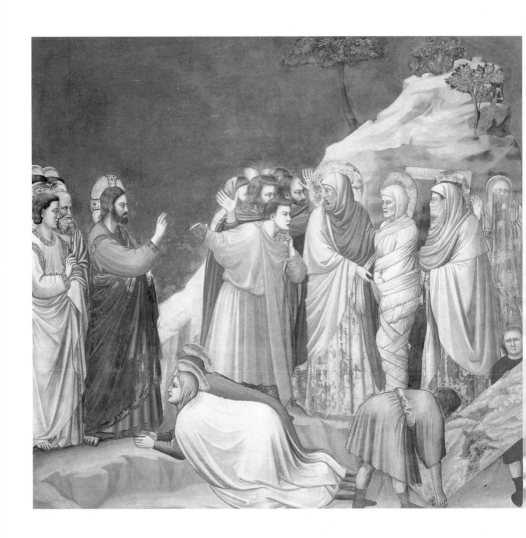

had included one of the figures in his *Last Supper* 'as ornamentation, as we all do', he was speaking to the heart of the matter.) The man in green in the *Lazarus*, for example, cantilevered against the hillside, looking and wondering, with a brown halo of faces framing his stare, seems to me the perfect figure of just such a worldliness; but so is the sea-green tombstone braced against the picture's bottom corner; or the fabulous pink of the prone woman's robe, with its russet repeat just above; or simply the blue of Giotto's sky, so absolute and terrestrial, with Christ's fingers drawing down into them all the colour's plain power.

No doubt these episodes, and others just as gripping in the Veronese, are put at the service of the story; but the more we look, the more the 'service' – the ornamentation, the visual array – presents itself as a strange, self-generating, entirely material thing. And thus (though this, I know, is my most abstract assertion, which the book as a whole will support or gainsay) the question of belief or unbelief, in Giotto and Veronese, yields to the subtler, and in the end more corrosive, problem of the priority of the here-and-now over the imagined. 'Till the sea itself floweth in your veins, till you are clothed with the heavens':[3] the man in green in the *Lazarus* is my figure of that clothing. And his power over the image as a whole – the power of his triumphant earthboundedness – seems to me complete.[4]

Of course a painting's way of questioning the reality of heaven can be less internal and embedded than the dialectic just described. Bruegel's calm scepticism – his practical, unspoken atheism – is one great marker of early modernity. His *Triumph of Death* (fig. 3) lives on for many of us, in the age of Islamic State and Predator, as the touchstone of godless lucidity in the face of all wars of the faithful. Nonetheless, I have no interest in disputing the common-sense notion that each of the four painters treated at length here, Bruegel included, was a 'believer'. An atheism of Bruegel's sort, or an earthliness of Giotto's, is indissociable from belief. It is all the deeper and more unnerving, it seems to me, because it is steeped in the view of the world it puts in question –

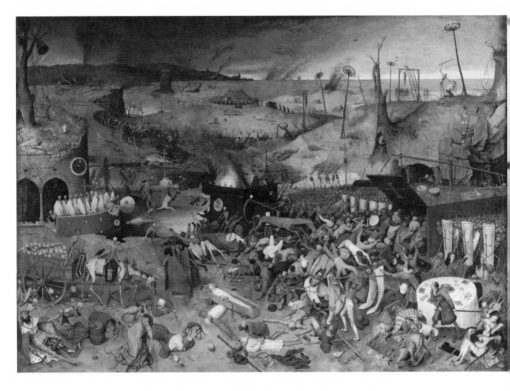

3. Pieter Bruegel the Elder, *Triumph of Death*, c.1562,
117 × 162 cm (46⅛ × 63¾ in.). Museo del Prado, Madrid.

because it is a product of that view. That is why, writing in a time of renewed wars of religion, I find myself obliged to reach back to the late medieval and early modern ages. A succeeding Enlightenment is no longer for us. The wonderful easy godlessness of French painting in the nineteenth and twentieth centuries, still my teacher of the beauty and depth that so-called 'secularization' can attain, has little to tell us, sadly, as men in orange jumpsuits plead for their lives on camera. We need the wisdom – which includes the bitterness – of men for whom the *Massacre of the Innocents* and the smell of heretics' burnt flesh were commonplace.

4. Pieter Bruegel the Elder, *Massacre of the Innocents*, *c.*1565,
109.2 × 158.1 cm (43 × 62¼ in.). Royal Collection, Windsor.

At the heart of the book lie two aspects of the religious and political
imagination: neither are constant or indispensable features of religion and
politics, but they speak to the hold of a certain dream of transfiguration
on both. First, there is the idea that the world we inhabit might open
onto another – be interrupted by it, or called to it, or visited by it and
make sense at last in the light of the visitation. Call it the image of the
earthly giving way to the heavenly, the miraculous, the truly revolution-
ized. The second is the idea, close to the first but distinct from it, that
the world we know might be raised to a higher power, 'deified' by an
energy that, though it may ultimately be a gift of God, is manifest here
and now in a quickening, an intensifying, an overflowing, a superchar-
ging of altogether human powers – be they imaginative, erotic, ecstatic,
intellectual, irenic or jihadist, possessed by an exceptional individual or
created by a fused group.[5] Again, the man in green in Giotto's *Lazarus*,
and his attendant 'fused group', is my figure of that possibility – at least

17

in its positive form. The armies of death in Bruegel's *Triumph* stand for the other, maybe more familiar, side of the story.

The four painters around whom the book revolves, and the seven paintings by them described at length, approach the arrival of heaven on earth in very different ways. Veronese, in Chapter 4, is and is not a believer in 'higher being'. In much of his painting he entertains the idea of a life lived by a set of men and women apparently transformed by something – some lordly freedom, some nobility, some power of desire or understanding – that has made them, though they are recognizable, more than ourselves. But the 'more' that he shows – the 'higher' in his version of higher being – is a strange quantity, above all in the four *Allegories of Love* the chapter focuses on (figs. 59–62). The Renaissance, we may think, was never so grandly exultant in its dream of a super-humanity; but the atmosphere in the four panels seems to include – to depend on – comedy, vulnerability, infidelity, absurdity, abjection, as well as respect for others, poised disillusion, endless revelling in the moment. How high 'higher being' may turn out to be, then, or ought to be – how far above us as we look at it, how connected to or discon-nected from the realm of the fallen – is Veronese's question.

There is a great, and as usual problematic, passage in Nietzsche's *The Will to Power* (which is given in full towards the end of the Veronese chapter) where Nietzsche tries to sum up his general intention as a writer. 'I have guessed,' he says, 'to what extent a stronger type of human being would necessarily have to conceive the elevation and enhancement of the human as taking a different direction', developing in a realm populated by creatures whose purposes we can only guess at, 'beyond good and evil.'[6] But just before this declaration, Nietzsche has talked of his project as being 'a Dionysian affirmation of the world as it is, without subtraction, exception, or selection … the same things, the same logic and illogic of entanglements'.[7] There is a tension between the two impulses, and it is never resolved in Nietzsche as a whole. Perhaps it is unresolvable. Perhaps any vision of a 'beyond' to human affairs is

doomed to obstruct the recognition, which is alive in *The Will to Power* at its best, that all such visions are vacuous if they fail to include – are not able to thrive on – 'the same logic and illogic of entanglements' as govern our everyday lives. This is where Veronese's *Allegories of Love* may help. I know of no more rigorous attempt to think through the tension appearing in the passages just quoted. And again, it seems to me that it is just because the ideas of 'vision', 'higher', 'enhancement' and 'entanglement' are explored – materialized – mutely in the *Allegories*, in terms of pictorial scale and placement and orientation, that Veronese can think them dialectically as far as he does.

I have said enough already about Giotto and Bruegel to give a rough sense of the parts they play in the book. But the paintings by them that loom largest strike a rather different note from the four illustrated so far. Bruegel's *Land of Cockaigne* (fig. 24), which dominates Chapter 2, is an envisaging of a better world. Such a world is not, when we look at it closely, entirely sealed off from the one the artist shows us in his *Triumph of Death* and *Massacre of the Innocents*. The date written on the grass at left in *Cockaigne*, 1567, is that of a terrible year in Netherlandish history. The world to come has soldiers in it, still wearing armour. Nonetheless, the painting goes as far as Bruegel ever allowed himself towards a dreaming of escape. 'There shall be no more death, neither sorrow, nor crying, neither shall there be any more pain';[8] 'Then the rain of blessing shall descend from God morning and evening, and the earth shall bear all fruits without man's labour. Honey in abundance shall drip from the rocks, fountains of milk and wine shall burst forth. The beasts of the forest shall put away their wildness and become tame.'[9] With what degree of ironic serious-ness Bruegel treated this kind of paradise in *Cockaigne* – with what kind of sympathy for a peasant vision of the hereafter – is my chapter's main question. But whatever his picture's tone, to catch this painter immersed at all in Eden is to see him in territory profoundly not his own.

Giotto's *Joachim's Dream* (fig. 5), similarly, is an exceptional moment in the Arena Chapel cycle and in what we can reconstruct of Giotto's

career. The panel has to do with the actual moment of contact between heaven and earth – angelic visitation, 'vision' happening in the here and now – and it gives the subject perhaps the strangest, most complex, most equivocal treatment to have come down to us from the past. The turbulence of the European world around 1300 is alive in the picture. 'Medieval' and 'modern' consciousness coexist in it. The *Dream* gives doubt – inwardness and mental reservation – indelible form. (Not that doubt is ever very far away in Giotto's universe – the man in green in *Lazarus* is, characteristically, arrested at the moment of not quite believing his own eyes – but normally it is sewn tightly into a story of Truth Incarnate. In *Joachim's Dream* the angel brings news of a mystery and urges the fulfilment of God's purpose; his appearance is trustworthy, but never has a picture been so sympathetic to its hero's uncertainty about the difference between miracle and mirage.)

This leads directly to Poussin's *Sacrament of Marriage* (fig. 46). In that painting the viewer is placed among a crowd in a high chamber, perhaps the porch of the Temple in Jerusalem, where a great miracle has taken place. Joseph, the oldest of the Virgin Mary's suitors, has just seen his offering of a staff burst into flower – the sign of God's preference among the men in the room – and now his betrothal to Mary is being solemnized. The central story of Christianity is beginning; men and women look on, pass comment, think deeply, join their hands in prayer. The room is dark; sunshine comes in through tall doors and windows, picking out particular figures and episodes – never very dramatically. We may feel that this is as sober and worldly an account of miracle – of God's intervention in human affairs – as any painter has given us. (It is not surprising that in a letter Poussin can be found poking cautious fun at the miracle-culture of Catholic Italy.) But sobriety, again, does not necessarily mean scepticism. The restraint and worldliness of the event as Poussin imagines it may be intended to bring home the matter-of-factness, almost the banality, of grace: what we are presented with is truly God's kingdom coming, giving a

sign of itself, launching the strange logic of incarnation at one entirely ordinary moment in the history of Rome. Imperial (provincial) tombs and columns catch the light outside.

And sobriety is not the picture's only note. A sacrament, so the theologians tell us, is above all a mystery. Clearly over time people come to take its ceremonies for granted, but there always remains about them a trace of the incomprehensible or ominous. Grace is interruption. It is paid for by Christ's blood. Over to the left in the *Sacrament of Marriage* stands a figure – an upright figure in a long blue dress, with a white or beige veil stopping the sun – that may come, as we look, to seem the representative of just these possibilities. A column intersects the figure: it is wonderfully incomplete. All we see of it is a pattern of folds. We cannot be sure of the individual's gender (or maybe we are, but we are not sure why) or even of the direction of its gaze (if it is gazing). But for all these reasons it holds us.

I see the body by the column in Poussin as rhyming profoundly with that of Joachim in Giotto. Both configurations set out the painters' deepest thoughts about *attending* – looking, reflecting, participating, being present or absent – at the moment the world is transformed. Being present or absent; that is, being inside or outside the sphere of action and belief. And, therefore (this will be my further argument), I take the two figures to exemplify the power and incompleteness – the power of incompleteness – that proceeds from looking or imagining from outside. This 'outside' is what I shall call in the book the *worldly* – the wordless, the un-figured, the faceless – the here-and-now. The world as it happens. Assessing what Giotto and Poussin 'have to say' about this condition seems to me vital.

∽

Introductions should not promise too much. The book that follows will either speak to its time or not, and it will not necessarily be to its disadvantage if it fails to. But it would be avoiding the issue not to say

something, however brief and preliminary, about the ways *Heaven on Earth* is linked to the present. My concluding chapter, on the mural Picasso painted in 1958 for UNESCO's headquarters in Paris (fig. 70), brings the story closer to a world like our own. There, even the central institutions of enlightenment show themselves willing – maybe obliged – to give wall-space to a new version of Bruegel's unflinching *Fall of Icarus*. And my brief coda, 'For a Left with No Future', written as the elements of the book began to coalesce, gives a glimpse of the politics underlying the whole project. Nonetheless, here at the beginning, running the risk of generality, I need to make some of the book's assumptions and purposes explicit.

We live in an age of revived or intensified religion, and of wars in which God's will is once again invoked to deadly effect. But the intensity of this religious revival is shadowed – I would say fuelled – by an underlying sense of an ending. Religion (and the verdict certainly applies to Islamic fundamentalism just as much as its Evangelical rivals) reappears, on the other side of a failed nationalism or socialism or 'modernity', in retrospective mode. It is permeated by the repressed, or sometimes flaunted, recognition of its being a thing of the past. It stands in relation to the religions of history, that is, in essentially the same way as did Verdi's great *Requiem* to the sung mass, or Eliot's *Ash Wednesday* to the poetry of devotion. A dreadful secularization goes on overtaking it. And it is this that brings religion back to world-historical life. Its strength derives from its desperation, its half-hold on the present – its belatedness.

Bruegel and Poussin and Veronese, in the paintings the book is concerned with, seem to me already to hold the question of religion's believability in suspense. They revel in the ability painting has, perhaps more than any other means of representation, to imagine the world transfigured – have it be entirely familiar and concrete, calling out all our established responses, but with everything in it larger or lighter than life. (Or darker and more agonized: the painter of the *Garden of*

Earthly Delights is the painter of the fires of hell.) Whether this other or higher realm is *true* is the wrong question. Heaven has an existence for us. Pictures make it possible to think about what that existence consists of – what it is, does, makes available, occludes, renders real or unreal. The specific character of alternative worlds is what matters, and what is normally not looked at: the writer of the Book of Revelation is representative in his brilliant generality. For looking too closely brings back the question of heaven and hell's dependence on the world they displace: 'Eternity is in love with the productions of time.'[10]

∽

The question forced upon us by the past century, and now again haunting our daily lives, strikes me as this: Could there ever be a thinking and acting directed at changing the world – at truly transforming or revolutionizing it – that did not result in 'paradise for a sect' (meaning hell for everyone else)? The thinking and acting appear to be indelible features of the human mind; but does that mean they are to be understood, in the light of past horrors, as necessarily malign, or at least as essentially dangerous and self-deceiving?

Here is the verdict passed by the philosopher Leszek Kolakowski on the main idiom of revolutionary politics in the twentieth century. That his judgment is fuelled by bitterness and condescension could hardly be more obvious; yet whatever his tone, much of what he says remains unanswerable, or anyway unanswered:

Marxism is a doctrine of blind confidence that a paradise of universal satisfaction is awaiting us just round the corner. Almost all the prophecies of Marx and his followers have proved to be false, but this does not disturb the spiritual certainty of the faithful, any more than it did in the case of chiliastic sects: for it is a certainty not based on any empirical premises or supposed 'historical laws,' but simply on the psychological need for certainty.

23

In this sense Marxism performs the function of a religion, and its efficacy is of a religious character. But it is a caricature and a bogus form of religion, since it presents its temporal eschatology as a scientific system, which religious mythologies do not purport to be ... The self-deification of mankind, to which Marxism gave philosophical expression, has ended in the same way as all such attempts, whether individual or collective: it has revealed itself as the farcical aspect of human bondage.[II]

The argument has strange shifts. Many readers will fall to wondering, for example, if a 'temporal eschatology' really has anything to gain, in terms of contribution to human bondage, from claiming to be God-given rather than inscribed in the laws of history. Perhaps Kolakowski would have agreed: he seems simply to have wanted the subservience to illusion he thought characteristic of the species to declare itself as such. This is very Nietzschean. But again, whatever the level of evasiveness and cliché underpinning Kolakowski's prose (the 'psychological need for certainty' is a typical Cold War chestnut), too much of it strikes home. And the question follows: What kind of heaven on earth, accepting that human beings seem unable to do without one; what vision of higher being, or time of radical discontinuity, or moment of access to a 'known unknown'; what metaphor or leap of the imagination, borrowed as it must be from the past of the gods, will *not* lead its users back to a terrible or farcical parody of religion?

We find ourselves going to unlikely places for help. Take Veronese's *Allegories of Love*. They represent a thinking of the 'self-deification of mankind', and even of a paradise of universal satisfaction, carried out in a truly inscrutable register – at once entirely serious and declaredly unreal. Built into Veronese's stance is no doubt some form of aristocratic pessimism: a certainty that the world as we know it will never entirely change. But the message, or even the specific choreography, of the *Allegories* is not the main thing. It is the *mode* of thinking these

paintings exemplify that matters: their acceptance of illusion, and of the way illusion is bound into the fabric of life; their freedom from the kind of smug glumness that is so often assumed to follow from that recognition; and the kind of lucidity that does follow, about the powers and vulnerabilities of 'higher life' and the logic and illogic of its entanglements.

<center>〜〜</center>

To go back to Voltaire, finally, and try to rethink his too famous 'If God did not exist' … Some of us may be tempted, facing again the cruelties of religious war, to say that if God existed it would be necessary to disinvent him. But have we not learnt from Enlightenment (that is, from its failure) how difficult the disinvention will be? 'God' turns out to be shorthand for 'otherworldliness', and Nietzsche was right to insist that the frames of mind, or ways of being, summed up in the latter formula are worked deep – too deep, he thought – into human sociality. Men and women perpetually gravitate towards the conviction that the world they belong to is false, a spume on the surface of reality; and that this reality is about to reveal itself, so that 'former things [will have] passed away'. The appeal of such a vision seems basic to the species: time and again it is what shapes and holds together the 'fused group'. Thomas Traherne's difficult contrary model, of a heaven wholly and only existing in the world we have, here and now, through our common ownership of ordinary experience (each individual, Traherne says, 'sole heir of the whole world, and more than so, because men are in it who are every one sole heirs as well as you'[12]) is peculiarly hard to grasp. Divesting ourselves of the otherworldly impulse, that is – drawing a line between imagining things otherwise and having the otherwise be a territory, a Truth, a kingdom come – remains a dream. But understanding the impulse may be possible. Traherne and Giotto are parallel texts. Heaven may still be brought down to earth. The paintings I deal with in what follows are steps on the way.

Giotto and the Angel

VLADIMIR. I've seen you before, haven't I?

BOY. I don't know sir.

VLADIMIR. You don't know me?

BOY. No, sir.

VLADIMIR. It wasn't you came yesterday?

BOY. No, sir.

VLADIMIR. This is your first time?

BOY. Yes, sir.

[*Silence.*]

VLADIMIR. Words, words. [*Pause.*] Speak.

BOY [*In a rush*]. Mr Godot told me to tell you he won't
 come this evening but surely tomorrow.

[*Silence.*]

VLADIMIR. Is that all?

BOY. Yes, sir.

[*Silence.*]

<div align="right">Samuel Beckett, Waiting for Godot</div>

The painting by Giotto called *Joachim's Dream* comes almost at the beginning of the great sequence in the Arena Chapel. It is high on the wall to the left as we look towards the *Last Judgment*: the fifth in a row of six panels telling the story of the birth of the Virgin (fig. 6). Giotto had access to the legend probably in several versions, perhaps including handbooks that have not survived, but the text he appears to have responded to most deeply is one his contemporaries knew as the *Liber de Infantia* or the *Historia de Navitate Mariae*, which I shall call *The Book of*

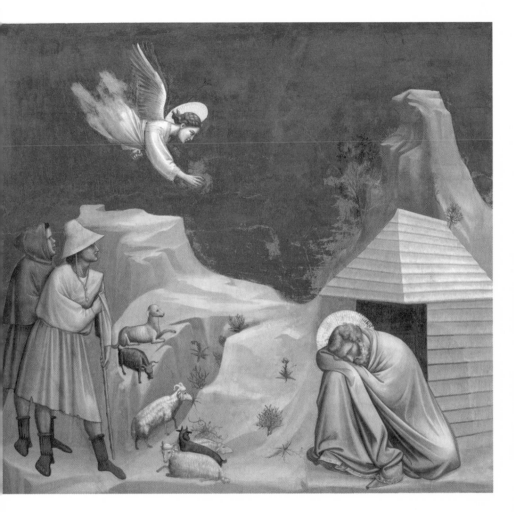

5. Giotto, *Joachim's Dream*, *c*.1303-5, fresco.
Arena Chapel, Padua.

Mary. Readers in Giotto's day believed the book had been written soon after Jesus's death: some said by the apostle James, some by Matthew. Nowadays we think it was put together in Latin in the seventh or eighth century.[1] *The Book of Mary* lay behind many retellings and embroideries of the tale in the late Middle Ages – it is the main source for the story in the *Golden Legend*, which established its hold on the faithful at much the same time the Arena Chapel was being decorated – but Giotto and his advisers seem to have studied the older narrative first-hand.[2] Its treatment of Joachim's time in the desert has a level of detail, we shall see, and of quiet eloquence that sparked the painter's gifts.

The story has to do with the Virgin's Immaculate Conception. Joachim, an elderly Israelite of great piety and enviable wealth, is married to Anna. After twenty years together they have no children. The old man (the texts do not insist on his age, but I take my cue from Giotto's depiction) goes to make an offering in the Temple, and the high priest rejects the lamb, saying the couple's barrenness represents the Lord's judgment. Joachim takes his humiliation away into the desert hills, staying there for months on end, out of touch, alone with his shepherds and flocks. (His interaction with the shepherds is one main theme of the early Christian source.) Then an angel comes to the grieving Anna and tells her she will give birth to a daughter. Joachim, knowing nothing of this, sacrifices to the Lord in the wilderness, and a miraculous youth appears, making the same prophecy. Joachim hesitates about whether to act on the vision, and the angel appears to him a second time as he is sleeping – the scene shown in the panel that concerns us. This time the old man is persuaded. He makes his way back to Jerusalem. Anna meets him at the Golden Gate. She is already pregnant with Mary.

∽

Giotto is a storyteller, and in due course the human and natural details of *Joachim's Dream*, all of which are charged and fine-tuned, will need spelling out. But the picture's first, and most lasting, way of being for

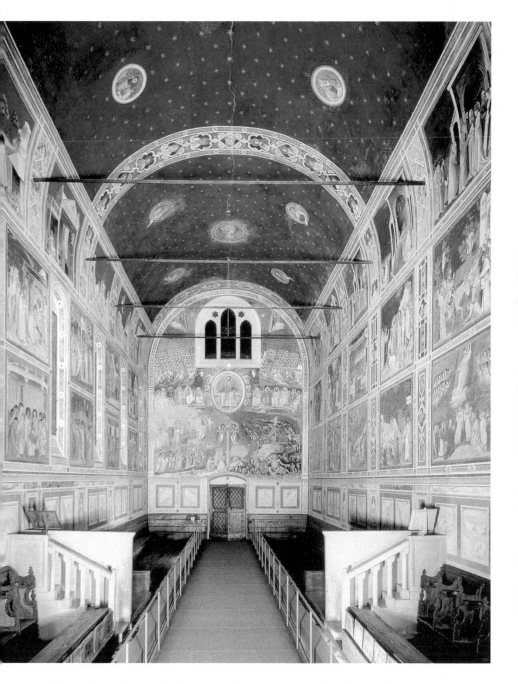

6. Giotto, Arena Chapel, Padua, general view looking towards the *Last Judgment*, c.1303-5.

the viewer is (for want of a better word) 'formal'. Broad masses and emphatic interaction of colours are the painting's prime facts and must always have seemed the key to its authority. They are what tell the story most intensely. Blue and grey are therefore my starting point.

Seen from the floor of the chapel 25 feet below, the bleached grey of the hills and the shepherds' hut reads essentially as a single shape, and the blue as an answering force field. Both shapes loom large: the frescoed frame containing them is just over 6 feet wide and 6½ feet tall. The grey and blue are spread across the picture plainly and strongly enough, whether looked at from a distance or in reproduction, that episodes occurring within them and in front of them – the angel, the old man muffled in his cloak, the hut, the shepherds, the long-suffering animals – seem almost the colours themselves in high concentration, crystallizing out, finding their terms of exposition. The shepherd at left, leaning on his stick, gathers the colours and folds of the hillside into his smock, warming them a little. The angel is the blue incarnate – emerging from it (incompletely), articulating it, absorbing the monad's whole power.

Having the painting be so much a matter of two equal and opposite plain fields in this way, laid out like crumpled geological strata, may have to do in the first place with Giotto's desire to establish, in line with his sources, that what we are looking at is a wilderness, a scene of bare life. 'Being therefore put to shame in the sight of his people,' says *The Book of Mary* about Joachim, 'he retired from the Temple of the Lord weeping, and did not return to his house, but went to his flocks, taking with him his shepherds into the mountains to a far country, so that for five months his wife Anna could hear no tidings of him.'[3] A rich man, turned away from the Temple because his marriage had not borne fruit, seeks out a barrenness in the world that will answer to his condition. The fresco preceding *Joachim's Dream*, showing *Joachim's Sacrifice* in the desert a day or so before, is structured in much the same way. But the comparison brings home the *Dream's* intensity. Earth and sky in it are forces, specific forms, organisms interacting.

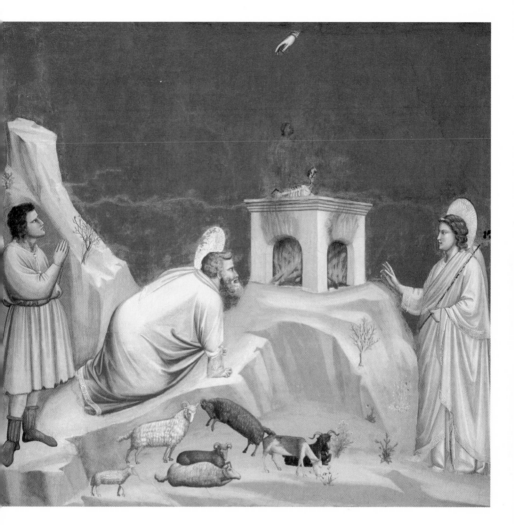

7. Giotto, *Joachim's Sacrifice*, c.1303-5, fresco. Arena Chapel, Padua.

The colour blue in Giotto is most often a positive, consistent, plain thing, the opposite of 'atmosphere', handled with inimitable matter-of-factness. Exactly what shade of azurite Giotto and his assistants chose in the first place for Joachim's sky we shall never know – all of the blues resulting from recent restoration campaigns are beautiful, and even the scarred half-ruin still visible in illustrations from the 1990s has its own grim strength – but no doubt the colour was always strong, solid, essentially uniform. Blue was an entity the eye could touch. The schoolmen's understanding of Aristotle's optics may have been in the background.[4] Yet the colour as Giotto applies it opens time and again onto an aspect of God's creation that seems to exceed, and perhaps oppose, the human drama below, making even our deepest agonies (in Joachim's case, despair and isolation) insignificant. Maybe this is what the angel has been sent to explain. He addresses the dreamer compassionately but from an infinite distance. The shrieking angels in Giotto's *Lamentation*, similarly, much closer to us in the Arena Chapel and certainly readable as figurations of pity and terror, are severed from the action they are reacting to – the world of broken creatures on the ground – by an impassable blue trench. The absolute blue in *Joachim's Expulsion* (fig. 9) – conjuring an emptiness no human effort can ever stave off, uninflected and godforsaken, the Temple floating on it like a tipping life raft – seems to speak to a bleakness of vision that Giotto's art, taken as a whole, surely exists to refute. No other composition of his is so fundamentally unbalanced. We are at the beginning of the chapel's story: redemption is nowhere in sight. The blue in *Joachim's Dream* is less cruel – the angel, after all, does appear in it – but it remains as cold as a colour can be, pressing down into the desert at the angel's behest almost as far as Joachim's halo; we understand at once why the sleeper has wrapped himself tight in his cloak. Earth and heaven are stripped to the bone. The sheep forage in the gully; spindly spiked plants fight for life. The hut is too small to offer a man shelter.

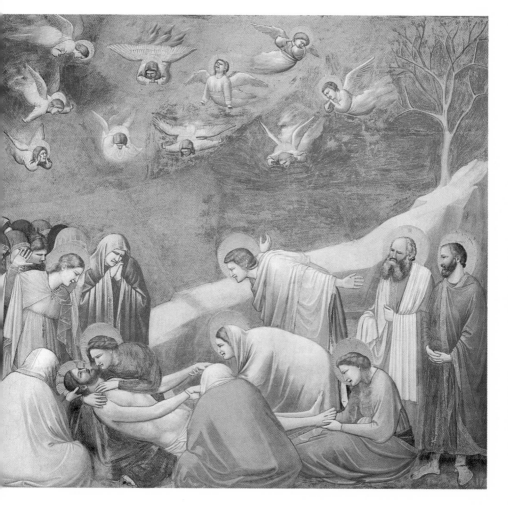

8. Giotto, *Lamentation over Dead Christ*, c.1303-5, fresco. Arena Chapel, Padua.

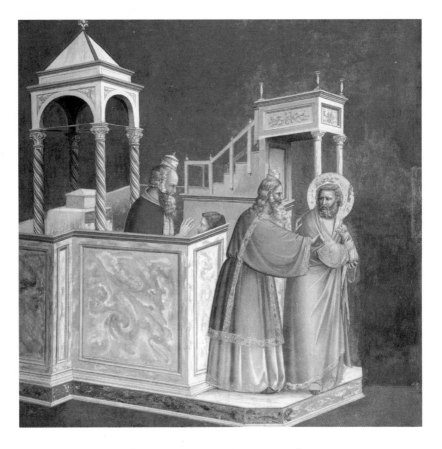

9. Giotto, *Joachim's Expulsion*, c.1303-5, fresco,
Arena Chapel, Padua.

Blue and grey, then: equally weighted, essentially singular, and stand-
ing for the opposites of the universe as a Trecento intellectual might
have understood them; but at the same time these are opposites tied
together, with almost a bravura flourish, by the looping line of the hills,
the hut, the rearing mountain – as if the angel's hand had unravelled
the contour from the shepherd's conical hat. And it is above all in this
drawing of the boundary between colours – this particular staging of
relation between earth and heaven – that Giotto's understanding seems
to me to pull away from any 'period' frame of mind.

Originally, we can guess, the mountain's edge must have been a little less bare. There is now a single tree clinging to it, and its leaves, done after the fresco had dried, have lost their green. It seems there was a smaller shrub in the dip – the trace of one is just visible. The landscape is structurally much the same as that shown in *Joachim at the Sheepfold* two panels earlier, but the comparison only points up *Dream*'s buckling and clearing of its desert switchback. The blue in *Sheepfold* keeps its distance behind the trees. Flowers and fruit are in evidence. The sheep are happy in their small enclosure. Even the mountain is sunnier, more domestic.

The shape of the world against the sky (and vice versa) in *Dream* is precipitous, by contrast, and unlike any other in the chapel. This is

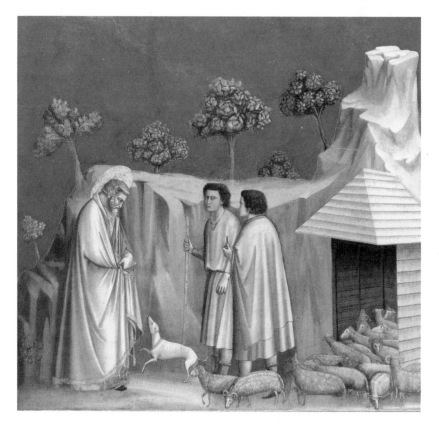

10. Giotto, *Joachim at the Sheepfold*, c.1303-5, fresco. Arena Chapel, Padua.

not to say that Giotto is normally unconcerned about such natural dividing lines in pictures or uninventive in his handling of them. On the contrary: one has only to look at the long hilltop in *Lamentation* and admire, as many have done before, the cantilever of John's body against it, flying forward – as if his grief made him wish to emulate the angels – for it to be clear that Giotto was the genius of horizons. In panel after panel they are part of the drama (in a way that even the best of his followers was unable to repeat). The *Expulsion*'s blue, for example, would not strike us as so impatient of human wishes if the Temple's towers and stairways had not made such an effort, it seems, admirable and labyrinthine and full of the pathos of partition, to frame and contain it. Right next door to the *Lamentation*'s left-to-right rising hilltop is the *Noli Me Tangere*'s descending one, like the resolution of a dissonance – from the *Actus tragicus* to *Lass, Fürstin*. The lances and torches in the *Kiss of Judas* (fig. 12) wave above the black honeycomb of helmets in the way of accents on an ancient script, dividing the blue into clauses. And so on: no artist has ever had a surer, stronger sense of painting as the art of demarcation.

What is special about the horizon in *Joachim's Dream*, set against these normal achievements, is the fact of its silhouette being so intricate and strongly marked, yet standing in such a mysterious relation to the drama. (One might say the same of the *Kiss of Judas*'s play of staves, but everything in that masterpiece pushes painting into realms – into kinds of semantics – that none of us has words for.) The horizon does not *participate* in Joachim's drama, exactly, or not in the way the hillsides in the Passion scenes do; rather, it is a commentary – a sermon – on the story. It is part of the picture's teaching.

∽

This chapter can put the horizon into words only indirectly and gradually. The distance of the horizon from the world of discourse is part, again, of 'what it has to say'. The angel speaks in sentences, and the line of the

11. Giotto, *Noli Me Tangere*, *c.*1303-5, fresco. Arena Chapel, Padua.

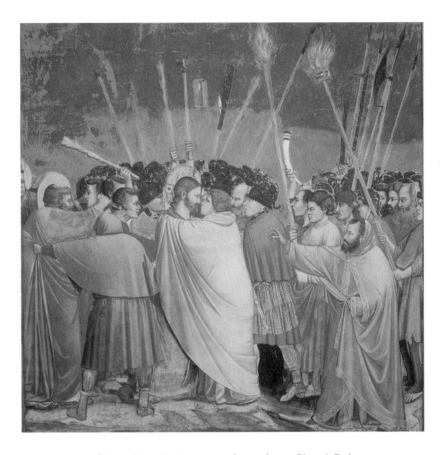

12. Giotto, *Kiss of Judas*, *c*.1303-5, fresco. Arena Chapel, Padua.

hilltop, if we take it for a moment to be his enunciation, flows from him with all the controlled unexpectedness – the troughs and convolutions, the gathering crescendo – of a great orator's summing up. But Joachim, distrustful of messages (the angel had first spoken to him a day or so earlier, and, in spite of his shepherds' urging, the old man had put off a decision about how to respond), is fast asleep, wound in the coils of his clothing. 'Then Joachim, throwing himself on his face' – thus *The Book of Mary* on the aftermath of the angel's first visit – 'lay in prayer from the sixth hour of the day until evening. And his lads and hired servants who were with him saw him, and not knowing why he was lying down,

thought he was dead; and they came to him, and with difficulty raised him from the ground. And when he recounted to them the vision of the angel, they were struck with great fear and wonder, and advised him to accomplish the vision of the angel without delay, and to go back with all haste to his wife. And when Joachim was turning over in his mind whether he should go back or not [*cumque Ioachim in animo suo revolvendo cogitaret si reverteretur aut non*], it happened that he was overpowered by a deep sleep; and behold, the angel who had already appeared to him when awake, appeared to him in his sleep, saying ...'⁵

> Suffer us not to mock ourselves with falsehood
> Teach us to care and not to care
> Teach us to sit still
> Even among these rocks,
> Our peace in His will.⁶

(Though whether these lines from Eliot's *Ash Wednesday* are best imagined in the angel's mouth or the saint's is something the picture leaves open.) The other sources for the Joachim story – again, we cannot be sure what lost handbooks Giotto may have looked into – move from vision to action with little ado, and have Joachim returning to Anna immediately following the scene of sacrifice. None besides *The Book of Mary* has the angel appearing twice. Only Giotto, if we compare him with his Byzantine predecessors or the later Italian tradition, seizes and dwells on Joachim's doubt. (There is an altarpiece in Pisa, done in the last decades of the thirteenth century by a master indebted to Cimabue [fig. 13], which has essentially the same set of Joachim episodes, including the sacrifice and dream.⁷ It seems to hint at an established pattern – perhaps specifically an Italian one. But the pattern did not take hold; and Giotto's farewell to it a few years later – if his six scenes do follow an earlier template – broods on the implications of *The Book of Mary*'s story in ways the Pisan painter does not come close to.)

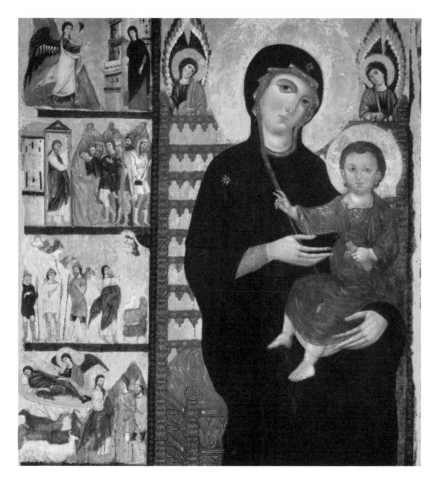

13. Master of San Martino, *Madonna and Child with scenes from the story of Joachim and Anna* (detail), *c.*1270-90, tempera on panel, 162 × 125 cm (63¾ × 49¼ in.). Museo Nazionale di San Matteo, Pisa.

The twists and turns of Joachim's cloak in *Dream*, more animate and substantial than any others in this world filled with flowing garments (for Giotto is the master of folds) speak partly, I think, to its wearer's psyche. They are a kind of carapace, a secret knot, a snail's shell – elaborate but vulnerable – set up in opposition to the horizon's sweeping onward movement. The abstract black square of the hut's interior, pressing down on the sleeper's shoulder, confirms the sense of huddled

constraint. Whether such an inward-turning, 'defended', 'withholding' human being as Joachim will ever be able to understand the angel's line – the balance between earth and heaven God's intermediary has come to spell out – is the picture's question. 'And Joachim,' says *The Gospel of the Nativity of Mary*, another medieval retelling, in explanation of the saint's thought processes, 'covered with shame from this reproach that was thrown in his teeth, retired to the shepherds, who were in their pastures with the flocks; nor would he return home, lest perchance he might be branded with the same reproach by those of his own tribe, who were there at the time, and had heard this from the priest.'[8]

We are meant, with Joachim, to find it hard to throw off the memory of public ignominy; hard to be sure that the angel, even appearing a second time, is not a will-o'-the-wisp; and hard, too, to understand the creature's lesson in theology. 'God is the avenger of sin, not of nature,' *The Gospel of the Nativity of Mary* has the angel saying, 'and therefore when he shuts up the womb of anyone, He does so that He may miraculously open it again; so that that which is born may be acknowledged to be not of lust, but of the gift of God.'[9] Even the messenger recognizes the difficulty: 'If therefore the reasonableness of my words does not persuade thee …'.[10] As so often in writing about pictures, the task will be to make language mimic, or at least not hurry on past, the moment of Joachim's uncertainty.

∽

Ruskin was right (speaking of Giotto more generally now) to put the question of the artist's pre-eminence first in terms of his conception of the task, and the place of that task in a wider order:

> All [Giotto's] important existing works are exclusively devoted to the illustration of Christianity. This was not the result of his own peculiar feeling or determination; it was a necessity of the period.[11]

Or this, from *Fors Clavigera*, comparing Giotto to Titian:

I found he was, in the make of him, and contents, a very much stronger and greater man than Titian; that the things I had fancied easier in his work, because they were so unpretending and simple, were nevertheless entirely inimitable; [and] that the Religion in him, instead of weakening, has solemnized and developed every faculty of his heart and hand.[12]

The job of the painter in Padua was to conjure the world of the Gospels: it was God's will (God's work) that he should. Conjuring was a matter of craft, of visual fluency and persuasiveness, issuing from a context of workshop ingenuity and immense painterly pride: none of the subtleties and strengths I have been pointing to – the play between halo and black hut door would be another – do more than try to catch up with Giotto's extraordinary pictorial thinking. 'Nondum venit alius eo subtilior', to quote an early commentator.[13] And the painter's imaginative energy coexisted, we know from the documents, with special powers as an organizer and entrepreneur, much remarked on at the time, and quick common-sense erudition. I am with the artist's nineteenth-century idolaters in thinking it part of the Arena story that Dante himself stood in the chapel now and then, talking things over. But also that Giotto, as he listened, was likely calculating the drying times for *giornate* that week (in a cold September), or trying to remember which of his workmen did sheep's wool or angel's feathers best.[14]

Ruskin's point about the conception of the task, and the nesting of that task in a whole surrounding culture, goes along with another recognition that many a viewer has arrived at, standing in the Arena Chapel: that there never has been, in the realm of painting, a power of mind to compare with Giotto's; or at least a power of mind so entirely focused on the task at hand, and able to bring its full range of knowledge to bear, for the moment that counted, on nothing but the act of

picturing (he is the anti-Leonardo in this); and that time and again
the mind's quality is signalled by its striking through, astonishingly,
to the question 'What is it that matters in this scene?' or 'What is this
story about, essentially?' Or – here is the question unpacked, inevitably
with too doctrinaire a ring to it – 'What is it that lies behind the event
or situation laid out in my sources, and which, for all this ultimate
meaning's elusiveness, I can make exist entirely on the surface of the
event (wholly in the form it takes) … embodied by objects and persons
situated in a familiar world, even if finally they open onto a dimension
that puts, as it must, the very idea of "world" in doubt?'

> Here one can neither stand nor lie nor sit
> There is not even silence in the mountains
> But dry sterile thunder without rain
> [...]
> This is the time of tension between dying and birth
> The place of solitude where three dreams cross
> Between blue rocks
> [...]
> In this last of meeting places
> We grope together
> And avoid speech.[15]

It may be thought that these lines – again from Eliot in the 1920s – are
too close to the nihilism of the 'modern' to represent, or even approxi-
mate, Giotto's vision. ('Mr Godot told me to tell you he won't come
this evening.') But Eliot was out to remind us – and did so irrefutably,
I think – that Dante's Catholicism, world-accepting and exultant as it
is, had its roots in an experience of sterility and solitude that no other
poet has made more real. Exile in Dante is the ground of understand-
ing. Blue and grey in Giotto are on the same knife-edge. They promise
salvation, but on the other side of despair.

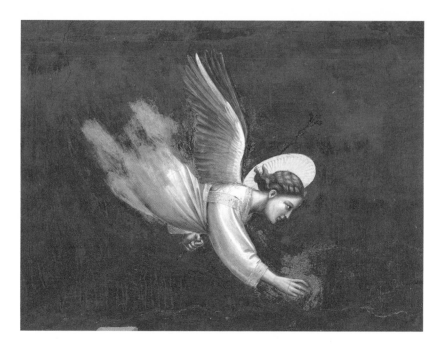

Detail from fig. 5: Giotto, *Joachim's Dream*, c.1303-5, fresco. Arena Chapel, Padua.

The angel in *Dream* holds a sceptre in his left hand, by the side of his waist furthest from us; it acts as a kind of fulcrum for his leap in space. Following the sceptre's trajectory behind the angel's upper body and halo, and trying to lay hold of the movement in depth implied, and therefore the breadth of the angel's torso and his halo's orientation … and then being struck by the sharp, forked tongues of the angel's hair silhouetted against the gold, and sensing the distance between hair and halo: it is a typical set of Giotto suggestions, none of them straightforward, as a result of which the angel, in his half-coming-into-being for Joachim, takes on palpable life. The half-rhyme between the shocks of hair and the fading tails of the angel's pale garment – the first all salience, the second all dry volatility – is the creature's ontology summed up.

God's messenger is a thing of contraries, matter and energy in apposition, but entirely convincing as a body in flight. Proust was right

in *Albertine disparue* to say that what in general characterizes Giotto's angels is that they 'are represented ... as winged creatures of a particular species that must once have really existed, and figured in the natural history of biblical and apostolic times'.[16] He goes on to make a famous comparison between the angels and the young men of his own time in their gliders, but what he writes in the rest of the paragraph smacks of Ruskin more than the Futurists. The word 'real' rings out three times. 'Really existed', 'real creatures capable of flying', 'the same impression of actual, literally real activity'.[17] But again following Ruskin, he knows that Giotto's is a naturalism unlike any other. The reality the angels embody is ultimately that of the firmament just above in the Arena, super-nature, the great blue hood of the chapel's ceiling – 'so blue that it seems as if the radiant daylight had crossed the threshold with the human visitor in order to give its pure sky a momentary breather in the coolness and shade'. We may resist his paragraph's final jibe at the angels of the Renaissance and later, 'whose wings have become no more than emblems' – he need only have looked, for example, at the angel hovering above St Nicholas in Veronese's San Benedetto Po altarpiece (fig. 14) – but his feeling for what makes Giotto's inventions uniquely moving is all the surer for being so old-fashioned.

The angels are real, but painted. Real but miraculous; with miracle, for Giotto, always intertwined with the new great thing called 'illusionism'. That appearances can be deceptive is integral to the Joachim story. When the angel comes down to Anna, his first words in *The Gospel of the Nativity of Mary* are: 'Fear not, nor think that it is a phantom which thou seest.' (The word in Latin is *phantasma*.[18]) Phantoms, in Dante's world, were familiar – part of Satan's bag of tricks. Giotto's delight in the *Dream* angel's leap into life out of the fresco, so clear in his treatment of the figure's coat tails – the feeling for painterly touch at this point, for transparency and opaqueness, for the dry encounter of pigment with brush – *is* his way of reflecting on God's creation, on 'reality' and its discontinuities. This is what Ruskin has to teach.

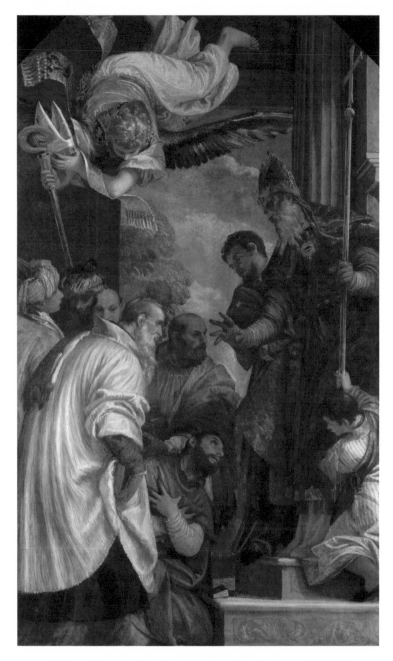

14. Paolo Veronese, *The Consecration of Saint Nicholas*, 1562, 286.5 × 175.3 cm (112¾ × 69 in.). National Gallery, London.

Matching such dialectic in language is a peculiar challenge. We need words for the poise and solidity of the angel – like 'an extinct species of bird', says Proust, with his young face so solemn, his fingers firm and expository – but also for the fabulous smoke-signal of his eruption. We want a language that recognizes and celebrates the demonstration of painting's new powers – of painting's triumphant self-consciousness – but that does not lose hold of the powers' being put to use in the service of the story, the ontology. The angel in *Joachim's Dream*, we recall, is the third in a sequence of supernatural appearances following one another along the Arena Chapel's top range: first, the no-nonsense half-body of the angel squeezing through the window into Anna's living room,

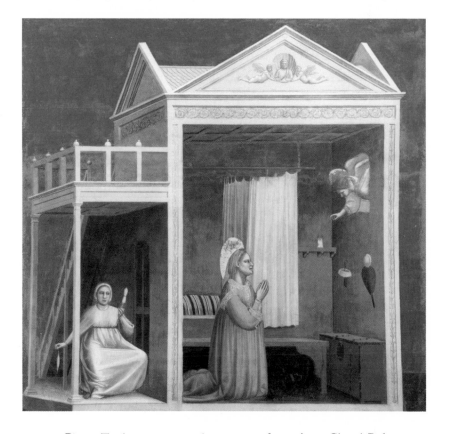

15. Giotto, *The Announcement to Anna*, c.1303-5, fresco. Arena Chapel, Padua.

shoulders broad, wings seemingly a little in the way of revelation (maybe to reassure us he is no phantom); next, the immaculate but diaphanous young man standing on the ground in *Joachim's Sacrifice* (fig. 7; the creature's strange brilliance is stressed in the sources[19]), at the edge of the panel, somehow not quite part of it in terms of colour and location, as if Giotto wished to hint at what, in the first apparition, might have struck Joachim afterwards as unbelievable; and finally, in the picture we are looking at, the angel come back – neither flesh nor spirit, stopped at the moment of transition, *of becoming an image* – to spell out God's message a second time.

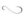

That there are special difficulties involved in writing about Giotto hardly needs saying. He is the Shakespeare of painting. That is, he is the inaugurator of the drive to match more and more of the detail and substance of the material world – the drive we now (half-guiltily) call 'European painting' – but also the inheritor of that great palimpsest of popular and elite understandings named (likewise in retrospect) the 'late Middle Ages'. The Middle Ages live and die in him. He gathers together the powers of a civilization – again the Shakespeare analogy – at a unique moment of health and energy and change and confident summation of a long past. In Giotto's case the powers he seizes on most immediately are those implicit in the culture's habits of visualization, of 'scenic' and public exposition – in a word, its taste for images. But the particular engagement here – Giotto's way with the medium, his brilliant mobilization of pictorial possibilities, his underlying sureness about the image's power to communicate – is inseparable from his conception of the task. The medium leads to the drama; or, rather, the sense of the story (the intuition of the story's place and meaning in the culture's revolving of its world) *produces* the medium, or makes the medium do wholly new things. The pink smoke of the angel's coat tails has all the outlandishness and simplicity (the 'rightness') of a Shakespeare neologism.

What is daunting in Giotto, to put it again, is the certainty of the balance struck between an appetite for the world's appearances (and an interest in organizing and rationalizing them) and a constant sense, provided by the culture, of what should guide, restrain, focus and intensify the play of vision – what the visualization was for, fundamentally, what job of exemplification (of what set of truths) it was called on to perform. And this leads immediately to the great Giotto lesson. In a painting that tells a story, we learn from him, *not too much should be happening* in terms of incidents, episodes, things filling the frame. A picture is held together essentially by broad masses, balanced pattern. Incident – and the picture will not amount to a world without it – should happen in and around the broad masses: it ought to be an inflection of them, not an addition of 'more and more'.

Of course Giotto, revelling in his powers, sometimes trod the line of redundancy. I look again at Joachim's cloak in *Dream*, and wonder at the tiny escaping tongue of it, up front, close to us, lying on the ground. But even here – to offer my intuition – the redundancy ends up contributing to the guardedness, the pathos, the vulnerability of the whole figure. Habitually in Giotto, when the scene is set in nature, there is at the bottom of the picture a falling away as into a cleft or gully. We viewers are on the other side of the abyss. The gap is not stressed in the Padua frescoes: it is essentially an inheritance, a convention borrowed from Byzantine prototypes. But genius is the power of putting conventions to use. Here the cloak's last tongue seems to rest, in the desert, on the edge of the world. The black sheep with splayed legs peering down into the gully is Joachim's double. From the front-most fold of Joachim's cloak – the point that almost touches the picture plane – to the infinite black square of the hut's interior is ... well, who knows how far apart they are? And where, if we are interested in estimating distances, is the angel hovering in relation to the mountain-top plinth just below him (its shape his uncanny grey double)? What is his distance

from, or proximity to, Joachim sleeping in front of the hut? The saint, by the sheer force and solidity of his folds, has carved out a space for himself between the hut door and the gully's rim. But constantly the roof and door press forward against his huddled half-pyramid, edging him almost out of the illusion.

I do not think the result of these (and other) uncertainties in *Dream* is, in the end, a destabilization. The panel's stability is absolute, and its key relations immediately graspable. No scene in the chapel says 'stillness' more plainly. The angel and Joachim are equal and opposite weights. It is rather that Giotto seems to have felt instinctively for a way to establish, as part of the stillness, that the distance between his two main actors – between heaven and earth, or a body in the world and one 'appearing' to a mind turned in on itself – is, precisely, immeasurable. Which is different from elusive or volatile (though volatility – the angel's materialization out of the blue – can be part of it).

∽

There is a moment in Ruskin's essay on the Arena Chapel when he seems to me to strike a wrong note. 'The *drawing* of Giotto is, of course, exceedingly faulty,' he writes. 'His knowledge of the human figure is deficient.'[20] No doubt at one level the judgment is reasonable: we all make instinctive allowances for, or rough and ready corrections of, the young shepherd's upper body in *Dream*, or his hold on his stick, or his feet on the ground. Nonetheless, Ruskin need not have made the concession. He should have looked at Giotto's treatment of the figure as part of the pictorial field. He might have thought about the dialogue between the shepherd and the mountain behind him. And then considered the *function* of the shepherd's awkwardness and frontality, above all in relation to the pose (the entirely fluent and authoritative three dimensions) of Joachim. In a word, he should have followed his own instructions, given in the great third chapter of *Mornings in Florence*. Ruskin is talking there about a fresco by Giotto

16. Giotto, *St Francis before the Sultan*, c.1515-20, fresco.
Bardo Chapel, Santa Croce, Florence.

in Santa Croce, *St Francis before the Sultan*, and he turns to the question of what the artist chose and chose not to articulate in his subject:

> That there is no 'effect of light' here arrived at, I beg you at once to observe as a most important lesson. The subject is St. Francis challenging the Soldan's Magi – fire-worshippers – to pass with him through the fire, which is blazing red at his feet. It is so hot that the two Magi on the other side of the throne shield their faces. But it is represented simply as a red mass of writhing forms of flame; and casts no firelight whatever. There is no ruby colour on anybody's nose; there are no black shadows under anybody's chin; there are no Rembrandtesque gradations of gloom, or glitterings of sword-hilt and armour.[21]

And the reason for this, he says, is the role of fire in the story: the aspects of it that are relevant:

> That the fire be *luminous* or not, is no matter just now. But that the fire is *hot*, he would have you to know. Now, you will notice the colours he has used in the whole picture. First, the blue background, necessary to unite it with the other three subjects [on the wall], is reduced to the smallest possible space. St. Francis must be in grey, for that is his dress; also the attendant of one of the Magi is in grey; but so warm, that, if you saw it by itself, you would call it brown ... The rest of the picture – in at least six-sevenths of its area – is either crimson, gold, orange, purple, or white, all as warm as Giotto could paint them ... And the whole picture is one glow.[22]

I would generalize Ruskin's instruction as follows (it is very basic, but strangely hard for art history to take): Whenever we encounter in a work of art some awkwardness or abbreviation that strikes us as 'not realistic' or 'not true to life' – as we do all the time, in the anatomy of a kouros, or the composition of a Le Nain, or the colour of a Bonnard – we should at least ask ourselves the question: What *other* aspect of the thing seen or event imagined does the 'unrealistic' notation make vivid?

In the case of Giotto's figure drawing, the answer is this. His painting is concerned in the first place to present the viewer with the salience of each 'natural kind' on view: that is, with the separateness of each body or entity, its completeness and integrity, the simple extension of the entity in space and the felt difference between the solid and the space containing it.[23] And it does so with unique force. The angel in *Dream* is only an extreme case – a kind of emblem – of this overall sureness. No other artist's drawing is so 'clear and distinct'. And this is not simply a matter of hard edges or abbreviated modelling, though clearly both play a part. Look again at the angel, or at Joachim in his cloak. 'Identity', in cases like these – the tails of the angel's tunic, the

spiked hair and halo, the black square at Joachim's shoulder, the fold of cloth at the edge of the gully – depends time and again on a decision, inspired and improvised and most often unrepeatable, about the *kind* of relation there should be between the figure and the space containing it, and the best means painting has to conjure it out of thin air. It can be a choice of colour: the yellow of Judas's robe in the *Kiss* (fig. 12). Or a sudden change in the level of detail: the thinness and tightness of the lines on the winding sheet in the *Raising of Lazarus* (fig. 2), as compared with the same picture's man in green or the wonderful woman on the ground in pink – 'life', both of them, to the corpse's stiff ghostliness. Or space itself congealed into a solid – the hillside in *Lamentation* (fig. 8) – and then pushed back, dramatically, behind John's body.

Giotto in Padua is an artist whose style is consistent, sustained through an enormous range of scenes and kinds of task. The reality of this in the chapel is overwhelming. But the longer one looks, the more one sees that the style is open at the edges, and even its most basic modes of apprehension – its materialism, its ontology – are brought into being by an extraordinary variety of means.

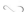

Giotto, I said previously, is the master of folds: Joachim's cloak is a typical triumph. Dante in the *Paradiso*, looking for a way to explain why his language has to admit defeat in the face of heaven's utter strangeness, reaches for a metaphor from painting: 'Because our speech, not to say our imagination, has no colors / To match folds like these.'[24] Giotto here may be specifically in Dante's mind: the play of light and shade on a fall of drapery is the very image of 'representation' as the poet understands it. Heaven, at the very end of the *Divine Comedy*, throws up shadows and highlights that defeat our efforts to reproduce them; but everywhere else – even in hell and purgatory, as Dante imagines them – God's creation is a kind of unfolding. The great artist is one whose colours show how.

Yet here, too, in Giotto's practice as in Dante's, the rule of restraint applies. The world is an unfolding, but as it were of a cloth that is strong, close-woven, resistant, gathered in great slow sweeps: its folds are not jagged or brilliant, corners are turned gradually, darknesses are never very dark. The recent restoration of the Arena Chapel is entirely convincing in its decision for a gentle, light-toned colour world, with plenty of white mixed in, and soft greys in the shadow.[25] Things unwind and meander (look again at the movement of the grey mountaintop in *Dream*), but always with a sense of extension being parallel to the picture plane. 'Frontality' is not quite right; but there is in the chapel a constant implied idea of painting – of painting's various imagined substances – being fundamentally singular, impenetrable, aiming at totality. The hut's black square is painting summed up. Thus far I have barely mentioned the illusionistic frames provided for each scene in the chapel and the Old Testament figures in the frames, enshrined

17. Giotto, *Joachim's Dream* with surrounding frame and saints, *c*.1303-5, fresco. Arena Chapel, Padua.

in Gothic niches. (The prophet next to *Joachim's Dream*, we notice even from far away, is a second Joachim turned to face us.) But all of this surrounding – elaborate, lavish, Roman, insisting on a world of false stucco and marble – has the effect of making the *Dream*, like every other panel in the chapel, shuttle between being a view through a window and a plaque on a dazzling Cosmati throne. 'Picture' and 'panel': neither word quite captures the image's place in its world.

Basic to Giotto's sensibility as a painter is his feeling for the coloured rectangle as essentially all one thing. No doubt this is what made the Arena Chapel a revelation for Matisse when he first saw it in 1907;[26] and no doubt totality was a period preference. But for critics in our own day to retreat from Matisse's (or Roger Fry's[27]) emphasis, murmuring about its being 'modernist', seems to me a mistake. The unity of the picture in Giotto is paramount, and belongs to (proceeds from) the action dealt with in a way that makes most other 'composition' seem forced. What needs explaining is the intention – the climate of feeling – that made such totality possible. My answer is the one Ruskin might have given. The painted rectangle in Giotto is uniquely electric with its enclosing limits, filling every inch of the panel with the same decisiveness, and with every lesser internal element speaking its place in an order derived from the panel's basic shape, because that shape, for the artist and his audience, *was the limit of a world*. A picture was finite because it showed a necessary state – a specific intersection of earth and heaven – in the story of salvation.

But to call a state necessary is not to call it stable. Unity is the tension of opposites. The *Dream* spells that out. The world, for the Christian, is constantly shot through with negativity, 'words, words', dry sterile thunder. The mountain rearing against the sky in *Dream*; the two shepherds just keeping their footing bottom left, squeezed a little by the frame, and on the edge of another falling away of the earth at the corner; the hut hinged implacably to the picture's right side; even the tongue of Joachim's cloak – they *exemplify* the edges of the picture

in the way they do, once and for all and irrefutably, because always beyond them, this culture believed, lay chaos. Joachim was Everyman. All reality, potentially and often actually, was a desert in which men waited for revelation.

\backsim

These, put briefly, are the aspects of Giotto's achievement that make giving an account of any picture by him a daunting task. But *Joachim's Dream* is a special case. After all, most of the panels in the Arena Chapel tell a story: that is, they turn on an encounter, a moment of recognition, an action and reaction of bodies in touch. The peculiar nature of *Dream* is highlighted by its being followed in the upper range by one of Giotto's greatest portrayals of just such touch and tenderness, the *Meeting at the Golden Gate*. The cradling of Joachim's face in the folds of his cloak is replaced there by the hand and half-face of his wife. The cloak's convolutions fall free. The tongue of material becomes a bare foot. The hut's black square is a widow's veil.

Pictures that turn in this way on bodily encounters are easier to put into words than *Dream*. They teach a lesson. The whole of the painted rectangle still counts, of course: *Golden Gate* would be an immensely lesser thing without the naive civic pride of its architecture, the dialogue between the two haloes and the gold gateway, the sky caught (but not caught) in the city's square turrets, the rock face that doubles and ironizes the gate's rustication. The to-and-fro of episode and totality in a picture of this sort will still be hard to stage in language, but at least a writer will have the feeling – here is the contrast with *Joachim's Dream* – that the picture is focused around a bodily event, and the ripple effect of that event as read on secondary faces, plays of feature, expressions. Again, the action in a Giotto is never simply the sum of 'X does this to Y and Z sees it'. How, for example, the trio of accompanying women in *Golden Gate* fits into the strange porch or pavilion Giotto has placed inside the gate, and why the configuration tells us as much

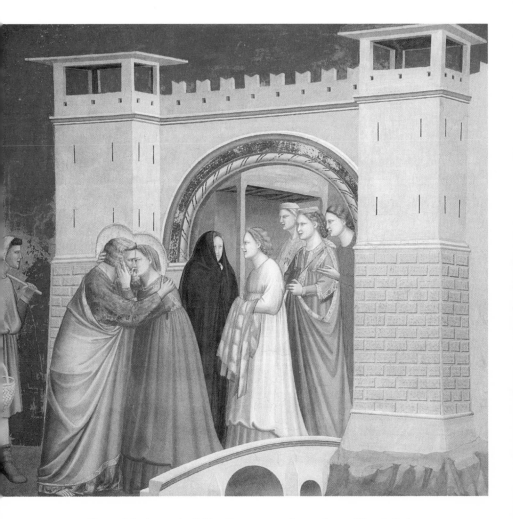

18. Giotto, *Meeting at the Golden Gate*, *c.*1303-5, fresco. Arena Chapel, Padua.

as it does about the world of enclosure and care Joachim is returning to ... these are typical Arena Chapel questions. Nonetheless, the picture does have a centre – all the more determinate a centre, semantically, for being moved a little to one side. Joachim brings the far desert in with him: the shepherd to his left is distance personified.

In a word, I can envisage a poem about *Golden Gate* – a picking and choosing among the picture's appearances – that would (whether it worked or not) at least be true to the picture's mode of address to the viewer. Here is such a poem: it might be titled 'A Lesson from Giotto':

I think we should turn our eyes away from the widow in the
 Golden Gate,
Wonderful and wary as she is in her unportentous shroud,
And notice the young housemaid next to her, holding the towels,
Her profile a study in simple stupid kindness.

Well, just look at the two of them, she is saying, at their age,
 in front of us all.
I only hope I have someone in years to come whose beard,
Back from the wilderness, my fist will dig into so tenderly.

The gold on the archway has worn through to black.
Cities, in this innocent desert, choose each a rock platform
For stability more than defence, the blue of the sky
Boxed in the watchtower, the sun not out,
Low scrubbed bridges leading to the centre of the earth.
'The falling lines of the draperies,' says Ruskin –
Hers like a hanging brown husk of a flower –
'Owe a great part of their value to the abrupt and ugly
Oblongs of the masonry next door.' (Unfair to the men
Whose combs so carefully roughened the face of each brick.)

The old man holds on to his lost beloved, his cloak pulled up
In loose pink creases like flayed skin. 'Because our speech,
Not to say our imagination, has no colours
To match folds like these.' Folds and restraints.
Two corrugated, serviceable haloes touch with a soft clang.

Maybe a truly strong poet – a T. S. Eliot – could make something of
Joachim's Dream. I'm sure I cannot. I need prose – I think art history in
general needs prose – to circle round the emptiness, the lack of connec-
tion, at *Dream*'s heart. The dry gully, the isolate plants and animals, the
unravelling boundary between earth and sky – these are all tremendous
metaphors, but of a moment of vision (and bafflement) that only the
hesitations and qualifications of the 'unpoetic' can hope to suggest.
A prose, in short, like Joachim's 'turning over in his mind whether he
should go back or not'.

I have tried to keep alive in my account of *Dream* an awareness that
heaven and earth, for Giotto, were (probably) two equally believable
realities. But in the end I am with Walter Benjamin in thinking the
pretence of the historian to enter the 'lost' mental world of a long-ago
maker a hopeless fantasy.[28] In front of *Joachim's Dream*, I do not believe
it can ever be me who time-travels to the Trecento; on the contrary, it
is this stubborn fragment of an utterly unknowable world that brings
(or refuses to bring) its 'now' with it into my present, putting my picture
of pastness and continuity in doubt. I either own up to my own naive
claim on the work, that is, and the way the work answers and resists
that claim – the way it suspends my usual pragmatic sense of history
– or I settle for that far flight of historicist fancy called 'looking with
a period eye'.

Why, then, did I choose from the richness of the Arena Chapel (or
find myself chosen by) *Joachim's Dream*? Partly the answer is obvious,
though it came to me slowly. My secular, sceptical, atheistic mind *wanted*
the moment of doubt in Giotto's story. But that moment does exist,

19. Giotto, *Desperatio*, *c.*1303-5, fresco.
Arena Chapel, Padua.

I believe. The very inclusion of the *Dream* episode, and the extraordinary
weight Giotto gives it – the deep absorption, in this panel, of story and
'idea' into form – is testament to this culture's ordinary intimacy with
inwardness, barrenness, irresolution. All cultures – one has only to look
at *Desperatio* among the Vices on the chapel's dado – know what it is
to despair. Only some – this was Giotto's advantage – can envisage,
other than abstractly, *Desperatio* and *Spes* face to face.

∾

20. Giotto, *Spes*, *c*.1303-5, fresco.
Arena Chapel, Padua.

Blue and grey. I return to the *Dream*'s main colours, though without much confidence that I can put their relationship into words. The immediate and abiding impression in front of the panel is that its two colour fields are equal, held in balance. It is hard to see how. The line between them is like a complex – deliberately esoteric – yin and yang. One of the black square's many functions in the picture, speaking now purely formally, is as a kind of distillation and compression of the grey terrain, weighting it against the blue. Without it heaven would be overwhelming.

The best I can do to suggest what the weighting and interaction 'tell us', theologically, is to offer a comparison. Veronese's *Dream of St Helena* is a striking one. For here, too, alongside the obvious similarity of subject and even of basic set-up, the essential effort of the painter has been to engineer a transition, or a sudden shift, between the spatial world of the sleeper close to us – the room, the proximity, the softness and heaviness of Helena's folds, her figure half-braced against the frame – and the further vision of heaven. Partly Veronese's means are different. For him orientation is crucial. He wants the discontinuity of the two realms on view to be enacted by a *turn*, taking place across the panel's halfway dividing line, away from the gentle low relief of the woman's body towards a deeper and steeper spatiality – that of the cross – which the angels seem to be struggling to subdue. The ungraspable slope of the cross's upright is one key to this, as is the distance from the cross's near point to the windowsill. Some of this, one guesses, would have struck Giotto as overstressed. Torsion is alien to him. Even when his angels manoeuvre in space and strike different poses, as they do in *Lamentation*, they are always, spatially, spread out across the picture plane in the same way as the figures on the ground. Veronese is just as alert to the picture plane as Giotto – Helena's folds are tied to it like tapestry to a wall – but all the more ready to puncture or parody it, as his sign of the 'world' giving way. In from elsewhere come the little winged boys. Where they and their burden are in relation to Helena is a mystery.

The means are different, but the interest – I would say, the seriousness – is analogous. Earth and heaven are in question: the object-world and its hidden ground. Something is crossing the threshold between them.

∽

The *Dream* itself, as Ruskin saw, contains an extraordinary figuration of its own status as image. What it depicts is an apparition; but it seems to want to show us that this appearing-in-the-world takes place in some strong sense outside the space of the visible. Compare *Dream* to *Sacrifice*

21. Paolo Veronese, *Dream of St Helena*, c.1570,
197.5 × 115.6 cm (77 ¾ × 45½ in.). National Gallery, London.

(fig. 7), and in particular the figure or figures far left in both. 'It is interesting to observe,' writes Ruskin of *Dream*, 'that the shepherds, who of course are not supposed to see the form of the Angel (his manifestation being only granted to Joachim during his sleep), are yet evidently under the influence of a certain degree of awe and expectation, as being conscious of some presence other than they can perceive, while the animals are unconscious altogether.'[29] I'm not sure about awe and expectation. But *Dream*'s two shepherds, so oddly discriminated – the one in dark robe and hood has almost a monkish look – do seem in the presence of something that holds and arrests them, that they attend to, that keeps them on tenterhooks. They are 'beholders'. (A strange word, in which the hand seems stronger than the eye.) Witnesses. (Again, a word rooted in presence or apprehension rather than vision specifically.) It is fitting that the shepherd's conical hat shades, but also bisects, his eyeball. In *Sacrifice*, the same hat has been pushed back. Joachim in *Sacrifice* looks directly at the angel; the shepherd at a minuscule hand way up in the blue. It is all (slightly absurdly) a matter of seeing-is-believing – or, in Joachim's case, seeing, believing and then having second thoughts. The inwardness of attention in *Dream* is all the more striking.

Inwardness and uncertainty go together. The *Dream* surely wants us, along with Joachim, to be held in a state of suspense. The shepherds at one level are our alter egos. *The Book of Mary*, to cite it again, has them not understanding their master's hesitations in the wake of the angel's first visit ('They were struck with great fear and wonder, and advised him to accomplish the vision of the angel without delay'). Thinking too precisely on the event, that is – not doing immediately what God or the ghost tells you – is a privilege of 'inner otherworldliness', for which these working men have limited sympathy. The wilderness – look at the plant the sheep is prodding with its muzzle – is a bad place for the flock. The shepherds are on the angel's side.

Nonetheless, inwardness – invisibility – is what the painting celebrates. The black square is its ground bass. We could say, thinking of

the picture's place in history, that it ushers the 'mental image' into the realm of representation. And, again in a way typical of Giotto, it does so by showing us the entire ordinariness – the necessity, the physicality – of 'inwardness' and 'vision' in the world we know. Thus far I have accepted the traditional title of panel five, *Joachim's Dream*. But the word 'dream', and even the title's innocent possessive, beg the question. *The Book of Mary*, to repeat, says only that when Joachim was considering what to do after the first encounter 'it happened that he was overpowered by a deep sleep; and behold, the angel who had already appeared to him when awake, appeared to him in his sleep.' Whether we call this appearance in sleep 'dream' is a moot point, and whether either the dream or the sleep is Joachim's, likewise. Sleep is an entity that overpowers the subject; and the visitation during sleep is *like* a dream – for Giotto this seems to mean that, in contrast to the dazzling young man in *Sacrifice*, the figure in the sky here has all the disarming materiality, the familiarity but impossibility, of a dream image – and therefore is more to be trusted and acted upon.

I have said more than once that Giotto's great subject in the *Dream* is the co-presence – the disconnection and tying together – of earth and heaven. But all the nouns here are too abstract. What counts in Giotto's treatment (feeling as he seems to have done for the true strangeness of the idea half-expressed in his main source) is the ordinariness, the worldliness, of the meeting of opposites. We talk of moments in life when the normal realm of action and decision – the man 'turning over in his mind whether he should go back or not' – is suddenly overtaken, or put in abeyance, by a parallel reality and its claim on us. But some such abeyance happens every night: for reasons that go on being mysterious, it takes up a third part of our time on earth. We talk also of messages or images arriving from an elsewhere, frightening or elating us, asking us to understand where they may have come from (what restorative or maleficent double of the world we know) and whether to take them seriously. But such an image-world sets our eyelids twitching – how

marvellous the creases of worry at the corners of Joachim's eyes! how great the effort he seems to make to cradle and continue his unconsciousness! – repeatedly as night passes. Deprived of this dream world we go mad.

No doubt the 'sleep' and 'dream' of Joachim are meant to register as out of the ordinary. Deep unconsciousness has taken hold of a man in broad daylight.[30] (Perhaps it is this that stops the shepherds in their tracks.) An angel image is in the sky. This is a miraculous, 'out of the ordinary' occasion, but its out-of-the-ordinariness is anchored in – modelled upon – the entirely physical and familiar. I believe this is ultimately the reason for a feature of the painting I have barely touched on so far, but that grows and grows semantically the longer the scene is looked at: namely, the triple pyramiding of Joachim's body, the roof of the hut he is framed by, and the anthropomorphic (or zoomorphic) mountain above. A tremendous nexus of wishes and imaginings is in play here. The whole three-layered structure – the combination of geometry and enfoldedness in it, of shelter and isolation, of solidity and ghostliness – reaches for meanings, for a great summing-up of the human, that part of me thinks should be left as is. This much, however, I have to put into words. The shape is the angel's counterweight. Only such a triple structure could have answered and balanced the angel's electric concentration. And the counterweight *is* the earthly: the pathos of sleep, the body protecting itself, the faint shadow that the body casts on the hut; the hut like a tomb but also a prism; the mountain like a giant (or tamed beast) in a carnival procession. Joachim is not abject – the beauty of his garment proclaims him master of men – but he is, in the desert, decidedly lying low. The hut and the hillside as Giotto presents them give Joachim the standing he lacks: they set him upright, lend him a grey solidity. The man we see next in *Golden Gate* has only recently, we sense – and tentatively – regained his footing.

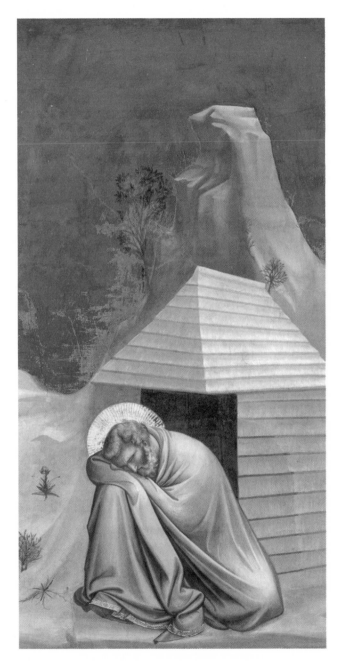

Detail from fig. 5: Giotto, *Joachim's Dream*,
c.1303-5, fresco. Arena Chapel, Padua.

Riches and sterility are at the heart of the Joachim story. It is, we recall, preliminary to the Immaculate Conception.[31] Joachim, before his *Expulsion*, 'had no other care than that of his herds, from the produce of which he supplied with food all that feared God, offering double gifts in the fear of God to all who laboured in the doctrine'. His lambs, sheep, and wool he divided in three: 'one he gave to the orphans, the widows, the strangers, and the poor; the second to those that worshipped God; and the third he kept for himself and all his house. And as he did so, the Lord multiplied to him his herds, so that there was no man like him in the people of Israel.'[32] But the Lord gives, and takes away. When on a great feast day Joachim went to offer sacrifice, the high priest 'threw his offering from off the altar, and drove Joachim out of the Temple'.[33] *The Gospel of the Nativity of Mary* has the priest asking Joachim 'why he, who had no children, would presume to appear among those who had: adding, that his offerings could never be acceptable to God, since he had been judged by Him unworthy to have children; the Scripture having said, Cursed is every one who shall not beget a male in Israel'.[34]

I have put my stress on the down-to-earthness – the unstressed materialism – of the case as related in the Apocrypha because Giotto's retelling feels at every point for ways to spell out the paradox of wealth, godliness, rejection and barrenness in terms his worldly audience could make sense of. Mountain fastness, sluggish animals (the small sheep stretched full length under the thorn bush seems in particularly bad straits), a ragged versus an embroidered hem. It may even be that the scholars are right, and Joachim's story is given the weight it has in the chapel because the patron, Scrovegni (and his clerical apologists), warmed to the idea of riches and piety coexisting, and still more to the image of riches despised and outcast but then redeemed.[35] Scrovegni's father lives on as the great figure of usury in Dante's hell. One or two documents from the time scoff at the unclean – unnatural – sources of the family's power. We do not need to see the Arena Chapel as specifically an act of expiation to suspect that putting the *Pact of Judas* – the ultimate image of money

and its temptations – across the chancel arch from the *Visitation* was an act of iconographical daring, in which hopes for forgiveness vied with confession of sins. (The *Visitation* calls out to the *Golden Gate*. The *Pact of Judas* is a kind of black antithesis to *Joachim's Expulsion*.)

Sheep, wool, infertility, poor pasture, the Temple and city shrunk to a hut. I believe a response to Giotto's panel ought in the first place

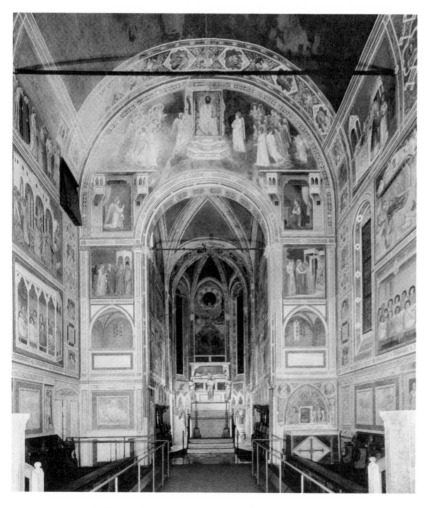

22. Giotto, Arena Chapel, chancel arch with *Visitation* and *Pact of Judas*, c.1303-5, fresco. Padua.

to represent – to find words for – this thinking of miracle in material terms. But ultimately my reading, from the distance of the twenty-first century, is bound to be allegorical. For me, Giotto's blue is the force of an unknown. It may contain – in a sense it must contain – a figure, a message, a determinate shape. But inwardness is uncertainty. Joachim in his world of one – his wound cloak, his intent self-holding, the hut's darkness, the mountain rearing like an apotropaic beast – holds onto his isolation and cannot forget the high priest's anathema. The *Dream* is doubt immortalized: that is, doubt – suspension of judgment, 'turning over in [one's] mind', deadlock of forces and possibilities – made over into a unique high tension within the picture rectangle of colour, figure, hard edge, soft gradient, stamped flatness, blue and black depth.

Yet the word 'doubt' may be the wrong one. It bears, from our distance, too much the secular seal of approval. We admire Joachim for persisting in it. Perhaps we'd do better to call the subject of *Dream* simply that moment of suspension in everyday life, entirely commonplace and recurrent, when something half-enters the world as we understand it and puts our world-picture to the test. The 'something' that materializes in this way may transfigure reality, or traduce it: we cannot (yet) tell which. It seems to me most deeply this sort of breach in the normal contract of understanding – a breach but also a necessity, since understanding without the possibility of incomprehension ('not following') is a non sequitur – that the blue dip in the hills, the black square of the hut, the twisted folds, the angel's innocent pedantry, all enact.

'And now you must leave the city, the community of the holy,' says Anthony of Padua in a sermon on penitence. 'You will dwell in the open country, as in a strange land … You will dwell there, I say, so that you may know your own estrangement.'[36] 'And when Joachim awoke out of his sleep, he called all his herdsmen to him, and told them his dream. And they worshipped the Lord, and said to him: See that thou no further despise the words of the angel. But rise and let us go hence, and return at a quiet pace, feeding our flocks [*Sed surge profiscamur*

hinc, et pascentes greges lento gradu redeamus].'[37] Giotto's feeling for the story is twofold. Knowing our own estrangement is a necessity, no doubt: Joachim's humility – a quality of mind valued more and more as the Middle Ages ended – is the source of his strength. But the time comes, say the shepherds, for an end to mistrust. Doubting is too close to despising: there is always a form of rancour hidden behind its reasonableness. Action need not be precipitate. It is beautiful that *The Book of Mary* has the shepherds advising a slow pace, with time for grazing, on the way home.

∽

It is beautiful, but not quite the *Dream*'s note. Trying finally to sum up that note, and in particular to lay hold of the difference between Giotto's treatment of the story and that of his key sources, we face again the question of the artist's place in history – belonging as he did completely to the Middle Ages, yet gathering together in himself the signs of that epoch's ending (perhaps, in the very composure of his reaction, pointing forward to an afterwards more decisively even than Dante). The apocryphal gospels, speaking from the past of the first Christian centuries, have a way of embedding Joachim's progress in the world of his shepherds and hired hands – *pastores, pueri et mercenarii, omnes gregarios* – that is all the more telling for its matter-of-factness. One hears in them the imperative Erich Auerbach pointed to in the New Testament: the need to portray 'the birth of a spiritual move-ment in the depths of the common people, from within the everyday occurrences of contemporary life', involving 'people from all classes, occupations, walks of life; people, that is, who owe their place in the account exclusively to the fact that the historical movement engulfs them as it were accidentally, so that they are obliged to react to it'.[38] Again, Giotto's relation to that imperative is double-edged.

On the one hand (to go back to Ruskin), Giotto responds to it deeply. The shepherds are active presences in his story, and if his version of

pastoral resonates somehow with late-medieval fashion – only a firmer knowledge than mine of patrician taste around 1300 could interpret the signs here – it is certainly a pastoral devoid of easy idealization or nostalgia for the simple life. The shepherds partake of the desert's colourlessness. The bare ribs of the sheepdog in *Dream* rhyme with its master's threadbare uniform. Yet the herdsmen are *there* – holding their ground against the mountain. I have pointed already to the originality of Giotto's decision to devote a whole panel to the angel's second coming; but even more anomalous (and without sequel, as far as we know) is the scene known as *Joachim at the Sheepfold* (fig. 10). It is an extraordinary extrapolation from the texts. Very often modern commentary assumes that what we are shown in the panel is Joachim's arrival in the mountains, joining his servants in the wilderness. Maybe the dog's greeting suggests as much. But *The Book of Mary* has Joachim and his men leaving the city together – Joachim ordering them into the far hills. What seems to matter most in Giotto's *Sheepfold* is simply an imagining – a realization – of the rich man and his servants together. Their coexistence, however, goes only so far: the gap between Joachim and his men is unmistakable. Joachim holds himself in a pose of inward-turning self-absorption that anticipates the one in *Dream*. He seems to have wound his pink cloak around clenched fists. His eyes are open but unfocused.[39] The shepherds' wariness in face of their master looks to have an edge of puzzlement to it, maybe of misgiving. Sadness in great ones is not their concern.

This is the dialectic *Dream* takes up. If we follow *The Book of Mary*'s stresses, the shepherds, after the angel's second appearance to Joachim, are straightforward in stating their disapproval of the master's previous conduct: *Vide ne ultra angeli dicta contemnas*. But theirs is a trust in the supernatural – 'real creatures capable of flying' – that belongs to an earlier age. Giotto may have opened himself to the shepherds' simplicity and made it part of his story, but ultimately it is Joachim's consciousness that preoccupies him. The *Dream*'s unprecedented totality

– its polarization of blue and grey, and the coiled spring of the colours' dividing line; the weight in the frame of Joachim's self-holding; the picture's whole feeling of arrest and insistence and anxiety, but also of dreamlike suspension of time – speaks to an inwardness demanding, as never before in painting, a space of its own.

> VLADIMIR. I've seen you before, haven't I?
> BOY. I don't know, sir.
> VLADIMIR. You don't know me?
> BOY. No, sir.
> VLADIMIR. It wasn't you came yesterday?
> BOY. No, sir.

Inwardness is question and answer. The black square *is* inwardness – the space of uncertainty that will turn out to be modernity's great gift. It is 'interiority' portrayed as essentially impenetrable, empty, abstract – a condition humanity may be entering around 1300, perhaps inevitably and even to its advantage, but as into an unknown. The square is abstraction, we might say: meaning abduction from the world of objects and events; the appeal of the absolute; ongoing distrust of 'appearances' whatever their earthly or heavenly guarantee; a power of generalization in human affairs that does not (cannot) know when to stop – to stop 'turning over in the mind'. Joachim's closure against the world in *Dream* becomes more striking the longer we look. At almost no point does his outline touch or abut some thing in his surroundings. Perhaps the little tongue of his robe was meant to offer the possibility of a way out.

If inwardness is question and answer, that is, *Dream*'s black square suggests the endlessness of the questioning once embarked on. (The 'boy' is bewildered by Vladimir just as the shepherds are by their master.) The square's non-colour is not yet determinant in Giotto – the angel still spells out God's message, the shepherds' faith is unshakeable, the blue is God's presence in the world – but a new age has begun.

CHAPTER 2

Bruegel in Paradise

Likewise the Lord said that a grain of wheat would bear ten thousand ears, and every ear would bear ten thousand grains, and every grain would give ten pounds of flour, clear and pure; and apples and seeds and grass would produce in similar proportions; and all animals, feeding only on what they received from the earth, would become peaceable and friendly to each other, and completely subject to man. Now these things are credible to believers. And Judas, being a disbelieving traitor, asked, 'How shall such growth be brought about by the Lord?' But the Lord answered, 'They shall see who shall arrive at those times.'

Papias, *Exposition of the Sayings of the Lord*[1]

The closest Bruegel ever came to painting the afterlife seems to have been in a mid-size panel, just over 20 inches high and 30 inches wide, called the *Land of Cockaigne* (fig. 24). The Dutch word for the place was *Luye-leckerlandt*, the hereafter as imagined by lazybones and gluttons. A certain amount is known about the hereafter's close German cousin, *Schlaraffenland*, which became a staple of early sixteenth-century chapbooks, intrigued by the idea's peasant origins and eager to moralize on the theme of eternity without effort.[2] There is a sense in the pamphlets, and perhaps in Bruegel's picture, that the idea is seen as 'medieval' – already looked back on from a leaner modernity.[3] Bruegel's panel is dated 1567: the same year as his *Conversion of Saint Paul*, that very modern subject, and in all likelihood the *Peasant Dance* and *Peasant Wedding*, now in Vienna. The child sucking its sticky fingers in *Peasant Wedding* is dreaming of a *Luye-leckerlandt* to come.

I began thinking about the *Land of Cockaigne* some years ago, mainly because of its treatment of gravity. Bruegel seemed to me a materialist,

23. Pieter Bruegel The Elder, *Peasant Wedding*, c.1567,
114 × 164 cm (44⅞ × 64⅝ in.). Kunsthistorisches Museum, Vienna.

perhaps the deepest and most thoroughgoing to have left us a picture
of the world; and in this he connected across history with certain other
painters – Poussin and Veronese chief among them – who had a similar
interest in the human world's overall orientation, in particular the way
the upright (or downfallen) body connected with the ground.[4] The fact
of bipedalism was central to these artists' vision. This is not the place to
explore the nature of such an interest more fully (it crops up later, in the
chapter on Poussin) except to say that it strikes me as rare in painting,
or rare in the sense that the interest shapes an artist's whole anthro-
pology. One part of me finds the infrequency puzzling, since painting,
of all the arts, seems in many ways best fitted to show how much of
human nature and culture derives from uprightness – anatomical high
standing – which the ground supports but at the same time qualifies.
To be a little ominous about this, it surely mattered profoundly to the
cultures from which Bruegel and Poussin emerged that human beings

24. Pieter Bruegel The Elder, *Land of Cockaigne*, 1567,
52 × 78 cm (20½ × 30¾ in.). Alte Pinakothek, Munich.

ended their days no longer vertical, and with the earth no longer their platform: 'Man comes and tills the earth and lies beneath.'[5] Some painters – surprisingly few, it emerges – make the contact of the body with the ground, and the actual physiology of three dimensions, their two great subjects. We could call their vision 'down to earth'. But there is no one ethical or metaphysical temper, or vision of the future, that this version of materialism brings with it. The painter of the *Land of Cockaigne* is the painter of the *Triumph of Death* (fig. 3).

Bruegel is the monarch of down-to-earthness. One sign of that interest is the attention he pays to the human urge to make 'ground level' – make the earth even and measurable, patting it down and truing it up and mixing in drainage and mulch. It is typical – a further aspect of his materialism – that in the great drawing of *Spring*, done in 1565, Bruegel presents the activity as class-specific, and maybe a little silly.[6]

25. Pieter Bruegel the Elder, *Spring*, 1565, pen and ink,
22 × 29 cm (8⅝ × 11⅜ in.). Albertina, Vienna.

26. Pieter Bruegel the Elder, *Children's Games* (detail), 1560,
118 × 161 cm (46½ × 63⅜ in.). Kunsthistorisches Museum, Vienna.

The up-to-the-minute *parterre* in the drawing's foreground (the French word was beginning its travels through Europe at just this moment) chimes in with the young swells visible in the distance to the right, playing at nymphs and shepherds in a gazebo. There are signs of a humbler agriculture continuing – sheep shearers, a pigeon tower, a beehive on a hill, a man who looks to be hoeing – but they are crowded out by modern pastoral. A grand lady gives the gardener instructions. A floral barge pulls up beside the picnickers. The strict perspective of the flowerbeds participates in the gentle pedantry.

Ground level is a class achievement, but basic to the species. Edward Snow, in his wonderful book on Bruegel's *Children's Games*, puts this aspect of the painter's thinking in a nutshell. He homes in on a pair of figures far back in the *Children's Games* mêlée – a boy on stilts, and a little girl on the ground next to him, looking up, her face unsmiling, with arms thrown wide – and says this:

Their juxtaposition is a key to the painting's anthropology. The human creature rises precariously on two feet (whose cumbersome black boots provide both immunity from the earth and anchored contact with it) and as a result has to devise for itself the world of functions and purposes which in nature seems merely given. One result is a paradox that the boy on stilts neatly illustrates: the device by which he goes about acquiring a sense of balance and a feeling for the laws of the physical universe nurtures in him both a fantasy of transcendence and a preoccupation with downfall and ruin. It is difficult, in fact, to know which is host and which is parasite in this symbiosis.[7]

The fantasy of transcendence takes a different form in the *Land of Cockaigne*. What the man of letters at bottom right in *Cockaigne* seems to relish or aspire to is not so much teetering levitation as endless sluggishness or stasis. But even these terms have uprightness (or its opposite) built into them. *Stasis* in Greek originally meant 'standing'. The stadium was where well-adjusted bipedal bodies strove to remain upright while others fell down. The winners had their honed verticality immortalized in stone. Bruegel's imagining of stasis as roundness, repleteness and horizontality is charged, in other words – scandalous – at levels we barely recognize. Snow is right. A whole anthropology is in play.

There is one further thread to my understanding of Bruegel I ought to make clear at the start. For to talk thus affirmatively of Bruegel's 'whole anthropology', and invoke as positive a view of it as Snow's, is immediately to put myself on one side of a great divide in the Bruegel literature.[8] On the other stands that majority of scholars who seem convinced that the artist's account of the human condition is at best pessimistic and comically condescending, and at worst detached, moralistic, crisply repressive, coldly calculating in its provision (to a new bourgeois audience) of the naive, the earthy, the old-fashioned and the grotesque.[9] This is the art historians' view of Bruegel, not the

museum-goer's. It is, at last count, dominant among experts and, oddly, its strongest proponents have given it a distinctly ultra-Right or ultra-Left inflection. The voice that matters most here is that of the great Vienna formalist and enthusiastic Nazi party member Hans Sedlmayr. I quote the chilling climax of an essay on Bruegel he published in 1934:

> What could be the common denominator of the preferred motifs we have just identified – peasants, children, the deformed (cripples, the blind, epileptics, fools), the mass, apes, and madness? They are all manifestations of life in which the purely human borders on other, 'lower' states that threaten, dull, distort, or ape its substance. Primitives – a hollow form of the human; the mass – more raw and primitive than the individual man; the deformed – only half human; children – not yet completely human; the insane – no longer human. These are all liminal states of humanity in which and through which the nature of man is cast in doubt.[10]

Some of this resonates with the *Land of Cockaigne*. No doubt the particular choice of words in Sedlmayr's paragraph is telltale and repulsive. The slide from peasants to cripples, or masses to monkeys, wears its date and allegiance too much on its sleeve. But I am struck by the fact that so much of right-thinking, Left-leaning art history over the past decades has ended up assenting to a great deal of Sedlmayr's verdict – at least, on what Bruegel chose to show us of the human condition, and even why he did so.

I need to be careful. It would be scurrilous to quote directly any one of our recent hard-headed art historians in proximity to the 1934 text, and I do not for a moment wish to imply that behind their more up-to-date vision of Bruegel – Bruegel the cold ethnographic comedian, Bruegel the anatomist of lower-class folly, Bruegel the artist of modern bio-power – lurks a version of Sedlmayr's contempt for the non-normal.

All I will say – and say it sharply, since the new 'progressive' certainty about art's essentially repressive mission and effect ought to be countered directly, with something of its own dismissiveness – is that Left and Right seem deeply to agree on the words that sum up Bruegel's attitude to his subject matter. His stance, for them, is of distance and condescension: achieved exteriority. The term that Sedlmayr brandishes is, predictably, *Entfremdung*, 'estrangement': meaning distortion, inexpressiveness, blank outwardness of appearance, human existence presented as a panoply of sluggish, intoxicated, absurd, degenerated mere behaviours. I do not see, in the actual descriptions many more recent art historians offer of Bruegel's treatment of his peasant actors, that in practice they dissent much from the *Entfremdung* diagnosis. And why should they, we might say, faced with the *Land of Cockaigne*? Does it not show us a world where even the hereafter 'borders on other, lower states'? Perhaps – but what follows from that proximity remains to be seen. Heaven may be shown to be earthly, even somnolent and ludicrous, without that being meant, *pace* Sedlmayr, to put the whole nature of man in doubt.

<p style="text-align:center">∽</p>

Let me begin with Bruegel's subject.[11] The basic idea of *Schlaraffenland* – a place where food is endlessly obtainable without effort, roast pigeon fly down obligingly into any mouth that has a hankering for them, houses are edible and fences made of a wicker of sausages – seems to have been a staple of the oral tradition in Europe long before it made its first textual appearances in the Middle Ages. The oldest written forms of the fable – a French *fabliau* from the middle of the thirteenth century, probably written in Picardy, or *The Land of Cokaygne*, a slightly later poem in English – already look to be turning the 'folk' material to purposes that are hard to grasp.[12] They may even be parodies of heaven. Who they were written by, and for, and against, are questions that exercise scholars. But one dimension to the legend was basic

to its appeal: it posited a world in which abundance overflows class distinction. And this side of the story loomed large after 1450: in its language and cast of characters, *Schlaraffenland* became more and more explicitly 'popular'.[13] (As usual in such cases, this does not mean that its appeal was restricted to the lower classes. The doings of peasants and proletarians, real or imaginary, seem to have amused and horrified their betters.) In the sixteenth century, alongside repeated textual retellings, *Schlaraffenland* began to be the subject of woodblocks and engravings. Mostly the prints were perfunctorily drawn – perhaps naivety was part of the point. We have, for example, a fluent but rudimentary woodblock *Das gelobte abgebildete Schlaraffen-Land*, done by a German workshop in the second half of the century, which is fully 2 feet high and over 3 feet wide, put together from eight separate blocks.[14] It is a kind of alternative world map or *Triumph of Greed*. Bruegel stays close to many

27. Anon, *Das gelobte abgebildete Schlaraffen-Land*, later 16th century, woodcut. New York Public Library.

of the standard features of such depictions: notice the woodblock's great mountain range made of buckwheat porridge, through which hopefuls have to eat their way to the promised land (with one prominent new arrival spewing and farting as a result), or the fence of sausages and house of tarts, or the pig with the knife holstered in its side – for which, in the print, a second newcomer reaches before the porridge has fully disgorged him.

Naturally, some of the written forms taken by the legend in the 1500s pulled it into higher ideological space. It was moralized, often sententiously; its tall tales of another world were updated, lightly, perhaps with a view to poking fun at the vogue for travellers' tales following (and preceding) 1492; there is even a moment or two in the texts – Herman Pleij has pointed them out – where the narrator seems to be toying with the notion that *Schlaraffenland* is connected to contemporary heresies.[15] Two manuscript poems in Middle Dutch – one of them dating from the first decade of the sixteenth century, but both recording much older material – put the kingdom, in passing, under the sign of the Holy Spirit. 'Dit is 't lant van den Heilgen Gheest.' Or again, more forcefully, 'Dat land maeckden dye Heylige Geist.' The jibe is outlandish, and in a time of Reformation potentially blasphemous: it makes no sense unless as a facetious reference to Adamite and 'Brethren of the Free Spirit' invocations of the Holy Ghost – accompanied as they were by dreams of (and experiments in) a new age of erotic godliness – which we know were on authorities' minds.

Cockaigne was a magnet: the legend's imagining of abundance attracted to it all kinds of new and old material. But the modernizings and moralizings do not touch the heart of the matter or explain the legend's continuing appeal. *Schlaraffenland* was not, after all, primarily a realm of Free Spirit eroticism: its genius was gluttony, not lust. Nor did the prints and poems insist on parallels with Brazil or Hispaniola: the costumes and flora of the giant woodcut are typical in being so firmly Northern European. A poem of 1546 may end by reminding the reader

of the link between *Luye-leckerlandt* and criminality – 'Until now this land was known to no one except Do-nothings [*Deugh-nieten*], who were its first discoverers, and it is to be found next to the gallows'[16] – and many of the chapbooks are similarly stern. But the basic light-heartedness of *Schlaraffenland* shrugs off these messages from the pulpit.

It seems clear from the woodblocks' image repertoire (the textual material sometimes suggests as much) that Cockaigne was originally connected to carnival in the popular imagination – to the battle between Carnival and Lent – and spoke to the enduring peasant economy of feast and famine.[17] Whether or not it is true that dearth and malnourishment actually increased in the late Middle Ages – the statistics are fragmentary, and a general answer is anyway beside the point – Pleij and others marshal a body of evidence to suggest that the *fear* of hunger grew from 1450 on, and with it the habit of publicly eating to excess.[18] Urban spectacles were incomplete without floats piled high with food, and a final wild stuffing and swilling by the crowd. The performance has the look of a defence mechanism – a 'ritual surfeit designed to banish all thoughts of scarcity'. The world of Bruegel's *Fat Kitchen* (fig. 28) and *Big Fish Eat Little Fish* is close.

In the *Land of Cockaigne* hunger is a thing of the past. That is the ruling counterfactual. No doubt certain viewers of Bruegel's painting – and buyers of the engraving made of it, perhaps after Bruegel's death (fig. 29) – would have been capable of making the connection with the New World. Maybe one or two even caught a whiff of the Free Spirit. But what Bruegel drew on most deeply were the dreams and wishes – and the sense of those wishes' ordinary unfulfilment – that had made the story worth telling for centuries.

∽

'Bruegel's heaven is an empty place,' wrote Max Friedländer. 'Only the earth, the here and now, was his proper realm.'[19] 'For Bruegel man was quite definitely not created in the image of God.'[20] 'The world

ABOVE 28. Pieter van der Heyden, after Pieter Bruegel the Elder,
Fat Kitchen, 1563, engraving, 21 × 29.3 cm (8¼ × 11⁹⁄₁₆ in.).
Metropolitan Museum of Art, New York.

BELOW 29. Pieter van der Heyden (attrib.), after Pieter Bruegel the Elder,
Land of Cockaigne c.1567-8, engraving, 23.1 × 30.4 cm (9⅛ × 11¹⁵⁄₁₆ in.).
Metropolitan Museum of Art, New York.

looked to him like a kind of clockwork that never needed winding.'[21] The last remark in particular comes back to mind each time I confront *Cockaigne* again and feel its world turning slowly – vertiginously – on the axle of the tree trunk. All of Friedländer's judgments strike home. They help us with the *Dark Day* and *The Cripples*, I feel (figs. 41 and 32) – and even with the terrible *Two Monkeys* – in ways that more careful contextualizations cannot.

But they may go too far. One guesses that Friedländer, looking at *Cockaigne*, would not for a moment have taken its 'alternative world' gambit seriously, or thought Bruegel and his audience did. The verdict he passes on the emptiness of Bruegel's heaven is followed, in the same sentence, by essentially the same verdict on the painter's hell: it 'is

30. Pieter Bruegel the Elder, *Two Monkeys*, 1562,
20 × 23 cm (7⅞ × 9⅛ in.). Gemäldegalerie, Berlin.

populated almost exclusively by Boschian creatures'. In other words, hell for Bruegel (says Friedländer) is essentially a second-hand concept – a leftover, a tissue of quotations – only imaginable through the medium of a previous genius. And whatever (still mysterious) specific orthodoxy or heterodoxy may have provided Bosch's vision in the first place with its motive power and perhaps some of its motifs, by the time Bruegel was addressing it the vision was a relic of the previous century.[22] Bosch had become the 'Boschian'. The visionary had declined to the grotesque.

Whether we think of *Cockaigne* as heavenly or hellish – or in the end neither – it is remarkable, among the thirty or so paintings from Bruegel's last four years, for being the only one to imagine (on the other side of the mountain) an alternative reality. And it is quietly, relentlessly anti-Boschian in so doing. The hybrid and the multiform have no place here. A fence of sausages and a cactus of loaves are assemblages, not mutations. The non-world is made from wholly (banally) worldly materials. Improbable things may be happening in the hereafter, but identities are not threatened. Eternity is in love with the productions of time. But does this mean that Friedländer is right, that for this artist 'the earth, the here and now' are all there is?

∽

Believe it or not, the art-historical consensus regarding Bruegel's intentions in *Cockaigne* is that he did it as a warning against gluttony.[23] I shall dispense with the battery of quotations, but I am hardly sharpening or simplifying their basic message: the purpose of the painting, say the authorities, was to show gorging and idleness for the sins they are.

This seems to me on a par with saying that Jane Austen's *Sense and Sensibility* is all about how sense is preferable to sensibility as a guide to conduct. Well yes, that appears to be the book's premise, and roughly its conclusion, but it is not what makes the book interesting – it is not what structures the play of Austen's attention and makes generations of readers wish to pick up its thread. I dare say Bruegel believed that

overeating was a bad thing: one has no quarrel with the printmaker's assistant who thought that words to that effect ought to go at the bottom of the *Cockaigne* engraving ('Those lazy and greedy peasants, soldiers, and clerks / arrive there and sample everything without having to work'[24]); but it seems to me an improbable, absurd hypothesis that Bruegel painted the picture in the first place – *this* picture, the picture painted this way – to illustrate the truism. *Cockaigne* is a study in ontology, not ethics. It is out to make us see and feel things, not remember what we are supposed to think about them.

The *Cockaigne* panel is not big. It measures, to repeat, just over 20 inches by just short of 31: barely half the width of its savage pendant, done a year later, *The Blind Leading the Blind*. Size, in Bruegel, does not correlate with ambition. His *Sea Battle off Naples* had compressed the scene of history into 16 inches by 27, and revelled in what miniaturization – the strange bird's-eye view of the sea and Vesuvius – could do to

31. Pieter Bruegel The Elder, *The Blind Leading the Blind*, 1568, distemper on linen, 86 × 154 cm (34 × 61 in.). Museo Nazionale di Capodimonte, Naples.

32. Pieter Bruegel the Elder, *The Cripples*, 1568,
18.5 × 21.5 cm (7¼ × 8½ in.). Musée du Louvre, Paris.

its objects. His *Cripples* fill a panel measuring 7¼ inches by 8½ inches,
the size seemingly intended to force us to look closely when we would
rather not. But there is a sense in which the dimensions and shape of
Cockaigne are even more unsettling – because it is harder to put one's
finger immediately on where the format means to situate us in relation
to the objects portrayed – and sometimes in the literature it is suggested
that the panel has been cut down. On the basis of the engraving it must
have lost no more than an inch at the top, unless the damage was done
before the engraver got a look. In any case the print is unreliable. It slices

an inch or so from the edge of the painting abutting the lean-to of tarts (notice what happens to the standing cheese in the print, and the hinge of the roof as it meets the picture corner), so who is to know if it did not add as well as subtract? The printmaker is struggling with something fundamental in the Bruegel and well beyond his pictorial capacities.

He struggles with proximity and interruption. There is a feeling in *Cockaigne* of things being close, the tree and its tabletop sleeve just as much as the egg and the sole of the young clerk's shoe; and of everything tipping and tilting towards the viewer, so that the egg has to work hard to keep its balance on the foreground slope. There is a feeling of things being crossed arbitrarily by the edge of the visual field: not just the trunk, branch and table, but the cactus of loaves to the right, and above all the lean-to with the tarts. The top left corner of the panel takes a slice out of the lean-to's architecture the way a knife takes a slice out of the cheese; and the slice delights in having us guess, and give up, at the general logic of the structure it cuts into. It echoes the painting as a whole in this. Corners are wonderful in *Cockaigne* – the roof, the buckwheat mountain at top right, the grass giving way to a chasm below – but they only confirm the general impression of stumbling into a space that never was. The porridge rolls into the picture like a lava flow.

Compare *Cockaigne* with what most scholars now agree was its closest visual source, an engraving by Peeter Baltens done maybe six or seven years earlier (fig. 33).[25] We know Bruegel and Baltens were acquainted and worked together at the start of the 1550s on an altarpiece for a glovers' guild; and there is no doubt that Bruegel took over his basic rough structure from Baltens's print, as well as one or two visual jokes – even the idea of a piece of tableware falling from the tree, suspended for ever on its way to the peasant's thick head. Baltens's image is fumbling and fussy, but in comparison with the Bruegel at least it *tries* to apply the new laws of perspective. In the event, the older artist makes a hash of them and cannot get his sprawling figures sorted out properly across a receding ground plane. But he knows what he is supposed to do: he

33. Peeter Baltens, *Land of Cockaigne*, *c.*1560 engraving. Bibliothèque Royale, Brussels.

struggles to keep his horizon line low (in the modern way) and have his house of tarts, top right, be plausibly rectangular. There is even a door off its hinges in front of it, like a perspective drawing frame. Bruegel, by contrast, deliberately closes and fills up and pushes everything towards the picture plane. The line of the hill grows higher; the house becomes a half-folded tent; the buckwheat mountain adheres to its corner; the tree sprouts its unplaceable tabletop; the egg spells out the gradient up front. Spatially, the whole panel is more like a frame from the journeyman's eight-block *Schlaraffenland* than the Baltens Bruegel had in front of him.

What Bruegel does here to Baltens's space is typical of his painting during the last four years of his life. It is as if he became confident, after making the anchored and intricate spaces of his 'Months of the Year' series in 1565, that from now on he could work – he needed to work – with two kinds of perspective in a picture at once. He would return to

the map-like, broadsheet spread of spaces characteristic of his earlier *Children's Games* or the *Procession to Calvary* or *Carnival and Lent*, but now have that kind of disposition interact with a space felt as empty, palpable, proximate. Not that 'perspective' had been lacking in the previous pictures – think only of the endless street in *Children's Games* – but it had tended to cede to something like a bird's-eye view as things got larger and closer. In *Cockaigne*, by contrast, the space conjured up by the rim of the table does not peter out at some point adjacent to the picture plane, giving way to the surface world of the egg: it somehow *includes* that surface world, looming over it, lending it geometry. (Block out the tabletop with one hand, even in front of a reproduction, and the foreground is robbed of half its vitality.) Perspective and broadsheet are in balance. The tree to the right, in front of the buckwheat mountain, is pure silhouette but also, one comes to realize, a bending, extruding entity in space – grabbed by the indefatigable mountaineer, and sucked in by the glacier of porridge.

Bruegel's *Cockaigne* is not crowded. The picture is one of the most striking examples of Bruegel's habit late in life of reversing a theme that seemed naturally to call for abundance and multiplication of episodes, in the way of the prints and texts, and instead restricting it, reducing it to a particular closed space and focused cast of characters.[26] It is typical of the older Bruegel that he should individualize the idea of excess. Of course the individuals in *Cockaigne* are carefully chosen and stand for the separate orders of society as Bruegel's world understood them – much more clearly than in Baltens, say.[27] Peasant with flail; cleric with book; soldier with lance and armoured glove; and a further man in armour vegetating under the roof of tarts – by the look of him maybe a full-blown knight to the other one's mercenary, though one cannot be sure. (It is important that military men predominate. The year, to say it again, is 1567: the Duke of Alba is massing his troops. It would have been foolhardy of Bruegel to risk too direct a comment on the subject, but some scholars believe that the soldier on the ground

is wearing specifically Spanish uniform and even sporting a Spanish moustache.[28]) All the figures are fascinating, that is, but surely the most spellbinding of them, around whose wide-open eyes the whole picture seems to orbit, is the young man to the right lying on his folded fur coat. Let us call him the 'man of letters' – one of the *clercken*, as the caption on the engraving has it. The clerk's inkpots and penholder are still laced delicately to his belt, part of an array of ties and strings that seems to be barely holding together under the pressure of his swollen stomach. He may be specifically a clergyman – the book beside him has the look of a Bible – but he could as well be a notary or wandering scribe. The manuscript being crushed by his sleeve has a legal look. He is brother to the man with the pens cavorting in the foreground of the Bruegel *Wedding Dance* now in Detroit.

I shall speak to the point of this cast of characters eventually, but first let me focus on there being so few of them. What does the reduc-

34. Pieter Bruegel the Elder, *Wedding Dance* (detail), 1566, 119.4 × 157.5 cm (47 × 62 in.). Detroit Institute of Arts.

tion make possible? Certainly a stress on the main bodies' weight and shape – the bursting seams, the slipping codpiece. But this is bound up with an emptying – or at least a relative clearing – of the ground plane up front, which means that the substance and surface texture of the grass, and above all the grass's orientation, become subjects in themselves. Relatively little is happening on Bruegel's hillside, and therefore its richness and strangeness and uncertainty of incline – its tipping and wheeling, as if in sympathetic response to the wild disc of the tree-table – attract our attention. That we can see the sole of the man of letters' shoe only makes the question of where we stand in relation to the earth it rests on the more puzzling. But surfaces here, whatever their orientation, are transfixing. The grass is a marbled, aqueous green, every square inch fretted and patted by the painter's brush. The fur is a slightly cruder rehearsal of the same procedure, as if to alert us to the softness and variance of the grass; the mercenary's chain mail is the variation mechanized. Of course the earth is infected by the analogy with fat asses and plumped-up pillows. It is a swelling belly, as smooth and elastic as the mountain of gruel. The sausage fence just spells out its slippery rotundity. Yet none of this is stressed or improbable. The earth is round, the globe turns slowly on its axis. The tree is an axle, with the bodies spokes to its wheel. The great shape of the ground plane does no more than confirm the new science.

Tilting in *Cockaigne*, then – and tilting and distending seem to be the picture's two topological models – carries a special, equivocal ethical charge. It is disorienting, but not overmuch. Most things stay put on the canting table. The scene is unstable, but not utterly shifting and precipitous. The swell is that of a pillow, not a wave. (The sea is flat calm and sunlit.) Tipping and swelling seem to coexist quite happily with this world's naive delight in geometry. The fastidious square of the tablecloth on the grass; the ellipse of the table, and those of the cactus plant; the house of tarts; the zigzag of lance and flail; the neat segments cut from the cheese and pig; the fowl's touching eagerness to fit the

parameters of its pewter dish. It is true the hillside lacks horizontals, and in large part verticals to match. The tree is a poor substitute for an upright body – especially *this* tree, collared and truncated, halfway between living thing and piece of furniture. But I do not see the absence of flats and uprights as morally (ontologically) improper, a sign of the human world degenerating. Regressing, yes – but sometimes that means becoming more itself. The Book of Common Prayer says simply 'that by reason of the frailty of our nature we cannot always stand upright'.[29] *Cockaigne*'s tone has the same forbearance.

Clothes are important here. It is telltale that Bruegel's Garden of Earthly Delights has no place for nakedness. (Or for sex in general. It is a male world, only partly demilitarized.) Friedländer says that Bruegel's difference from his Italian contemporaries hinges essentially on his lack of interest in clothing as 'drapery' – that is, as a system of folds whose purpose is to reveal the logic of the organism underneath.[30] The northerner's painting moves in the opposite direction. What it aims for is the outline – the whole shape of a body or an entity, and the kind of energy or inertia the shape conveys. Bruegel's world is a compilation of unique particulars, not a structure built out of ultimately abstract – infinitely interchangeable – gradients of tone and colour. Clothes are a source of endless fascination for him, exactly because they combine with bodies in such unpredictable ways – sometimes revealing and articulating them, sometimes concealing and muffling. He never stops cataloguing the ludicrous intricacy of apparel. The ties and knots and over-elaborateness all round the man of letters' midriff in *Cockaigne*, for example, are answered by the steady calligraphy on the soldier's trousers – contour lines all leading to Mount Codpiece. Bruegel especially delights in clothing that seems to be taking on a life of its own, maybe in the process robbing what it clothes of life. The iron glove still feels for the lance. The codpiece was the artist's preferred piece of human flummery (as the ruff was Rembrandt's or the wimple Van der Weyden's) just because it was extraneous, and what it claimed to be covering might or might not be

there in anything like the form that the covering implied. All clothing is armour or prosthesis. Human beings are not bodies in Bruegel, even when they have eaten their fill and lie there like over-enlargements of themselves: they are outfits with bodies in hiding.

∽

There is not a lot going on in the *Land of Cockaigne*, and Friedländer is again right that this marks the picture off from Bruegel's world in general, which is usually pullulating with activity. Even when the cast of characters is restricted, the main actors are usually frantically on the move. The very idea of 'world' for the artist is summed up, in his

35. Pieter Bruegel the Elder, 1568, *Misanthrope*, tempera on canvas, 86 × 85 cm (33⅞ × 33½ in.). Museo Nazionale di Capodimonte, Naples.

Misanthrope from 1568, by a goggle-eyed cutpurse pushing against the glass globe he has to live in, driven – driven mad – by wants, needs, schemes, delight in wrongdoing. In *Cockaigne*, by contrast, the clockwork has run down – but not stopped. The fur cloak of the man of letters transmutes matter-of-factly into the grass next door. Everything here is still capable of becoming something else, but not dramatically, not in some moment of metamorphosis. There is no hurry in *Cockaigne*. The pig is ambling, the egg is a child taking its first steps. Engulfing seems to be a better metaphor for change than metamorphosis – like the sticky grey hillside swallowing the tree. Change is digestion.

What would a world be like – this looks to be Bruegel's question – in which all human activities slowed to the pace of the large intestine?

36. Pieter Bruegel The Elder, *Netherlandish Proverbs* (detail), 1559, 117.5 × 163.5 cm (46¼ × 64⅜ in.). Gemäldegalerie, Berlin.

Thought, too: the man of letters is still visibly cogitating, but in the way of the woman in Bruegel's earlier *Netherlandish Proverbs*, who stares from her window at a stork flying past (fig. 36). Or compare him with the gooseherd in *Proverbs*, pondering the bipedalism of his charges: 'Hierom en daarom gaan de ganzen barrevoets', 'For one reason or another geese walk barefoot' (fig. 37). I for one do not believe that Bruegel, in seizing on this peasant recognition (part ironical, part

37. Pieter Bruegel The Elder, *Netherlandish Proverbs* (detail), 1559, 117.5 × 163.5 cm (46¼ × 64⅜ in.). Gemäldegalerie, Berlin.

acquiescent) of the way the world goes on presenting us with too many things to think about, wanted us to disapprove of blank wonder – of endless staring into space.[31] He had done some staring in his time.

Excretion is naturally part of things in *Cockaigne*. The man with the spoon falls into paradise like a turd from an anus. We know that shitting was something Bruegel habitually painted with affection and seems to have meant as a sign of life going on regardless. Shitting at the foot of the gallows (in the picture now at Darmstadt) is not so much cocking a snook at the Law as putting the world of culture in perspective and showing us what of nature will never say die. Shitting at the base of the Tower of Babel (in the picture in Vienna) has a similar valence (fig. 39). It takes place in a meadow where working people are taking a break between *corvées*. Some are swimming. One man is washing his smalls in the stream. The unobtrusive activities (the figures are tiny) go with the friendly lie of the land. The shitting figure is far away, but deliberately close on the picture surface to the emperor up front paying a visit to his folly, with stonemasons grovelling at his feet.[32]

Maybe the people in Bruegel's paradise still exist in the shadow of death. Surfeit is close to insensibility. No one here looks immortal. The young cleric seems to have his eyes fixed on something ominous, or at least a puzzle. Darkness surrounds him. I can imagine a reading of the *Land of Cockaigne*, it follows, that would start from the resemblance between its overloaded tree-table and that of the feckless courtiers in the *Triumph of Death*, ignoring (or trying to resist) the skeleton army. But such a reading would miss Bruegel's tone. The egg is not an actor in a morality play.

So what kind of play is it in?

An answer should start again from the source material – the basic mode of *Schlaraffenland*, and what we can guess about the mode's appeal. No one *believed* in the land of Cockaigne. It was a comic thought

38. Pieter Bruegel the Elder, *Magpie on the Gallows*, 1568,
45.9 × 50.8 cm (18⅛ × 20 in.). Hessisches Landesmuseum, Darmstadt.

39. Pieter Bruegel the Elder, *Tower of Babel* (detail), 1563,
114 × 155 cm (44⅞ × 61 in.). Kunsthistorisches Museum, Vienna.

experiment: not a vision, not a utopia (it did not posit itself as perfec-
tion nor as perfection gone wrong), not even really a wish-fulfilment.
Wish-fulfilments do not spell out their absurdity as they proceed.

Cockaigne seems originally to have been a product of the oral culture
of the European peasantry; and the legend's fundamental ludicrousness,
its unfathomable cynicism and materialism – including its cynicism
about materialism, at least in utopian guise (its resistance to the move
from imagining to positing) – tell us something central about the
texture of that vanished culture, of which we shall never know much.

Bruegel's painting responds deeply to *Schlaraffenland*'s spirit. It
is make-believe, not utopia; and its controlled unseriousness is what
allows it to think so deeply and humanely about what the material
world consists of, what the human animal is in its simple physical
existence, what being fully and exclusively in the material world could
be like. The unseriousness of the ethical and epistemological frame
is what makes the ontology possible. Obviously Bruegel was aware
of how closely the bodies and objects of his counterfactual world
duplicated – inflated, hypertrophied, but also in some sense perfected
and realized – those of his factual one. Laughing at exhaustion and
satiety was a way of discovering more fully what both are, physically,
experientially, gravitationally.

Cockaigne is a picture of gravity – of the pull of a gravitational
field, of pleasure as a planetary system with cooked food as its sun.
Cockaigne celebrates the cooked as opposed to the raw, we could say;
or, rather, the cooked replacing the raw altogether. It is a place where
the founding distinction of Lévi-Strauss's or Detienne's 'civilization'
has been permanently left behind.[33] The last unconscious residues of
the palaeolithic have vanished from the cultural bloodstream. No more
sacrifice and butchery; no more blood (the lance is discarded); no more
shadow of the cross.

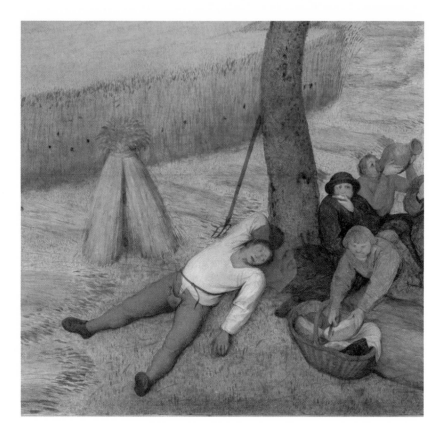

40. Pieter Bruegel the Elder, *Harvest* (detail), 1565,
119 × 162 cm (46⅞ × 63¾ in.). Metropolitan Museum of Art, New York.

And yet ... isn't Bruegel the artist who reminds us most constantly, following Genesis, that 'In the sweat of thy face shalt thou eat bread, till thou return unto the ground; for out of it wast thou taken'?[34] Compare *Cockaigne* with the *Harvest*. We surely would not need to know which picture of ease from one's labours came first – the man of letters under the table or the mower in the *Harvest* resting against the tree trunk – to sense that, for Bruegel, the two states were inseparable. One was always conceived as a variant of the other. (Still, in *Cockaigne,* the peasant lies uncomfortably on top of his flail. And his eyes are open – maybe more in exhaustion than satiety.) In fact, chronologically,

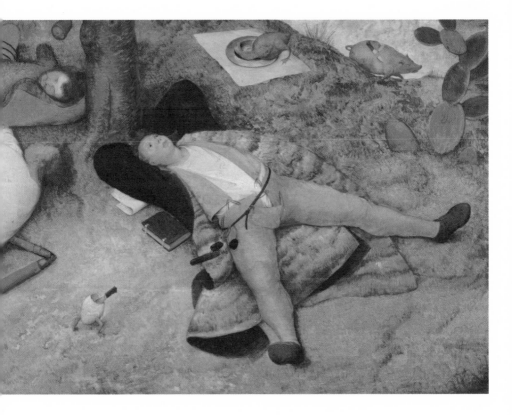

Detail from fig. 23: Pieter Bruegel the Elder, *Land of Cockaigne*, 1567,
52 × 78 cm (20½ × 31 in.). Alte Pinakothek, Munich.

the mower in *Harvest* preceded the clerk. Bruegel, that is, dreams the
impossible in terms of the everyday; but also – always – in terms of
the everyday world's extremity, of the way the everyday never ceases
producing the horrible, the preposterous, the luxuriant, the eternal.
Eternity here (remembering Friedländer) means nothing more than
the mad wish for stasis – for final fulfilment and perfection – that is
constantly present in workaday life, haunting it, taking advantage of it,
making it bearable. Bruegel, in short, is the opposite of a utopian; but
this exactly does not mean that he reverses utopia's terms, or is even
straightforwardly a pessimist. For no one has ever had such an eye as
he did for the non-existent in what exists, for everything in human

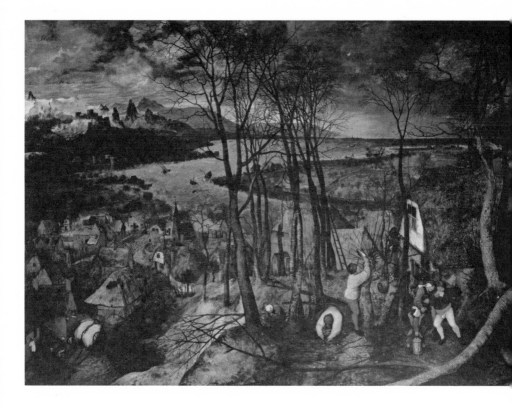

41. Pieter Bruegel the Elder, *Dark Day*, 1565,
118 × 163 cm (46½ × 64⅛ in.). Kunsthistorisches Museum, Vienna.

affairs that pushes insatiably towards non-identity: the will to pleasure as much as the will to power, playfulness as much as vacancy, the bride in the *Village Wedding* – dwelling for ever and ever in the moment – as much as the cripples' frantic determination to move on. The *Dark Day* is his vision of the good life.

It is typical of Bruegel that his vision of things transfigured, when at last he allows himself one, should not be The World Upside Down. The hereafter in *Cockaigne* is the world as it would be if it became more fully itself, with its basic structures unaltered and above all its physicality, its orientation, intact. The World The Same Way Up, Only More So.

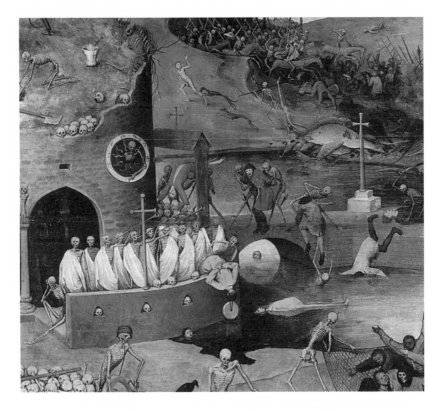

Detail from fig. 3: Pieter Bruegel the Elder, *Triumph of Death*, c.1562,
117 × 162 cm (46⅛ × 63⅝ in.). Museo del Prado, Madrid.

We come to the question of Bruegel and Christianity.

Consider the *Triumph of Death* in Madrid (fig. 3).[35] How common a
subject was it in Bruegel's time? And where does the title come from? No
doubt the basic idea stems from the world of late-medieval prints and
wall painting: one of the last times I saw the picture it resonated imme-
diately with a great Dance of Death, done around 1500, encountered
a few weeks before in Burgundy, at the parish church of La Ferté-
Loupière (fig. 42). That image-world was Bruegel's inheritance. But
this surely meant he was all the more aware that, in turning a Dance of
Death into a panorama of Death's Final Solution – a disciplined army
carrying out a scorched earth policy – he was steering away from the

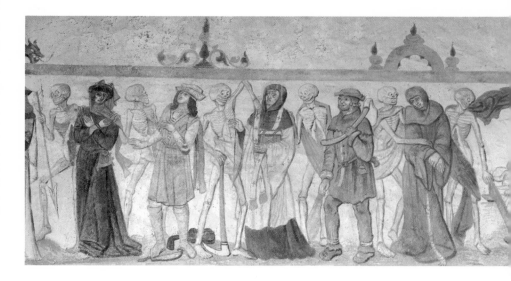

42. Anon, *Dance of Death* (detail), late 15th/early 16th century, fresco.
Saint-Germain church, La Ferté-Loupière, Yonne.

Dooms he could see in the churches towards something more down-to-earth and terrible. The *Triumph* is Hell, and also Last Judgment, but now with the dead coming out of their graves not to accept reward or punishment, but simply to take revenge on the living. Discreetly but unmistakably, Bruegel insists on the closeness of the story he is telling to that of Christian resurrection of the body. Twice he shows members of the skeleton crew busily digging up the coffins of their comrades, and right at the centre of the painting, in the distance, is a skeleton stepping from his grave. Not far away stands a horrible, blood-red filigree cross: signs of Christian burial are swallowed in the general tide of malignancy.

The skeletons are human. They are excited, eager, well-drilled, mechanical, patient, vindictive, cheaply satirical (especially when faced with courtly love) and occasionally despairing, tired of the monotonous one-sided game. At the stern of a ship of death to the left is a skeleton sitting disconsolately with one heel on the ice. Here, if anywhere, may be the limit case of Bruegel's pessimism. Even the work of death

becomes boring, and one or two killers fall out of line. What's the use, even of mortality?

It is not quite right to call Death's soldiers skeletons. Some have desiccated flesh still clinging to their ribs. And it looks as if they see the enemy as not merely the living, but also the too recently dead – the too fleshy, with too much of this world still about them. Otherwise what is the point of their dragging off corpses lying at rest in open coffins, as seems to be happening centre foreground? Why does the skeleton closest to us bother to slit the throat of an unresisting character already wearing a shroud? Death does not like clothes, perhaps: he does not like any kind of bodily envelope, natural or artificial. He will enforce the bare minimum.

Hell is an afterthought in the *Triumph of Death*, almost as if it were a concession to Boschian taste. Torture takes too much time. Demons appear round the edges of a black castle-kiosk stage centre, but they and their building look flimsy, like a carnival float. Perhaps the coffin-tunnel over to the right in the picture is the entrance to an underworld (though its floor seems level), but there is nothing to indicate where the darkness inside is leading. The structure resembles a holding pen. The living stream into it as if of their own free will, thinking it a way out, or at least a change. Death as we see it is done familiarly, with knives and swords. Skeletons are ordinary executioners. The hills are provided with a few more gibbets than usual. Smoke and fire on the horizon do not seem to promise a plunge into a Bosch-type pit: they just indicate – the signs would have been commonplace – that war is everywhere.

Two Deaths in the distance are busily felling trees. (Photosynthesis is uncongenial to them. Brown and yellow are their colours.) A skeleton sprouts from a clock face on a building, its bony finger pointing at 1. A naked man is chased by starving dogs and tries to shield his privates with one hand. Is it modesty, or an awareness that this is where the dogs will start? What will the skeletons do with the splintered and scattered

bones in evidence at the foot of the gibbets? Reassemble them? Or are some deaths – those administered routinely on earth, long before Death's army arrived – too total for even Death to reanimate?

∽

What Bruegel does to the image of hell in *Triumph* – that is, the ruthlessness with which he eliminates hell's distance, hell's otherworldliness – may help us with what he does in *Cockaigne* to the image of heaven.[36] The question, again, is why the *Schlaraffenland* story appealed to its audience and why it survived in early modernity. The answer may be this: Cockaigne was a dream world, but also repeatedly in the telling a parody of dream worlds. This meant that the legend could be brightly topical in the world following 1492, where marvels and alternatives were the talk of the town. But the story was not simply up to date: it spoke to something deeper in Europe's consciousness than travellers' tales or the wilder shores of Anabaptism. Cockaigne – the core idea, the basic counterfactual – was a parody of paradise. It was a desublimation of the idea of heaven: an un-Divine Comedy, which fully made sense only in relation to all the other (ordinary, instituted) offers of otherworldliness circulating in late medieval culture. What it most deeply made fun of was the religious impulse, or one main form the impulse took: the wish for escape from mortal existence, the dream of immortality, the idea of transcendence itself. 'And God shall wipe away all tears from their eyes; and there shall be no more death, neither sorrow, nor crying, neither shall there be any more pain: for the former things are passed away.' What Cockaigne said back to religion – and here its voice seems that of peasant culture itself, in one of its ineradicable modes – was that all visions of escape and perfectibility are haunted by the worldly realities they pretend to transfigure. (Blake's 'Proverb of Hell' on the subject, which I have quoted more than once, does no more than put in a nutshell the 'materialist' wisdom underlying the un-hellish proverbs Bruegel grew up with.) Every Eden is the earth intensified; immortality is mortality

continuing; every vision of bliss is bodily and appetitive through and through. Cockaigne speaks back especially to the Christian world of mortification – all the more unanswerably for refusing to occupy the same moral high ground, and shrugging off the spiritual with a smile. To all of this – the deep structure of the legend, so to speak, and the reason for its persistence – Bruegel's picture answers profoundly.

∽

But the legend, to repeat, is *unserious* – not despairing or sardonic or even *anti*-utopian, exactly. And don't those adjectives apply to Bruegel's retelling? Isn't the atmosphere of his *Cockaigne* decisively heavier and grimmer than that of the Baltens print, or the eight-block *Schlaraffenland*, or anything in the chapbooks? Aren't the horrors of 1567 in the background?

Some have thought so: Friedländer, for instance. I know there are viewers in front of *Cockaigne* who are struck by the painting's brownness and barrenness, and recoil from its vision of stunned immobility.[37] Paradise is just death dressed up, they reckon. The pseudo-animation of the bones and egg on the tabletop, doing their skeleton tapdance: that is the key to this afterlife.

There will never, of course, be a satisfactory answer to the question of Bruegel's pessimism – to the depth of resignation or despair built into his humour. He lived in merciless times. Certainly it is hard to see much sign of God's grace in the world he shows us. His view of humanity certainly includes – insists on, time and again – the species' capacity for cruelty and gullibility. World-weariness and world-revulsion (vanity of vanities) were clearly familiar to him, as to his culture as a whole. But I do not think, finally, that the bones dancing on the table sum up the painting's temper. There is no crisp or irrefutable way of saying why not: in a case as complex as Bruegel's, issuing from a world where complex thinking had to state its conclusions guardedly, it will always be a matter of intuitions, responses to atmosphere, understand-

ings of placement, the weight given to certain details, the vertigo (or euphoria) brought on by painting's stopping of everything in its tracks.

Paradise, so the great visionaries tell us, will possess a light of its own. The light in *Cockaigne* is a characteristic Bruegel achievement. When one sees the panel in the small room it occupies in Munich – I remember a January day, with grey sky reflecting snow – it is often brighter and paler than in memory or reproduction. Time of day and height of the sun are hard to interpret. The wonderful white glare on the sea could be that of an endless windless afternoon. There is an amount of darkness, though never deep shadow, in the picture's middle ground, under the table and up towards the fence of sausages. Perhaps brown is the panel's predominant colour, though the soft grass green of the foreground – which hits home first as the picture comes in view, and only slowly stops drowning out the pinks, reds, yellows, whites and greys – is worked into and over the brown across fully two-thirds of the picture surface.

Sometimes when the atmospherics are good in Munich it seems as if the effect Bruegel must have wanted was a variant on the one he perfected in the *Harvest* (in many ways *Cockaigne*'s closest point of reference): the same ivory haze on the edge of thickening into overcast. That would make sense of the light on the sea. Is there even a faint sun in the sky over the distant city? But the comparison with *Harvest* soon breaks down. *Cockaigne* is darker: not dismally dark – I resist the idea of the dream world as barren or ominous – but in the end not quite partaking of any daylight or half-light we can recognize.

The green is astonishing: no one analogy will lay hold of it. It does have a wonderful watery lightness, like marble or a throw of extra-fine velvet, but it is not in the least stony or marble-smooth or aqueous. It is grassy, obviously, maybe even mossy, but dry; like a thin, almost papery covering on top of the earth; in places (towards front right, for example) it seems like the colouring of a rock face.

The falling away of the green into a chasm is unmistakable when one is in front of the real thing in Munich – far more so than in any

reproduction. At bottom left, especially, grass gives way to earth. But again, whatever upset and instability the tilt of the land may bring on is more than counteracted – this is my answer to the idea of *Cockaigne* as the world in negative – by the painting's relish for things, details, textures, contours, all the contents of the world's full stomach.

There is no good way of repeating the relish in words. Pointing out and enumerating are what language is designed to do, whereas what is glorious in *Cockaigne* is just pointless endless proliferation. Look at the airholes in the cheese! Look at the excellent ironwork on the flail. Or the fine silver clamps on the Bible. How exquisite the man of letters' face – pink cheeks and nose, glinting eyes, delicate nostrils and lips. Look at the flayed-flesh pink of his tunic and leggings, the latter like exposed tissue. Compare the furred lightness of the soldier's chain-mail. How beautiful the drawing of the young man's shirt, especially its neckline and long liquid folds. Notice the roots of the tree by the mountain of gruel – a typical Bruegel interest here in the character of a particular root system, plus a specific kind of spreading into the surrounding earth, and a set of outrider saplings.

Two of the cactus loaves are half sunk in the grass, like tombstones. The peasant has a thick mane of hair. The soldier's lance is steel-tipped, glinting even in the shadow. The egg in the foreground has yolk spilling down the right side of its shell!

Some of these wonders must have been worked on meticulously and at length. But Bruegel is entirely a 'modern' painter, and much of the panel's surface was evidently covered fast, the freehand movement of the pigment throwing up and half cancelling identities. All round the foot of the cactus of loaves, for instance, there are thrown-off commas and curlicues of brown that would not look out of place in a Corot. At the bottom edge of the tablecloth, just to the left, the signs of speed are unmistakable: grass comes up the line of the white cloth, smudging over it at one point, retreating from it at others, with the panel's primed ground still visible. Side by side, the grass and the man of letters' fur

Detail from fig. 23: Pieter Bruegel the Elder, *Land of Cockaigne*, 1567,
52 × 78 cm (20½ × 31 in.). Alte Pinakothek, Munich.

lining alert the viewer to the handmade character of both. In the same
way that the little bush's blotted, transparent leaves against the sea (just
to the right of the tabletop) make the viscosity and stodginess of the
porridge opposite more palpable.

∽

None of the dictionaries agree with me, but I cannot help thinking
that the homophony between the word 'Cockaigne' and the useful
substance extracted from the coca plant is not coincidental. I imagine
a nineteenth-century pharmacologist, naming and sampling, getting
at least a brief laugh from the way the new anaesthetic chimed in with
the old. And this licenses me to say a word or two about the difference
between Bruegel's dream of consumption – his vision of pleasure and

fulfilment – and ours. The relation of heaven to appetite is always a question: the schoolmen worried about angels' intestinal tracts.[38]

Bruegel lived at the moment just before 'consumer society', which is to say, before the world of goods accelerated and expanded in the first age of globalization, before the mass production of commodities, and before the notion of bodily well-being was transformed by a 'modern' multiplication of addictive substances compatible with the new tempo and discipline of production.[39] The idea of consumption in Bruegel had surfeit as its ruling figure – eating and drinking to the point where wild dancing breaks out, or men and women fall helplessly to the ground. Consuming for Bruegel (and his culture, by the look of it) meant primarily ingesting, relishing, dreaming a full identity with the world of things, swallowing them whole. He would not have understood, I think – or rather, would not have had much sympathy for – the world to come, with its carefully regulated doses of pleasure, its quarter-intoxications, its small hits and highs: caffeine, tobacco, cane sugar, the international alcohols (rum, gin and so forth), opium and its derivatives, and, later, the pharmutopia of anxiety and despair.

Consumption went on for Bruegel's contemporaries under the sign of scarcity and insecurity. *Cockaigne* is not heavy with soldiers for nothing. It was a dream of the opposite to a world of toil and malnutrition: a still world, a fat world, an idle and irresponsible world, a world of bodies. And none of these descriptions apply to the dream of consumption that now possesses us. An intensification of 'consumption' is not only compatible lately with an increase in the pace of work and in hours spent on the job – we surely do not need statistics to convince us that the past forty years in the West have seen an extraordinary speed-up and hyper-exploitation of white-collar labour – it is a condition of that increase. Consuming and recreation go on at the pace of work, in work's shrinking interstices, using an apparatus that has to present itself as an extension of – a magnification and perfection of – the gadgets and disciplines we come home from. The gym is a factory; the big game

an animated spreadsheet; the body sweating on the treadmill is turned away as decisively from its actual carnal experiences – towards the TV on the wall, or the calorie app on the iPhone – as the coldest Weberian Puritan balancing his ethical and financial books.

Bruegel's world of consumption was oriented to the notion of anti-work. Therefore play was one of its basic categories: that is why in talking so eloquently about *Children's Games* Edward Snow could give us a view of Bruegel as a whole. But play only fulfils its human potential – only carries an insubordinate charge – if it is posited as counterweight to the grown-up world of purposiveness. We, on the other hand, exist in a world where the 'adult' and the 'juvenile' are hopelessly commingled; where leisure time has been both increasingly infantilized and increasingly regulated, domesticated, depoliticized, dosed and packaged. The infantilized and the commodified are one. Bruegel's terms are different. He goes in for the childish, the foolish, the grotesque and the boorish, as opposed to the infantile – which last is a word that really gathers force only in the eighteenth century, and does not spawn the verbal form 'infantilize' till the twentieth. Consumer society for Bruegel was still bound up with the festive, the gargantuan, the multitudinous, the carnivalesque: all the kinds of performative community, in other words, that preceded the great clean-up we call 'modern'. Whether Bruegel approved of the performances does not concern me. How modern he was is an unanswerable question.[40] He showed us the non-modern bodies in action; he inhabited and articulated them. That is what counts.

We go back to the ground in *Cockaigne*, and Bruegel's treatment of standing and falling.

Bruegel – to put it briefly – was a connoisseur of bipedalism. Edward Snow is right: humankind's posture determines Bruegel's view of the species. By the time he does the pen drawing called the *Fall of the Magician Hermogenes*, probably in 1564, the artist's view of the

43. Pieter Bruegel the Elder, *Fall of the Magician Hermogenes* (detail), *c*.1564, pen and ink, 23.3 × 29.6 cm (9⅛ × 11⅝ in.). Rijksmuseum, Amsterdam.

impossible and demonic in existence – of the non-human, that is – has clarified to the point of pedagogy. The banner in the magician's room spells out the argument in picture language: to diverge from the human, which is what Hermogenes' disciples are bent on achieving, is to do something else than stand on two legs. Magic is upside-downness, or levitation, or walking the tightrope, or standing on one's hands; or, ultimately, having a body in which the 'up' of ingestion, perception and production of language and the 'down' of standing firm, moving forward, excreting and copulating are utterly scrambled. The creature in the foreground of *Hermogenes* balancing the bowl on its groin sums this up.

One comic consequence of this loss of bearings, Bruegel likes to point out, is what happens to the phallus. Both of the humanoids on the banner – one of them crablike on all fours, the other crawling on his belly with legs flapping as decorative appendages (like coxcombs) – are given the last touch of monstrosity by their codpieces' being extruded from their bodies by the logic of their poses, inviting an opponent's knife. (Codpieces, we know, were regularly a focus of Bruegel's attention. Part of that, too, was bound up with his anthropology – for codpieces are armour, or the ritualized after-image of such. Isn't one of the problems of bipedalism, among many, that it puts the male sexual organs somewhat at risk, as compared with their sensible hiding place on all fours?) The man hanging in agony from the ceiling in Bruegel's pen drawing *Justitia* repeats the pose of the humanoid bottom right in *Hermogenes*. Which is to say that the arrangement of limbs in question is perfectly possible in the real world, if men try hard enough. Again the codpiece is detailed. *The Cripples* remain unbearable for us, and no doubt were originally laughable, in particular because of the substitutes they have improvised for putting two feet on the ground. Speech they do not lack. If there is a question of their threatening our definition of the human or dancing at the edge of it, this cannot be because they lack language. They look to be talking too much.

44. Pieter Bruegel the Elder, *Justitia* (detail), 1559, pen and ink,
22.4 × 29.5 cm (8⅞ × 11⅝ in.). Bibliothèque Royale, Brussels.

Only Bruegel could have thought of putting his cripples on such tender, delicate, succulent grass. But why? What response did he mean to provoke?

◠

We confront the question of Bruegel's ethics. *Justitia* (fig. 44) and *The Cripples* (fig. 32) put the question most mercilessly, but there are other late Bruegels almost as dreadful: *The Blind Leading the Blind*, for instance, or the *Two Monkeys* (figs. 31 and 30). The challenge for viewers of Bruegel has always been to understand how these visions of the frailty and cruelty of our nature could coexist with the immense humanity – the charity, the inclusive laughter, the compassion – of *Village Wedding* or the *Harvest*. Even *Cockaigne*, we have seen, is for some viewers a jeremiad.

Let us concede that the 'attitudes' of Bruegel's contemporaries to cases of agony and deformity, or even of unthinking callousness, were different from ours. Let us assume that the art historian Hessel Miedema is right when he tells us that sixteenth-century Netherlanders would have greeted the spectacle of leglessness with laughter.[41] 'Did people laugh?' he asks. 'Undoubtedly they did. They laughed above all at the bizarre, the deformed and the weak.' I hear this laughter echoing in the spaces these pictures first occupied. And, equally, I hear the voice of the preacher, citing the obvious text. The blind leading the blind are no different from the rest of us. We are all falling.

Bruegel's pictures, in other words, issue from a world of derision and sanctimony. But that solves nothing. However hard a viewer may try to see Bruegel's actual visual preferences and strategies – his choices of scale, his particularization of expressions and movement, his set-up of spaces and ground plane, his turning of actors to face us or face away from us, and so on – *as* forms of dismissive laughter or moralization, it will always feel like forcing to do so. Why that is, exactly, is hard to pin down. It is not that the paintings in question are clearly at odds with their parent culture or intent on reversing that culture's terms.

I doubt that even a phrase as anodyne as 'complicating the patron's frame of reference' is appropriate. What takes place, takes place in practice. When Bruegel comes to visualize his stock figures or stage his pieces of proverbial wisdom – making the figures fully present in a picture, setting them upright or lying them down, having them be 'idle' or 'crippled' or 'good for nothing' – the terms of understanding transmute.

And this is not because any sort of magic has been performed. Making anything in the world *particular*, taking advantage of the physical resources of the medium with that in mind, means that qualities and dimensions in the thing portrayed are taken seriously for the first time – aspects common wisdom ignores. But those aspects and dimensions are not (ever) invisible or non-existent in everyday life. They haunt the world of established truths and exclusions. People of all kinds – not just 'great artists', but people negotiating the ordinary ambiguities of the world – take advantage of this haunting, this latency. Life would be a self-destroying mechanism if they did not. Derision implies the possibility of pity, or sympathy, or common humanity. 'Blessed are the meek' is not so very distant from 'blessed are the outcast, the halt and the lame'. And even had this culture not possessed a set of canonical texts in which the Son of Man could be seen consorting with the wretched of the earth, or himself suffering the full blast of sadistic laughter, the culture would still not have been easy – unequivocal – in its contempt for and dehumanization of the weak or disabled. No culture can be: dehumanization is an activity, a feat (no doubt often performed effectively) that has in its bones a sense of what, in its object, the conjuration is directed against. All human vocabularies have a gradient that expresses this awareness; and especially a gradient that harps on the thinness of the line between the genuine ethical negative and its various counterfeits – between roaring anathema and frozen reproach, between pessimism and misanthropy or piety and sanctimoniousness, between moral judgment and cant. One man's blasphemer is another's early Christian martyr.

Bruegel seems specifically to have been interested in the fine line. His *Misanthrope* (fig. 35) stands precisely on it: neither securely figure of fun nor hero of inner otherworldliness. As usual the artist enlists the full ambiguity of the proverbial to put us, as readers and viewers, in a quandary. 'Om dat de werelt is soe ongetru / Daer om gha ic in den ru': 'Because the world is so untrue, I go about in mourning.' It is unusual for the proverb to be written, as it is here, more or less in the picture space.[42] And does not the declaration have just a trace of ostentation to it? Could performing one's withdrawal from the world in this way – one's disappointment in it – end up as just one more performance among others? Are not the *pleurant*'s clasped hands and pursed lips a touch self-congratulatory? ('Hij schijt op de wereld.'[43] But even this Bruegel is capable of sympathizing with.) Bruegel's pictures are short on villains. Even the cutpurse World has his reasons: he wants to get out of those ragged trousers. The misanthrope's purse is too big, red and heavy. The analogous cripple in *Netherlandish Proverbs*, slipping inside a similar globe of glass, provides the proper apology: 'You have to slither if you want to get through the world.'[44]

How often the word *wereld* sounds out in Bruegel. Of all forms of speech, proverbs are the least afraid of totalizing: the world for them is as concrete a thing as a broom or a barrel or a gallows. In *Netherlandish Proverbs* the blind leading the blind exist at the farthest point of the proverbial universe portrayed: they are striding round a headland at the edge of the sea. The sun goes with them (but also the gallows across an estuary). They seem to be exiting towards the landscape of the *Fall of Icarus*. The proverb itself – 'When one blind man leads another, they both fall into a ditch' – applies here only lightly. I think that the full-scale painting of the blind men Bruegel did later set itself the task of *making* the proverb apply, literalizing it. But literalizing it – monumentalizing it, making the proverb loom up in the flesh in front of the viewer – also

peeled it away from the proverbial frame. Proverbs are concrete but blessedly abbreviated: their fewness of words is the key to their power: they slip by or slip out almost before the user is aware of producing them. Stopping a proverb in its tracks, magnifying it, giving it specific features – this is always in a sense turning it into something else.

The *Land of Cockaigne*, I have been arguing, comes out of this proverbial world. And as with many a proverb, its tone is hard to catch. It is comic, certainly; it wears its wisdom and compassion lightly, and works to show us a world – a set of human and animal actors – that is absurd and wonderful at the same time: unbelievable and irresistible, just because (this seems to me the thought) that is the nature of the world in general. Some such proposal about humanity underlies all the best of Bruegel: he wants us to go on wondering at the juxtaposition, in his great *Magpie on the Gallows* (fig. 38), of a crude instrument of public death, taken for granted by those who have grown up with it, and an irrepressible urge to dance in its shadow.[45] I do not think the word 'callousness' will do to sum up the attitudes and forms of life in play here – Bruegel's and the dancers' – any more than 'peasant simple-mindedness' or 'sheer will to survive'. Something of these, no doubt; as well as unapologetic earthiness and openness (on the part of people who work the land) to the instigations of weather, light, the seasons.

That there are parallels between *Magpie on the Gallows* and the *Land of Cockaigne* is obvious. The peasant shitting in the corner of *Magpie* is partner to the man in *Cockaigne* pulling himself out of the gruel; *Magpie*'s beautiful centre foreground – the sunlit hummock supporting the gallows, with its animal skeleton and pecking bird – is *Cockaigne*'s tilting slope quieted down; the dancers in *Magpie* have made a small eternity for themselves, where death for a moment is in abeyance. But it would be wrong to press the analogies too far. *Magpie* is as close as we come in Bruegel to a comprehensive statement about the place of

human sociability – the strange mixture of sadism and togetherness that seems intrinsic to it – in the whole order of the earth. It makes sense that the picture (if we are to believe an early biographer) is singled out in Bruegel's will as a bequest to his wife, apparently a special treasure. *Cockaigne*, by contrast, is the opposite of a panorama or 'world landscape'. It is imaginary – essentially a close-up. Paradise – an end to sadism *and* togetherness, it seems – can be posited only as something too near, too fat, too immobile to be true. I do not believe that Bruegel's picture is simply satirizing the Evangelist's 'no more death, neither sorrow, nor crying' – it looks to me full of wonder at the idea of escape from all three – but the last thing it asks us to do is assent to the vision or believe it a real possibility.

So how *is* the picture's amalgam of gravity and light-heartedness meant to be taken? What did Bruegel expect from viewers if not their assent? Here he is, the great pessimist, entertaining for once the idea of a life free from hunger and terror. But in what spirit?

Such questions are sharpened – but only made more perplexing, I feel – if finally we try to confront the full meaning of the picture's date, written above Bruegel's name in capitals bottom left. There is no need for a full catalogue of horrors, but it bears repeating that 1567 was a fateful year – a turning point – in the revolt of the Netherlands against Spain, and that, as so often, religious differences focused and embittered the struggle. On 22 August 1567 the Duke of Alba arrived in Brussels at the head of a Spanish army, tasked with ending civil rebellion and liquidating Protestant heresy. On 5 September he set up his 'Council of Troubles'. Five years of bloodshed followed. Alba boasted later of having executed 18,000 Calvinists: an exaggeration, but pointing to the spectacle of cruelty – mass public executions, burnings, torture, shaming of women and maddening of children – that was an integral part of his campaign.[46] Monstrosities of this kind had not begun with Alba's invasion and did not stop when his army went south. Tens of thousands of Protestants (as far as numbers can be reconstituted) had

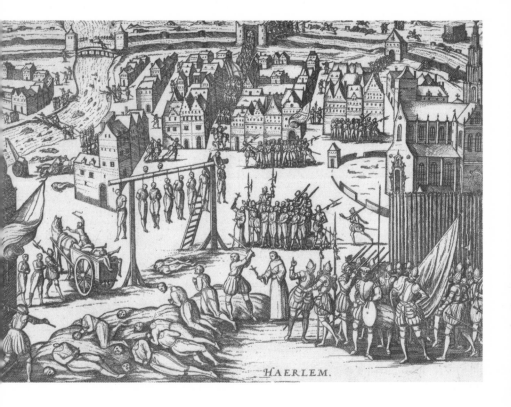

45. Frans Hogenberg, *Siege of Haarlem*, 1573, etching,
21.8 × 28.2cm (8⅝ × 11⅛ in.). Rijksmuseum, Amsterdam.

been executed even before 1565; as many as 150,000 chose exile in the
half-century following.[47] True or false, overblown or invented, scenes
like the one I illustrate – from a Dutch print denouncing the Spaniards
at the siege of Haarlem – are the *Land of Cockaigne*'s (and *Justitia*'s)
proper accompaniment.

Through the decades, viewers of *Cockaigne* have sensed its nearness to
such obscenities. Heaven on earth is hard to disentangle from hell. And
this may be Bruegel's point: his *Cockaigne* speaks back to the murderous
certainties in the city along the shore. It offers a model for thinking of

alternative worlds – thinking them through, realizing them, dwelling on their substance and detail – without the thinker 'believing' in the thought as it comes into being ... having the thought be shot through with a consciousness of its impossibility, maybe even absurdity ... but not having the disbelief *invalidate* the thought ... insisting quietly, on the contrary, that the thought keeps alive a necessary dream, a horizon of action and consciousness, an insubordination intrinsic to the human.

Of course, I have also been suggesting that Bruegel, in offering such a way of thinking in 1567 – maintaining the kind of balance he did between seriousness and unseriousness, even in the face of horror – had resources at his disposal that we now seem to lack, at least those of us living in the tranquillized 'West'. His unseriousness could tap naturally into a vein of insolence and down-to-earthness (and an unappeasable wish for escape) that ran deep in the culture of the European working masses. The nexus of wishes involved here, as far as we can understand it, was the opposite of a dead, generalized cynicism about 'power' or a fatalism posing as hardheadedness. Compare the mass culture we know.

Paradise may be fantastical in Bruegel, but nothing will convince me it is simply a delusion. The egg has emerged from the gully and steadies itself on splayed chicken legs. The grass slope beckons. The creature's pride in what it has to offer is immeasurable. Down one side of its shell runs the thin stream of yolk. The man coming out of the porridge will soon need feeding. The earth's great cycle begins again.

Detail from fig. 23: Pieter Bruegel the Elder, *Land of Cockaigne*, 1567, 52 × 78 cm (20½ × 31 in.). Alte Pinakothek, Munich.

Poussin and the Unbeliever

Marriage on earth seems such a counterfeit,
Mere imitation of the inimitable ...
<div align="right">Robert Browning[1]</div>

Poussin's painting the *Sacrament of Marriage* (fig. 46), now hung in the Octagon at the National Gallery of Scotland, was the last of a set of seven *Sacraments* to be completed. We have a letter from Poussin dated 23 March 1648, saying he had been hesitating for a week before packing it off to Paris.[2] One understands his reluctance to say goodbye. He was fifty-four, and his health was fragile; he would never see the painting again.

Even if the canvas had come down to us without a title, it would surely be clear that we are looking at some kind of marriage ceremony, taking place in the Roman Empire. The architecture speaks irrefutably to this – both the columns and Corinthian capitals and garlands hung in the shaded interior, and the glimpse of sunlit public monuments outside. To be precise, we are in Judaea during the reign of Augustus – some say in Jerusalem itself, standing in the porch or narthex of the Temple.[3] If so, the outer rooms of the sanctuary seem to have been thoroughly Romanized. Likewise what people are wearing: the twenty-odd guests at the wedding have the look of well-heeled provincials, in long togas and *pallae* for the occasion. The young men's bare feet are strictly for show. Poussin has feasted as a painter on the different colours, sheens and degrees of crispness of the draperies. One imagines him standing for hours in front of the senators and matrons to be seen in marriage

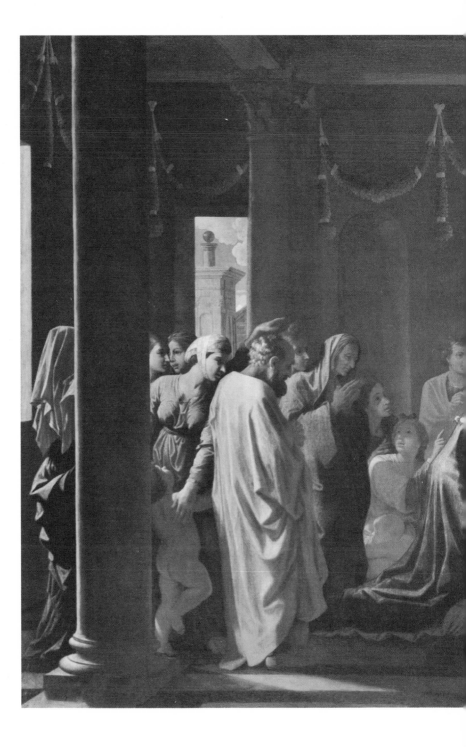

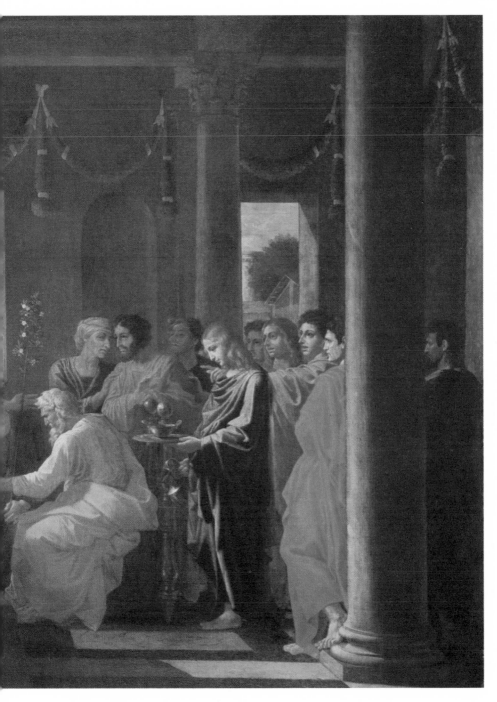

46. Nicolas Poussin, *Sacrament of Marriage*, 1648, 117 × 178 cm (46⅛ × 70⅛ in.).
Bridgewater Collection Loan, National Gallery of Scotland, Edinburgh.

47. Sarcophagus of Cardinal Fieschi, *c.*210-220, marble.
San Lorenzo fuori le Mura, Rome.

processions on many a sarcophagus in the city that was his home – for
example, the massive and famous one in the nave of San Lorenzo –
absorbing the details of costume and stance.

We know that the woman almost at the centre of the *Sacrament
of Marriage*, kneeling, dressed in blue, is the Virgin Mary. What we
are looking at is the moment of her betrothal (not her marriage) to
the ageing Joseph. Notice the rod silhouetted against the wall, just to
the right of the door plumb centre. It is sprouting leaves and white
flowers – the sign from God of Joseph's having been chosen as Mary's
husband-to-be.

I have started matter-of-factly with the painting, trying to establish what it is of. But the plainness is largely illusory. Great swathes of shared knowledge (I hope) are built into my 'we are in Judaea'. The San Lorenzo sarcophagus may or may not be relevant. The young men's bare feet – well, interpret them how you will.

Maybe we could plant ourselves on firmer ground with *Marriage* if we left aside its maker's sense of history and attitudes to early Christianity, and tried to pin down the picture's visual temper – its overall mood and tone. But this is not easy to do. The room in the Temple is airy, and a strong morning light pours into it from the left. Yet the dominant note is cool and neutral; the whole upper half of the painting is empty. Someone in the Virgin's retinue seems to have tried to make the anteroom a little less bare by hanging garlands high on the wall, but the decoration looks more suited to a funeral than a wedding. The city outside is alive with heat, with high clouds building; the paved floor in the foreground is mostly in shadow. One fancies it cold to the touch. Maybe the man in red by the column to the right is resting his toes so nonchalantly against the column base partly to give himself relief from the chill underfoot.

The seven paintings of the *Sacraments* are, even by Poussin's standards, severe. They are feasts of measurement and geometry. *Marriage* is in many ways the least relentless of them: if you compare its colour and architecture with *Confirmation*, say (fig. 48), the difference is striking. A viewer senses immediately that *Confirmation* is taking place deep underground. Sarcophagi – not carved with proud citizens remembering their marriage vows – line the space in the picture's dark rear. (Who was it who called the early Christians 'haunters of tombs'?[4]) It is important, therefore, and distinctive, that *Marriage*'s space opens directly onto the city above ground. Its doors are open. If the structure we see through the door to the left is a funerary monument (and it might be: I shall return to this), then it is a proudly public and imperial one, basking in the sun. And of course the actors of the *Sacrament of Marriage* are not

48. Nicolas Poussin, *Sacrament of Confirmation*, 1645, 117 × 178 cm (46⅛ × 70⅛ in.).
Bridgewater Collection Loan, National Gallery of Scotland, Edinburgh.

– not yet – the first Christians. They are Romans and Jews, inhabitants (inheritors) of the world of Joachim.

Marriage, that is to say, is less severe and claustrophobic a picture than the other indoor scenes in the series. But at the same time it comes across as the most calmly measured of the seven. It is the painting with the strongest and most all-determining crisscross of verticals and horizontals. Even the *Eucharist*, which is the scene that best rivals *Marriage* for sheer beauty and complexity of architecture, looks empty and frontal and straightforwardly vertical by comparison. Poussin has decided in the *Eucharist* not to give us the strong beam lines of the upper room's ceiling. The ins and outs of the room's massive cornice – truly High Roman these, with their play of attached and freestanding

49. Nicolas Poussin, *Sacrament of Holy Eucharist*, 1647, 117 × 178 cm (46⅛ × 70⅛ in.).
Bridgewater Collection Loan, National Gallery of Scotland, Edinburgh.

pilasters – break the horizontal into discontinuous segments. And down
below, where the disciples take bread – the contrast alerts us to the key
compositional choice in *Marriage* – there is no internal reiteration of the
room's four walls by freestanding columns, and no answering geometry
spelt across the floor. Of all Poussin's paintings *Marriage* seems to me
the one in which space is most elaborately compartmentalized. Not
just the four columns marking out the room within a room inside the
porch, but the three rear doors presenting the space of the city and,
above all, the spaces to right and left of the great columns close to us
in the foreground.

These last spaces in particular have always fascinated viewers – or,
rather, one of them has. No one has ever cared much about what

happens on the right. There the picture ends, essentially, with the young man in red leaning on the column: the space beyond him is negative. Another man can be made out after a moment or two, lurking in the darkness, but surely all he does, once noticed, is say something to the effect: 'The picture stops here; has already stopped.' Nothing could be further from the effect of the space on the left of the canvas, and the figure that occupies *it*. The space is vibrant, and the figure transfixing. Compositionally, the segment to the left of the column is pivotal: it opens the picture towards the viewer, and lets in air and light. (Screen off the left-hand margin with a thumb, and the picture immediately looks boxed-in and flat.) The bright edge and its occupant are a second centre to the Virgin's betrothal, vying with the ceremony at centre. The great sculptor Bernini, when he saw *Marriage* in Paris in 1665, spotted the left-hand side immediately and pulled back the curtain further to get a better look (Chantelou, who owned the *Sacraments*, had each painting hidden behind an individual drape).⁵ Bernini, so Chantelou tells us, was transfixed in particular by the figure standing next to the column. Presumably he was interested above all in what Poussin had chosen to leave out in his depiction of it, and how the leaving out only made the figure more spellbinding. Chantelou, when he wrote up the day's events in his diary, called the figure 'celle qui est à moitié d'une colonne' ('the one who is half behind the column', though the French, taken literally, having referred to the 'filles et femmes' attending the ceremony, says 'the one who is half of a column').⁶ In what follows I shall mostly retain Chantelou's ellipsis, which I think responds to that in the picture. And I shall press it even a little further from time to time, referring to the figure as the *femme-colonne*. Veiled body and bare stone cylinder make a strange unity.

Any proper interpretation of the *Sacrament of Marriage* – let me state as much straightaway – will have to take the *femme-colonne* as seriously as Bernini did. Poussin, after all, never had a viewer more powerfully

equipped than Bernini to understand him. This does not mean that there should be outright war in interpretation between the picture's left-hand side and its centre. If the woman by the column simply displaces the Virgin in my account, then things will have gone wrong; for this is not what happens in front of the painting. But equally, if I fail to suggest at least something of what had Bernini draw back the curtain and look and look again, I shall have failed even more deeply. For Bernini was right. The *femme-colonne* is one of Poussin's – one of painting's – prime inventions. The picture turns on it. Once seen, it never retreats into peripheral vision.

∽

Paintings are not propositions: they do not take the form of image-sentences. They are not even *like* propositions. That is, they do not aim to make statements or ask questions or even, precisely, to seek assent. They are best not seen, it follows, as strings of individual image-elements or phonemes, arranged according to some overall grammar, out of which a governing meaning is generated for the array as a whole – maybe a complex or ambiguous one, but nonetheless a meaning derived from a knowable lexicon and a set of combinatory or semantic rules. Naturally a painting 'takes a view' of things; it adopts an attitude to them; it discriminates and prioritizes, putting a small world in order. But this is not the order of the linguistic. It is an ordering of things more open and centrifugal – more non-committal – than grammar can almost ever countenance.

Pictures are taciturn. Their meaning is on the surface – merely and fully apparent. These are limitations to painting as an art, doubtless, but also glories. Painters understand this. 'Moy qui fais profession des choses muettes,' Poussin described himself on one occasion ('I who make a profession of mute things').[7] Or again, to Chantelou: 'Il vaudra mieux que je m'estudie aux choses plus aparentes que les paroles' ('It is better for me to occupy myself with things more apparent than words').[8]

'Mes tacites images,' he called his canvases.[9] There is a modesty to these statements, but unmistakably a touch of pride. The world resists our efforts to name it. Painting from its very beginnings – from the rush and overlap and transparency of the beasts on the walls of the caves – is about that resistance.

I am suggesting, then, that Poussin does his deepest thinking at a distance from the linguistic – that muteness and ungrammaticality are the key to his view of the human. 'Things more apparent than words.' But what things, most persistently? What are the constants of Poussin's anthropology?

Let me begin in the negative. For the vast majority of painters, the strange upright posture of the human body, standing on two feet as opposed to four, is something taken for granted.[10] It is a constitutive feature of the human, obviously, but maybe because of that it stays on the edge of vision, of awareness. (It is striking, if one walks the halls of a great museum in Vienna or New York or Taipei, how seldom pictures of all kinds show us feet planted convincingly on the ground, and how often depicted human beings peter out round mid-calf.) The body is vertical and bipedal, and therefore poised in unique – maybe problematic – relation to the ground beneath its feet. But it does not follow that most painters take uprightness and good footing, and the special nature of the human animal's negotiations with gravity, as the basis of their world-view. The earth and floor for them are simple givens; their pictures establish ground level as a small part of the pantomime (a stage for it) or leave it out altogether.

Most painters – again like most human beings, it appears – exist naturally and unthinkingly five or six feet off the floor. What they see is other bodies, lined up roughly on a level with their own uprightness; and beyond those bodies, a world of further uprights men have built to contain and reiterate their standing: walls, columns, arcades, lofty or intimate rooms. If they look further, and many of them do, they plot the ensuing distances as the eye seems to prefer to, looking out over

a landscape from a special vantage point – 'vantage' meaning vision moving unimpeded from near to far, not obstructed too much by the local ups and downs of the place, grasping the whole topography at one fell swoop, not touching down all the time, not getting distracted by the character of the grass.

But this is not the whole story. Remember, by way of contrast, the famous accounts of Poussin coming back from his walks by the Tiber, and his admirers noticing 'that he carried in his handkerchief pebbles, moss, flowers, and other suchlike things' ('jusqu'à des pierres, à des mottes de terre, & à des morceaux de bois' is how Félibien puts it) 'which he wanted to paint exactly after nature'.[11] Certain painters, in other words, step away from the common unconsciousness. They, too, exist in a world of uprights, inhabited by bipedal bodies. But for some reason this uprightness is, or comes to be for them, a subject in itself: not a fact taken as read, from which proceed all the actions and aspirations that constitute the interest – the value – of the human world but, rather, the fact of facts, which both (they propose) inflects and informs the whole texture of human doings, but also (they suggest) sets limits to those doings, threatens their equilibrium constantly, puts them off their stride. Yet at the same time it humanizes them, this mere physicality. 'Man comes and tills the earth and lies beneath.'

Perhaps one could say that most painters are chiefly interested in the first phrase of Milton's great request to God at the beginning of *Paradise Lost* – 'What is dark in me illumine' – and not in the one that follows – 'What low, / Raise and support.' The drama of illumination, and the tipping of human being always between darkness and light: this is a metaphoric world that painting occupies without thinking, seemingly as part of its very nature. Very few painters seem to see that their art could occupy the second of Milton's worlds just as naturally, putting the business of bodily raising and supporting up front; even articulating what that act of elevation involves, mentally as well as mechanically – what resistances it works against, what constraints it

acknowledges, and above all what lowness (what ground bass of materiality) it depends on. No doubt painters who do see this are likely to understand that the physical terms in play are also metaphorical. They know how deeply the figures of bipedalism are built into our ethical, metaphysical, erotic language. Uprightness is a value – for some, an absolute. Staying on a proper footing is as important as maintaining one's balance; being supine or prostrate or prone is never very far from lolling about and grovelling. Bipedalism may be the fact of our physical nature that speaks best to our having been made 'in the image of God'. Certainly our culture goes on thinking of failure or error as a version of the Fall.

Poussin's view of human nature is shot through with this awareness. So is Bruegel's. So (though less obviously) is Veronese's. All three are fascinated by the body's complex, and by no means trouble-free, standing on its hind legs. They paint the contact between upright man and the ground plane. But more: they give the ground plane an equal and opposite weight to the world erected on top of it. They may agree with Darwin and the palaeontologists that bipedalism seems to have been the great and puzzling step (and even 'step' is a metaphor that begs the question) by which the human animal became what it is; but they borrow a still more primitive scene from the anthropologists' story. Before bipedalism, and maybe driving bipedalism, there was simple terrestriality – the fact of coming down from the trees.

Of course I am not insinuating that in some fantastical way Poussin intuited the argument of *The Descent of Man* two centuries before it was published. Standing on one's hind legs is a great fact of human existence whether or not it is thought of within an evolutionary frame. For whatever reason – within whatever ideological matrix – Poussin came to see it, I think, as the key to our being in the world. (It was, for him, one of the 'things more apparent than words' that painting had access to.) So the ground in his pictures became something other than a notional 'plane' established in a system of equal

spatial coordinates or dimensions: it became a level, a grounding, a limit condition of the human.

All this is a view of things that could occur quite matter-of-factly to men and women in the seventeenth century. It is entirely compatible with Christian orthodoxy. 'The first man is of the earth, earthy: the second man is the Lord from heaven.'[12] 'We therefore commit his body to the ground: earth to earth, ashes to ashes, dust to dust.'[13] Or the following, from George Herbert's *The Church-floore*:

Mark you the floore? that square & speckled stone,
 Which looks so firm and strong,
 Is *Patience*:

And th' other black and grave, wherewith each one
 Is checker'd all along,
 Humilitie:
[...]
 Sometimes Death, puffing at the doore,
 Blows all the dust about the floore:
But while he thinks to spoil the roome, he sweeps.[14]

We shall see in due course how much of Herbert's thinking applies to the ground plane in *Marriage*.

∽

Look for a moment at the version of *Confirmation* Poussin painted, probably around 1640, as part of an earlier series of the *Sacraments* done for the great collector-intellectual Cassiano dal Pozzo (fig. 50). What more naive and touching an account of childhood and coming-of-age could there be? And does not everything depend here on the children's mere standing, or drawing back from standing – and the marvellous hardness of the square and speckled stone beneath their feet? How

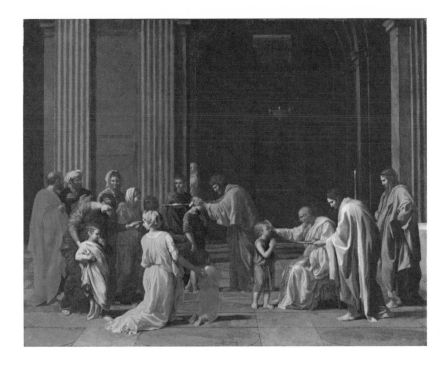

50. Nicolas Poussin, *Sacrament of Confirmation*, c.1638-40, 95.5 × 121 cm (37⅝ × 47⅝ in.). Dulwich Picture Gallery, London, on loan from Duke of Rutland, Cambridge.

tentative, how seemingly accidental, the positioning of bodies across the marble. How decisive the final adulthood – the compassionate, calm uprightness – of the young priest at far right.

Compare Chantelou's *Ordination* (fig. 51). What a hymn of praise to human ease and stability! What a *summa* of bare feet on mud! With the painting's architecture employed above all to extend and perfect the apostles' proud verticality – the belonging of men to the great world above. Or, deepest and most astounding of pictures, look at Cassiano's *Eucharist* (fig. 52). It is hard to think of another foreground in painting so elaborately shadowed, or a ground plane so dusty and grim.[15] And surely the treatment of our human wish (and need) to lie down again at intervals, taking the weight off our feet for a while, on a little platform protected from Death's puffing – no treatment I know of has

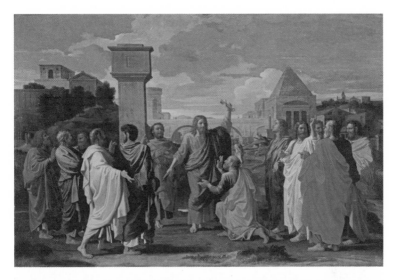

ABOVE 51. Nicolas Poussin, *Sacrament of Ordination*, 1647,
117 × 178 cm (46⅛ × 70⅛ in.). Bridgewater Collection Loan,
National Gallery of Scotland, Edinburgh.

BELOW 52. Nicolas Poussin, *Sacrament of Holy Eucharist*, c.1638-40,
95.5 × 121 cm (37⅝ × 47⅝ in.). Dulwich Picture Gallery, London,
on loan from Duke of Rutland, Cambridge.

ever caught more of that wish's essential pathos. Fallen man, sleeping man, making himself a space of repast and festivity, on a second floor above the shadow play beneath. Notice, specifically with *Marriage's* woman by the column in mind, the servant in a white shift exiting toward the light at left.

∽

A sacrament is a mystery. The original Greek word was *musterion*. A sacrament is a sign, an 'outward sign of inward grace, a sacred and mysterious sign or ceremony, ordained by Christ, by which grace is conveyed to our souls'.[16] This is the classic definition. The sign is of something deeply hidden: it is necessarily a bodily and sensate token of that higher reality, says Catholic doctrine, in which the natural dependence of man on the 'corporeal and sense-perceptible'[17] – the phrasing is Thomas Aquinas's, from the *Summa Theologica* – is admitted and put to use. A sacrament is a sign, or an outward form, that actually *produces* sanctity. It confers grace, it does not merely signify it. Much theological ink had been spilled on just this subject in the hundred years before Poussin took it up. Calvin and Luther were much on Romans' minds.

A sacrament is a mystery, but also an institution. It is, or has become, a familiar human thing – a social occasion, an instrument of solidarity. All Poussin's pictures respond to this. They are pictures of gatherings: they show the social world of early Christianity emerging. Sacraments, to quote *The Oxford Dictionary of the Christian Church*, 'are the means whereby the union of God and man consequent on the Incarnation is perpetuated in Christ's mystical Body of His Church, its members incorporated in Him, and through Him united to one another'.[18] Partly the means of incorporation are miraculous – I shall come to that – but partly they are ordinary, 'sense-perceptible'. Rituals are often ways of putting social differences aside. Some of the men to the right in *Marriage*, if we follow the story of Mary that Poussin would have

known, are disappointed suitors rather reluctantly acknowledging Joseph's victory. But they do acknowledge it. They have stayed around for the ceremony.

Sacraments, in other words, are social and natural facts. None more so than marriage, of course. 'If any one shall say that matrimony is not truly and properly one of the seven sacraments of the Evangelical Law, instituted by Christ our Lord, but was invented in the Church by men, and does not confer grace, let him be anathema': thus the Council of Trent.[19] No prizes for guessing whom the cardinals had in mind. 'No one indeed can deny,' said Luther, 'that marriage is an external worldly thing, like clothes and food, house and home, subject to worldly authority, as shown by so many imperial laws governing it.'[20] Or this, from Calvin's *Institutions*: 'Lastly, there is matrimony, which all admit was instituted by God, though no one before the time of Gregory regarded it as a sacrament. What man in his sober senses could so regard it? God's ordinance is good and holy; so also are agriculture, architecture, shoemaking, hair-cutting legitimate ordinances of God, but they are not sacraments.'[21]

Architecture and agriculture, if not shoemaking and hair-cutting, were things whose godliness and social dignity Poussin regularly celebrated. Does his stress on marriage as a quiet occasion in the provinces silently edge this one of God's ordinances into the same conceptual space? Possibly. Others have thought so. The art historian Jacques Thuillier, for instance, spokesman of the French rationalist tradition, ends his essay 'Poussin et Dieu' with the following verdict:

The seventeenth century recognized the indispensable intervention of grace [in human affairs], which alone could transform meditation on man and his destiny into prayer. Nothing indicates that Poussin had any such aspiration. Grace, in the strictly religious meaning of the word, seems truly absent from his work.[22]

I wonder. 'A sacrament,' wrote the Master of the Sentences, 'is in such a manner an outward sign of inward grace that it bears its image and is its cause.'[23] It bears its image – but what image, precisely? The Church has an answer it often repeats. Grace is conferred by Christ's sacrifice on the cross. 'The efficacy of the sacraments,' says *The Catholic Encyclopedia*, 'comes from the Passion of Christ.'[24] Insofar as the Virgin's promise to Joseph partakes of the sacramental, therefore, it must be because it figures forth proleptically the sacrifice to come. It takes place under the aegis of the Crucifixion: under the aegis – or, this being Poussin, upon the ground.

I wish there were a way of knowing how many readers noticed, before this moment when I point it out, that Mary's betrothal takes place on the sign of the cross. Because inevitably I have lost hold of how obvious or non-obvious the shape made in *Marriage*'s foreground by the stones of the flooring really is. But this much is prima facie. In all fourteen pictures of the *Sacraments*, Cassiano's series and Chantelou's, there is no other moment when a hidden – mysterious – sign of Christ's presence is so strongly, so centrally, asserted. Not to say there are no other mysteries. The 'E' on the column in *Ordination* is a famous example. But that is a mystery that declares itself as such: it is a public enigma, borrowed from Plutarch.[25] It is not something woven into the ordinary texture of the world; it is not the ground on which the action stands. There are other strong grounds, no doubt, in pictures from the *Sacraments* series – other church floors, even other pavements where light and dark slabs intersect to form crosses. But there is none like the cross in *Marriage* – none that is put as our broad, central way into the picture space (along a great orthogonal), none cleared so much of figures and obstructions, none so little offset by other geometries in the marble. It is a bold, didactic stroke. Once seen, the picture becomes more ominous. I would say that the cross in the marble is the chief of ways – and there are many – in which Poussin marks off this *Marriage* from his treatment of the subject ten years before (fig. 53). Everything

53. Nicolas Poussin, *Sacrament of Marriage*, c.1638-40, 95.5 × 121 cm (37⅝ × 47⅝ in.).
Dulwich Picture Gallery, London, on loan from Duke of Rutland, Cambridge.

in the picture for Cassiano had been more worldly and courtly, but nothing more so than the green and brown marquetry of the floor tiles.

Look again at the Master of the Sentences' formula. 'A sacrament,' he explains, 'is in such a manner an outward sign of inward grace that it bears its image and is its cause.' The Master's theology is literalized in *Marriage*. And where else, for an artist like Poussin, will the image of Christ's sacrifice be projected but under the actors' feet?

It follows – this is also characteristic – that putting the cross on the ground is also Poussin's way of thinking about Mary's relation to the Passion. The cross reminds us that Mary's betrothal to God, which

we see happening in the picture (more on this in a moment), will end with Mary's mourning over God's dead body. And this, too, the cross's placement suggests. The cross has come down from its vertical position, and the hem of Mary's garment just touches one side of its upright on the floor. Mary is kneeling. The cross stands in spatially – materially – for Christ's corpse laid out for burial.

The cross is fundamental, and yet my first uncertainty about viewers' actual seeing of it lives on. It may be the ground of a reading, for those properly attuned to Christian mysteries, but is it *noticeable*? Hasn't Poussin, for all his care with the symbol, done an extraordinary amount to make its central organizing power less coercive? Shadows fall in the other *Sacraments*, naturally. But in no other painting do they fall so fragmentarily across a foreground pattern, following a contrary logic to that of the floor itself. Nowhere else do shadows cast by figures interfere so palpably with the normal job of light and shade in painting as Poussin understood it – the job of shaping and clarifying, of making 'apparent', of expounding and stilling a particular state of affairs. The cross sets out the right-angled orderliness of things, which so much else in the picture reiterates. But the shadow obscures it with diagonals. It sews the cross back into the world.

There is, in a word, a tug of war in the painting's structure between strong symmetries – the cross on the floor, whose lines lead off in strict perspective to a vanishing point just above Joseph's head – and a left-to-right movement, a fall of light. The *femme-colonne* is clearly bound up with this. I do not think she would hold our attention in the way she does if she did not in some sense sum up – concentrate, epitomize – the whole diagonal force of light and dark across the sacred foreground. But let us put her aside for the moment and look instead at the strange symmetry and asymmetry built into the very centre of *Marriage's* action.

The question, to put it crudely, is who, in this picture of Mary's betrothal, is being betrothed to whom? Painters have ways of making such things clear if they want to. Consider the Cassiano *Marriage*, for

example. The question never comes up. Mary is Mary, on one side of the central trio, and Joseph is equal and opposite, holding her hand. His rod flowers discreetly. Between the two stands (not kneels) the priest, strongly marked as such, with cope and mitre. He is the centre of the centre, erect, with a hand on each contracting party. In the Chantelou *Marriage*, almost every term is transfigured. Opposite and equal to Mary is a white-bearded, white-haired man, seated (not kneeling) on a low throne. The throne's gold back is partly obscured by the similar gold of a serving boy's chalice and ewer. The old man's pose is wonderfully balanced and easy, abetted by the roll of his incandescent yellow robe.

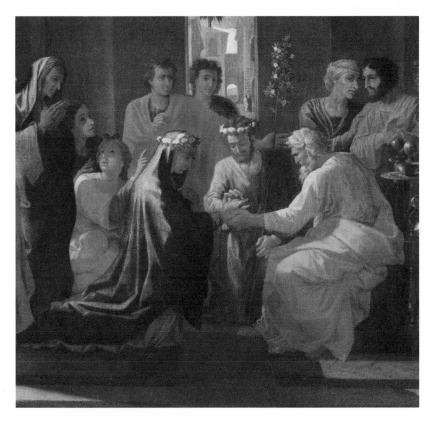

Detail from fig. 46: Nicolas Poussin, *Sacrament of Marriage*, 1648, 117 × 178 cm (46⅛ × 70⅛ in.). Bridgewater Collection Loan, National Gallery of Scotland, Edinburgh.

Light catches his sleeve and shoulder, repeating the white of his hair. One bare foot rests on the cross.

The man is godlike. And of course we realize that he is, in the scene, God's representative. He is the priest. He holds the Virgin's hand, and Joseph, who is the man in the middle, is in the very act, as I read it, of slipping the ring on the Virgin's finger. The three hands are a tour de force of foreshortening, and I cannot be sure of Joseph's precise gesture. But the man in the middle is undoubtedly Joseph. He it is who holds the flowering rod; and he wears a wreath of flowers in his hair to answer Mary's. His toga is exquisite and festive, catching and diffusing the light as if it were shot silk.

However many times I have looked at this group over the years, there still recurs the moment of slight bewilderment when again I register that the man in the middle is not the person joining Joseph's and Mary's hands. It is an astounding turn – a torquing of symmetry whose strangeness never quite goes away. And the idea, by the look of it, came late. If we go along with Pierre Rosenberg in thinking a drawing in the Louvre, perhaps a first, eventually abandoned, try-out for the *Marriage* of 1648[26] – notice the column and its flanking figures at left – then it is striking that in it the priest is still firmly in charge. And no one is kneeling, by the way. The Roman imperial tone is overwhelming. Betrothal takes place in a portico, as an important public matter. Columns magnify the human drama. The world of the marriage sarcophagi is close.

So the idea of rearranging the central trio occurred late on. And it seems to have been associated with a slight turning aside from the initial courtliness and *Romanitas* of the picture done for Cassiano (apparently Chantelou told Poussin specifically that *Marriage* was the picture in the earlier series he liked least) towards something more orthodox, more Catholic. I take the asymmetry of the central trio to be expressive of two solid post-Tridentine points: one, deriving from Paul, indisputable; the other, subject to differences of opinion among the schoolmen and still in doubt in Poussin's time. First, that matrimony is 'a figure

54. Nicolas Poussin, *Marriage of the Virgin*, early 1640s(?), pen and ink,
16.9 × 24.8 cm (6⅝ × 9¾ in.). Musée du Louvre, Paris.

of the union of Christ and His Church, according to the words of the
apostle': thus the Council of Florence.[27] 'Marriage,' to quote a later
pope, 'has God for its Author, and was from the very beginning a kind
of foreshadowing of the Incarnation.'[28] Mary in particular is the bride
of Christ. Her marriage crystallizes what marriage always is, conceived
as a sacrament as opposed to a social arrangement:

> So ought men to love their wives as their own bodies [this is the
> classic passage from Paul]. He that loveth his wife loveth himself.
> For no man ever yet hated his own flesh; but nourisheth and
> cherisheth it even as the Lord the church:

> For we are members of his body, of his flesh, and of his bones.
> For this cause shall a man leave his father and mother, and shall
> be joined unto his wife, and they two shall be one flesh.

This is a great mystery: but I speak concerning Christ and
the church.[29]

Mysterious the point may be, but I believe Poussin's arrangement was
meant to enforce it: that in Mary's case, above all others, the symmetry
in marriage is between her and the figure of the Church, and it is the
Church she takes as her bridegroom. Joseph is no more than a mediator.

But marriage is an exceedingly strange sacrament, theologians
concede, and there may be a further idea in play. For in a sense, theo-
logically, it is Joseph who administers the sacrament in this case, not
the priest. Many were the disputes among the Fathers, it turns out, as
to whether the presence of a priest was at all necessary in the marriage
ceremony. The Council of Trent put a stop to such doubts. But even the
Council admitted that the priest's blessing was, sacramentally speak-
ing, an added extra. For matrimony, to quote the *Dictionary* again, 'is
accounted peculiar among the sacraments in that the parties themselves
are ministers, the priest being only the appointed witness'.[30] Or this,
from Petrus de Palude: 'The essence of marriage consists in the mutual
consent, which the parties mutually express; this consent confers the
sacrament and not the priest by his blessing.'[31]

It is a subtle shift of emphasis, but you can see it is potentially a
dangerous one. The cardinals anathematized those who said that all
Christians were capable of administering all the sacraments, but they
were forced to admit, on Aquinas's authority, that marriage was an
exception. The priest ought to be there, but he did not confer grace.
I believe Poussin's staging intimates as much. And do not take these
issues as simply beyond most viewers' ken. Bernini, when he saw the
painting, after a little while said: 'It is Saint Joseph and the Virgin.
The priest, he added, is not dressed as a priest. I replied to him [this is
Chantelou speaking] that it was before the establishment of our reli-
gion. He responded that nevertheless there were great priests within
Judaism.'[32] At the very least this exchange is proof that Bernini under-

stood very well that the priest's not quite *being* a priest in *Marriage* had strange effects. The lack of clues in the protagonists' costume, I think, was seconded by the lack, or suppression, of clues in their placement.

∽

At the centre of the picture, then, there is symmetry and asymmetry. There are both. Neither principle wins out. Formally, geometrically – as an arrangement of shapes on a surface – the group of three figures is naively balanced and rectilinear, its edges tied into a rough quadrilateral. It echoes and concentrates the architecture of the room. The priest and Mary, sitting and kneeling, are cognate shapes, part mirror image, part free repetition. Eventually, with Bernini, we may come to feel the way this equilibrium goes on pulling against the real-world picture of who is doing what to whom. But the firm structure is capable of reasserting itself.

The same is true of the cross on the floor. The cross is central, and its symmetry is enforced, quietly, by the fact of its coincidence with one-point perspective. Perspective aims to place us, as viewers, exactly in line with the cross's upright. But the cross is presented as an anamorphosis, so sharply foreshortened that perhaps we never quite 'see' it, stably, *as* a cross; and the anamorphosis is crossed, in turn, by the fall of light from the left. The cross will always call us back to the three hands touching; but the light will lead us to where it comes from.

∽

So here we are, in the space to one side of the column. And here I shall stay, essentially. It is, for me, the *femme-colonne* at left who is the picture's presiding deity. And, like all such deities, she is mysterious. She is veiled. What she is – what she stands for – is truly a matter of interpretation.

The space to the side of the column is narrow – remarkably narrow considering its effect on us. It is less than a fifteenth of the painting's width. What attracts our attention to the space is the figure it contains,

primarily, but also the strangeness and vividness of the form immediately to the figure's left again, drawn along the painting's outer edge. This looks to be the opening of a window – the embrasure, not the window itself. (It is a window, not a door, incidentally: the bottom sill is sharply described. A window, I think, in contrast to the three doors in the rear – though we cannot be sure, in fact, of the nature of these openings, since all of them have figures standing in the way.) Light

Detail from fig. 46: Nicolas Poussin, *Sacrament of Marriage*, 1648, 117 × 178 cm (46⅛ × 70⅛ in.). Bridgewater Collection Loan, National Gallery of Scotland, Edinburgh.

streams through the left-hand window unobstructed. Light in the abstract, light as unstoppable energy, trapped immediately in the folds of the standing figure's veil. The segment to the left of the column is a space of luminosity: hard-edged and electrifying, with the light crystallized into a figure. The folds of the figure's veil and *palla* are sharp, almost starchy. The woman seems made of cut glass.

All of this, surely, opens the figure to two kinds of intuitive understanding: two first rough feelings about what she is *of*. She is – simply by virtue of her marginality and incompleteness – the figure who stands outside the feast, who does not entirely fit in. A constant and necessary figure of myth and fairytale. Penia (Poverty) at the edge of Aphrodite's birth celebrations; the forgotten relative at the little princess Aurora's christening, bringing the gift of death. She is the figure of apartness, of that which always threatens the togetherness of the group. But she is equally the figure of illumination – of light coming in from the left. Morning light, presumably – light from the east, if you think about the most likely geography, with the sun still rising. Her colours speak to the heavens. And this could be reconciled fully with the story of Mary. Richard Crashaw rings changes on the metaphor of the sun-filled window in his 'Hymn to the Virgin', published, as it happens, in the same year *Marriage* was finished. Of course Crashaw's diction is florid. The first Eve's error would have brought us all eternal death, he says,

> Had not thy healthfull womb
> The world's new eastern window bin
> And given us heav'n again, in giving HIM.
> Thine was the Rosy DAWN that sprung the Day
> Which renders all the starres [Eve] stole away.[33]

'The world's new eastern window been ...' It is a strained conceit – but it could be that Poussin, in his very different idiom, is repeating

55. Nicolas Poussin(?), *Triumph of David*, c.1631-33,
118.4 × 148.3 cm (46⅝ × 58⅜ in.). Dulwich Picture Gallery, London.

it. The space at the side of the picture may be fully part of the story of
redemption. We shall see.

The figure intersected by the column had been brewing in Poussin's
imagination for many years. Two previous appearances seem to me good
foils. In the *Triumph of David* done in the early 1630s – not indisput-
ably Poussin's work, but I think it is – a young and festive prototype
of the figure crops up top left. She is bareheaded, climbing the steps
to the temple. Notice her bare heel. She is set in front of an elegant
archway, silhouetted against the leaves of a tree outside the gate, and
a glimpse of sun. She proves, at least, that there is nothing necessarily

ominous about cutting a figure in two. And yet the idea is associated, in Poussin's mind, *with* the ominous. The real germ of the figure in *Marriage*, to repeat, seems to me the servant in Cassiano's *Eucharist* (fig. 52): framed in the same kind of abstract lightbox, but this time exiting towards the world outside. The *femme-colonne* is the servant's negative: she is turned the other way, and seemingly engaged in the drama in front of her. But she partakes of the servant's outsidedness. These cut-off figures in Poussin occur invariably on the left. They tend to be a little sinister.

Poussin's drawings for the *Marriage* pictures – there are five of them, and in several cases it is not quite clear whether they were steps on the way to Cassiano's painting or Chantelou's – are all marvellous and instructive. The one closest to the Edinburgh picture, now in the Louvre, alerts us to how grey and steely the atmosphere of the

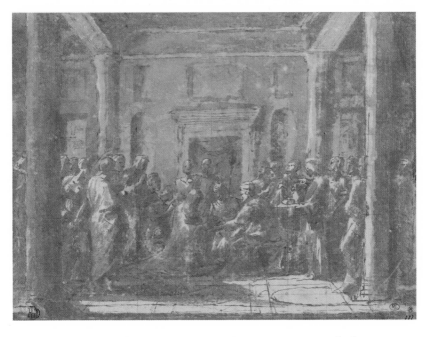

56. Nicolas Poussin, *Sacrament of Marriage*, *c*.1647, pen and ink, 16.9 × 22.9 cm (6⅝ × 9 in.). Musée du Louvre, Paris.

painting would have been had not Poussin decided to open the back wall of the anteroom to city and sky. The artist is working hard in the Louvre drawing at the pattern on the pavement, and the idea of the cross has still not come to him. For the moment, the *femme-colonne* is a shadowy aside.

Real work on the woman-column idea seems to have begun years earlier, in two drawings (figs. 54 and 57) that perhaps are afterthoughts from the Cassiano series as opposed to sketches directly tied to Chantelou's. In both drawings the figure at the column is male – costume and haircut are unequivocal. And the man has a female companion, a kind of completion of his figure, on the other side of the column. He embraces the column – firmly, almost passionately, as if it were a substitute for the woman it separates him from. The column is phallic: this does seem the point at which the Freudian cliché is appropriate. It is a magnification, an idealization, of the youth's energy and uprightness.

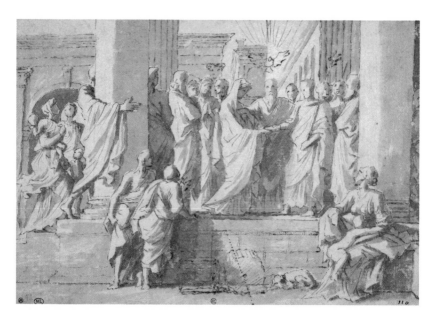

57. Nicolas Poussin, *Marriage of the Virgin*, c.1638-40, pen and ink, 13.1 × 20 cm (5⅛ × 7⅞ in.). Musée du Louvre, Paris.

We have no doubt that soon he will be married himself. Of course the change of sex that takes place in *Marriage* – I take it we never escape from the conviction that the *femme-colonne is* a woman – changes the figure's whole tonality. But figure and column are still deeply linked. They are parts of a whole. One does not have to cling to the other for that to be true.

Parts of *what* whole, then? What, finally, do I think Poussin did with his strange device? Let me return, before giving an answer, to the theology of the marriage sacrament. What I now have to say about it has already been intimated by Calvin's sarcasms on the subject of shoemaking and haircuts. For marriage, as the Fathers knew, was the most worldly – the most fleshly – of the sacraments. It had to do with sex – with passion, with procreation. 'We do not deny,' said Innocent IV, 'that carnal marriages are to be contracted, according to the words of the Apostle.'[34] And, indeed, Paul could hardly have been more insistent on the sacrament's physicality: 'For no man ever yet hated his own flesh, but nourisheth and cherisheth it … For this cause shall a man leave his father and mother, and [cleave unto] his wife, and they two shall be one flesh.'[35] This is a great mystery, says Paul, 'but I speak in Christ and the Church'. Paul may, certainly, but do the contracting parties? The whole theology of marriage is haunted by the suspicion that this is not what they are here for. Marriage, say the Fathers, is the moment at which we call on God's grace to subdue desire – to put a stop to the impulse that fires the young man embracing the column. But the paradox is inescapable. Marriage is carnal. The impulse is necessary to it. Marriage is about perpetuating the species. Poussin confirms this, quietly. On the other side of the column at left is a naked child, seemingly wanting to be picked up by its mother. The mother's broad body is rounded by the sun. And over further to the right, just behind the Virgin's train, is a beautifully laconic baby in a basket. The light is touching its pudgy cheeks and snub nose. Faint pink against neutral brown. The baby couldn't care less about the ceremony. It looks the other way.

This is the context, I feel, in which the woman by the column comes to make best sense. Marriage as worldly, in other words, but also marriage as a mystery. Marriage as flesh, marriage as grace. I want to reflect on the figure within this frame, starting from things already established. This will involve my playing constantly in what follows on the double meaning of 'figure' in English: figure meaning 'body', but also meaning 'metaphor' or 'trope' – to quote the dictionary, 'that which figures something more than, and different from, itself'. (Or Paul again, talking of God's presence in the world: 'Now all these things happened to them [the Israelites] in figure.'[36]) The 'more than itself' that the figure embodies seems central to the *femme-colonne*'s effect. It was what kept Bernini looking.

The *femme-colonne* is a figure of light. She traps light in her folds. She is light personified, but the personification participates in the mystery of the thing in question. She is a figure, but she has no face. And the more we look, the more we realize she has no body – or no body articulated, indicated, under the folds of drapery. We make a body out of the folds, immediately, irresistibly; but how we do it, what clues exactly we are responding to, becomes less clear as we go on. Compare the folds of the priest in yellow and white, where each twist and declivity defines the musculature within. The *femme-colonne* is a figure of light but also of darkness, of things veiled and obscure. Surely she is linked in Poussin's mind with the emblem of *Prophecy* he had done for Richelieu's Holy Bible of 1642 (fig. 58). 'To see God only, I goe out of sight.'[37] She partakes of a similar unnerving power.

And she partakes of the power of painting. Again, remember Bernini. At one side of the painting we are offered a tantalizing incompleteness, a figure without a face; and therefore the figure – the whole left edge of the painting – offers itself as an invitation to reading, to seeing a set of marks *as* something. And therefore the set of marks, and the mind's odd way with them, are brought to the surface of perception. The closer we go, the more spellbindingly abstract seem the building

58. Claude Mellan, after Poussin, *Prophecy*, Frontispiece for *Biblia Sacra*, 1642, engraving. Bibliothèque Nationale de France, Paris.

blocks of Poussin's illusion. The woman is a figure of the arbitrariness of painting's means, its basic codes: light versus dark, concave versus convex, salience versus declivity. The column next door only polarizes the opposites into a single geometric form, so that the figure intersected by it comes to stand, finally, for nothing less than the unstoppable tendency we all have, as viewers, to make the elementary binaries generate *things*. Things like us. Bodies obscured by drapery. Bodies with eyes.

There is something uncanny about this, I feel – especially about the certainty we have that the figure is looking. She has no face, but she is the very figure of attention. Bernini, according to Chantelou,

particularly admired the nobility and attentiveness of the women and girls in the scene, and specifically 'the one half behind a column'. This seems to imply that this woman, too, is admired for her attention, her concentration on what is happening. Walter Benjamin at one point in 'On Some Motifs in Baudelaire' quotes a wonderful, difficult saying of Novalis: 'Perceptibility is an attentiveness.'[38] I take this to mean that, in order truly to see something – to give it perceptibility – we lend it also a kind of attentiveness. Poussin's woman seems a figure of that. Novalis's saying is followed in Benjamin by the famous formulation: 'To experience the aura of an object we look at means to invest it with the ability to look back at us.' But this does not mean that the object – or the person – will choose to do so. She could if she wanted to, but here, of course, there are far more important things for the *femme-colonne* to fix on. She is the one of all the spectators, we are convinced, who looks hardest at the miracle. She is the 'viewer' personified. Not the viewer at the centre of things, placed there by perspective, following the lines of the cross, but the viewer who follows the left-to-right path of illumination – a pair of eyes that comes in with the light.

It is uncanny, this attentiveness. Maybe the child on the other side of the column, running to mother, recoils from it in fear. The woman is looking but she is veiled. What she sees, she sees darkly. She looks ahead, in the way of Poussin's *Prophecy*. What stretches before her is the shape of things to come. And what is that but death, after all – the death prefigured in Mary's joining of hands with God. The *femme-colonne* is half cut off by darkness. Maybe she and the darkness are a prefiguration of that other column at which Christ would be tortured and mocked. She surely has noticed the cross on the ground.

But lastly and triumphantly, I want to suggest, the *femme-colonne* is a figure of the human. Here is where we return to Poussin's anthropology – his sense of what makes the human body distinctive. What

matters most about the woman at the column may be simply the fact that she is upright. She is the figure of standing – of standing alone in the world. The column is that uprightness abstracted. It lends the woman massiveness and makes her immoveable. But of course it interrupts her, hides her, turns her into a kind of phantom. This is Poussin's deepest thinking. The body's verticality is the clue to its force, but also to its vulnerability and strangeness – its perpetually unfinished quality. Here is the clue, perhaps, to humanity's whole way with clothing. The standing body is uniquely exposed. It needs concealment. Poussin is the great painter of 'drapery', because he intuits how much of the social and sacred depend on it, on this provision of alternative skin.[39] So it is fitting that the woman at the column should be nothing *but* drapery, nothing but folds. Her immense dignity and self-possession are confirmed – doubled – by the way her nothing-but-folds is contrasted with the nothing-but-flesh of the little boy on the other side of the column. The boy's littleness, and his one-foot-off-the-ground imbalance, only go to make clear – to magnify – her tallness and stability. She too, by analogy, could be in motion – but a grand, slow, balanced, sweeping-forward motion, like the movement of attention itself.

The *femme-colonne* – this seems to me the fundamental fact about her – exists in the narrow space to one side of the sacred. This does not mean she can never be made part of it – think of Crashaw's 'new eastern window' – but it will always be the case that any such reading strains against the simple fact of separateness, of incompleteness. The woman is set to one side, but (in this the opposite of her double to the right) she does not register as something merely subordinate to the centre – something dark, recessive, diminished by its outsidedness. On the contrary. She is dominant, bristling with energy – the energy of photons – instinct with life. She can see the whole room.

I think we should hold on to the fact that Poussin took a decision here (as he did not in any other *Sacrament*) to mark a space apart from the sacred and have it be occupied, have its marginality be animate,

embodied. The *femme-colonne*, dare I say it, is all that is mortal in opposition to the reach of the cross. She is the profane, she is the fleshly – all the more so for keeping flesh so completely under wraps. This is why the fancy – of course it can be no more than a fancy, floating against the current of the painting's left-right flow – that her attention may actually be going in the opposite direction to the sacred will never quite go away. For formally, empirically, we are given just enough information by the woman-column's drapery for it to be an entirely possible reading that she is looking off to the left, through her veil, out the incandescent window. She is, as we have seen, in some sense an emanation of the light flooding through the rectangle at the extreme picture edge. The rectangle actually touches her; she is its continuation. Could she not be turning towards it and feeling its warmth, her head slightly tilting upwards to answer the light's fall from above? Is her veil half-transparent, then, and mostly the colour of morning sun?

Well no, not quite. The possibility seems to me no more than that; and to actualize and insist on it is, I think, to get the ethical balance of the painting wrong. The sacred commands attention here; the centre does hold. (We are back again at Giotto's turning point.) Nonetheless, it is entirely typical of Poussin that he should finally – in this last completed of his *Sacraments* – make such a space for the human apart from the drama of grace.

Two last thoughts. First, I have found that the more I focus attention on the *femme-colonne* the more the column that half-hides her – its stoniness, its size, its featurelessness, the simple binary that releases it, light versus dark, edge versus empty surface – asserts itself. And the column reminds me of *Joachim's Dream* – the black square next to Joachim as he sleeps. Both episodes bring 'representation' to the surface and show it for the strange thing it is. Nothing, we might say, is more real and substantial in *Marriage* and *Dream* than these two moments at which

darkness intervenes; but nothing is more abstract, more artificial. Reality *occurs* in the picture momentarily here, setting the fuss of 'figuration' aside – something comes close to us, almost like a presence the picture has secreted without intending to, perhaps against its wishes. And the reality is one of device, pure formality, the appearance of the negative, 'convention' becoming a thing-in-itself.[40] The negative presses down on Joachim's shoulder, or cuts the woman in two. And this negativity – this presence of shape and colour as such – is what gives the figures life.

Ultimate questions loom here, about the nature of our human contact with the world we belong to – and whether the terms 'representation' and 'reality' (let alone 'belief' and 'unbelief') touch, or touch deeply enough, on 'things more apparent than words'. Let me retreat from such mysteries and speak instead simply to the *femme-colonne*'s marginality.

Perhaps it is because we grow accustomed in front of *Marriage* to the idea of a painting's centre of interest being located off to the edge that the painting's other outsides and margins begin to attract attention. I mean in particular the spaces shown through the doors in the Temple's back wall – the views of the city, the city gates, the palms and cloudscape and flash of sun in the distance. Through the door that is closest to the *femme-colonne* we get a glimpse of a characteristic piece of Poussin architecture: a delicately articulated cube, with simple cornice, pilasters with Corinthian capitals, shallow blind niches. I see it, with my rough knowledge of antique building types, as a tomb – but decidedly a Roman tomb, proudly Augustan, a civic and public monument to a life spent in good standing.[41] And beyond the tomb is a freestanding column, to echo and answer the massive one close to us. The way Poussin handles that further vertical gently seconds the idea that columns in architecture always have the form of the body embedded in them. For the column has a capital, and even a *caput* to match. And the sphere itself – the ideal Form that the capital is there to uphold – is the same gold colour, the same light-catching soft gilt, as the veil concealing the *femme-colonne*'s head.

The world outdoors in *Marriage* is instinct with life. And, like the space to the side of the columns inside, it is peopled. Its inhabitants are tiny, but perceptually right at the heart of things. Insofar as it is possible to reconstruct the picture's elusive mathematics, the inch-high figure in the street beyond the central doorway, wearing a white toga, is placed just at the point where the Temple porch's ceiling and paving lines converge. I shall stop myself from entering in general into the question of Poussin's delight, as a painter, in figures like this one – tiny, fixating miniatures of the human, time and again played off against large figures in the foreground. Let me just say that they occupy a place in his pictorial thinking almost as important, at moments, as uprightness and standing.[42] The miniature – at times, almost the imperceptible – is for Poussin a kind of counterpoint to the upright and columnar close to. Making bodies small means insisting on the pathos of their verticality – seeing them as parts of a world. All of this thinking is in play here. The human world, as Poussin understands it, is a series of boxes: the Temple within the city, the city within the desert. The sacred is one such enclosure: necessary, it seems, but always opening onto the civic, the natural, the incidental, the everyday.

The reader will have noticed that my interpretation of the *Sacrament of Marriage* ultimately turns on what is not part of the scene at the centre. Exclusion – outsidedness – is a value for me. To be an atheist absorbed in the world of the *Sacraments* is, I am aware, to have ended in a strange place. But I do not regret the absorption, given the alternatives, and I go on believing that Poussin's paintings do give me such a place. We return, in a sense, to the point made about *Marriage* at the chapter's beginning: that, of all Poussin's paintings, it is the one in which space is most elaborately compartmentalized. And this speaks deeply to the picture's sense of life – of life's dividedness and darkness, of the body's necessarily occupying contradictory spaces, of there always being a non-person in the room.

Detail from fig. 46: Nicolas Poussin, *Sacrament of Marriage*, 1648, 117 × 178 cm (46⅛ × 70⅛ in.). Bridgewater Collection Loan, National Gallery of Scotland, Edinburgh.

This has nothing to do, finally, with the question of what Poussin may have believed. How deep were his reservations about the Catholic Church of his time, whether some of his friends had tried to persuade him that Christianity was essentially an unfortunate stepchild of Stoicism, what the conversation was like at Cassiano's table – about none of this are we likely ever to have good evidence.[43] Doubters in the seventeenth century learned to cover their tracks. Only a fool would have risked actually staging such doubts in paintings having to do with the central mysteries of the faith. No: the question is not whether Poussin believed the sacred rites and institutions were capable of ordering human existence – I am sure that he did – but what he thought that existence was, and what inventing an order for it depended on. This always was his real concern. 'Choses plus aparentes que les paroles.' The human animal in the full range of its being. Standing, falling, fearful, triumphant, attentive, looking in the wrong direction. Keeping close to a column, sauntering with a friend in the street.

Veronese's Higher Beings

One day when I was working from the beautiful maid of honour
in Veronese's picture, I was struck by the Gorgeousness of life
… Has God made faces beautiful and limbs strong, and created
these strange, fiery, fantastical energies … and given to the human
touch its power of placing and brightening and perfecting, only
that all these things may lead His creatures away from Him?
And is this mighty Veronese, in whose soul there is a strength as
of the snowy mountains, and within whose brain all the pomp
and majesty of humanity floats in a marshalled glory, capacious
and serene like clouds at sunset – this man whose finger is as
fire, and whose eye is like the morning – is *he* a servant of the
devil? And is the poor little wretch in a tidy black tie, to whom
I have been listening this Sunday morning expounding Nothing
with a twang – is *he* a servant of God?

<div align="right">– Ruskin, 'Notes on the Gallery in Turin'[1]</div>

Over the past half-century or so, when writers have turned their
attention to the four canvases by Veronese called the *Allegories of Love*
(figs. 59–62) they have spent their time trying to unpack the pictures'
iconography and said almost nothing about their visual character. This
seems nearly as odd to me as it would have done to Ruskin, since the
four pictures' subject matter is essentially banal, and their visual char-
acter unique and demanding. Iconographically speaking, the paintings
tell a familiar late-Petrarchan story of the pains and ecstasies of desire.
Matrimony is eventually called on in the stateliest of the four to quiet
things down, but most of the pictorial action in the three leading up
to it has to do with love's double dealing. The mysterious letter that

59. Paolo Veronese, *Infidelity*, *c*.1570-75,
189.9 × 189.9 cm (74¾ × 74¾ in). National Gallery, London.

60. Paolo Veronese, *Scorn (Disinganno)*, c.1570-75,
186.6 × 188.5 cm (73½ × 74¼ in.). National Gallery, London.

61. Paolo Veronese, *Respect*, c.1570-75,
186.1 × 194.3 cm (73¼ × 76½ in.). National Gallery, London.

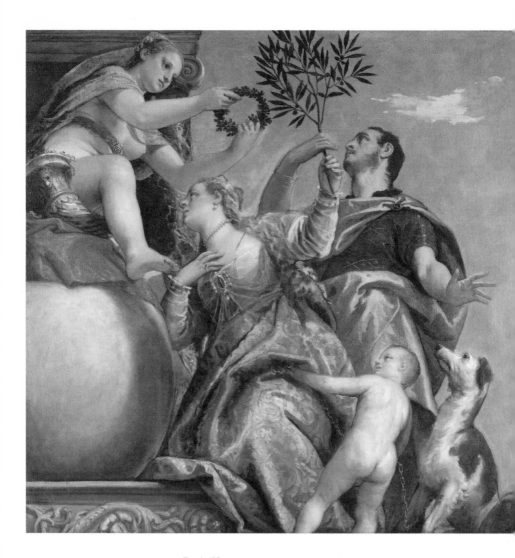

62. Paolo Veronese, *Happy Union*, c.1570–75,
187.4 × 186.7 cm (73¾ × 73½ in.). National Gallery, London.

goes from hand to hand in the painting called *Infidelity* is usually taken to have been written by the naked woman in the middle to the man towards the left – the 'soft musing poet', as Edgar Wind imagined him, sweating in a pink silk number, 'with some of the obesity of a coloratura tenor'.[2] The little winged cupid stands at the clavichord nearby, ready to play continuo to his young master's next outpourings. The poet looks to the sky for inspiration.

And surely Veronese is signalling to us what we should expect the poet to recite. More of the same as the fragmentary phrase in the letter, just readable upside down – 'che uno possede', most probably, or maybe 'che me possede' – in either case a piece of Petrarchan boilerplate. Elise Goodman-Soellner had no trouble finding the phrases in sonnets and madrigals from Brevio to Guarini.[3] The argument implied in the phrases is one the sonnets never tire of rehearsing: love is a state of irresistible possession, whose 'by whom' and 'of whom' are constantly in doubt; and therefore lovers go on being defined by their fear of erotic property being stolen or counterfeit. My bet is that the letter in *Infidelity* is the poet's work, not the woman's. Maybe she is giving the letter back to him – rather in the spirit of 'Try again; and this time find something new to say about Eros.'

Veronese does find something new to say. And he knows it; he signals it. The letter is his arrogant, light-hearted comment on the rote nature of his raw materials, and his confidence that he – not the poet – will give them unprecedented form. Taking my cue from Ruskin – from his conviction 'that more of Man, more of awful and inconceivable intellect, went into the making of [Veronese's] picture than of a thousand poems'[4] – I see the upside-down letter as Veronese's comment, in passing, on his art's effortless distance from language, from cliché, from prefabricated desire.

It would not be fair to give the impression that the iconographers of the *Allegories of Love* are unaware of this. Of course they know that the four paintings are astonishing visual performances, meant

to register as such. 'As would be expected in the work of Veronese' (here is the kind of thing art historians remember to say) 'the central idea in each episode is expressed with great – at times shocking – forcefulness, brought into focus by the actions of all the secondary figures, and vividly illustrated by the inanimate objects and symbols (the letter, the wine beaker, etc.).'[5] This is a quotation, not an invention; and it seems to me equivalent to saying that 'As would be expected in Shakespeare, the central *Revenger's Tragedy* idea in *Hamlet* is expressed with great – at times shocking – forcefulness, though the play does sometimes get lost in the twists and turns of its hero's self-study', or 'As would be expected in Kant, the central argument on space and time is pursued with great – at times trying – subtlety, not to say a positive delight in showing that contrary arguments always end in logical impasse.'

I am being unkind. But, remembering Ruskin, I stick to my guns. I do feel that Veronese has a Shakespearian ability to use the sensuous and structural qualities of his medium – the exact disposition of light, space, colour and shape within the picture rectangle – to make standard materials mutate. And surely the main task of an art writer is to give an account of how that's done. 'As would be expected ...' is no answer.

One way to set an account of the *Allegories* in motion would be by pointing to a basic, yet I think enigmatic, aspect of the four: that is, their orientation to us as viewers. Face to face with the enormous objects, each more than 6 feet square, an onlooker instinctively senses that in each of them the way through the picture plane is not straightforward – not an imagined movement across a transparency hung (which is to say, posited or intimated) right there in front of us, at eye level. We seem to be ushered upwards into the illusion from somewhere lower down. And a factual question arises: is it possible to know or reconstruct how Veronese, as he brought the canvases into being, would have envisaged their final real-world relation to us – to our bodies standing in the room they were originally made for?

Connoisseurs in eighteenth-century France (the paintings belonged for a while to the duc d'Orléans) gave us our first clue to the paintings' Italian titles – *Infedeltà, Disinganno, Rispetto* and *Unione Felice*[6]– and then later suggested they were meant as ceiling decoration. There is no evidence in the archives to support this, but the suggestion has stuck.[7] I see why. There is something about the visual organization of all four scenes that seems premised on their being seen from below; and this creation of a view from lower down – this construction of an 'above-ness' for the figures – is fundamental, you will see, to my sense of Veronese's achievement. But the question remains: from how far below? And with the plane of the picture in what sort of relation, exactly, to the viewer looking up? Is the plane grandly – spectacularly – overhead, way up on the ceiling at right angles? Or is it opposite us, maybe quite high on the wall, maybe with the painting hoisted a little above eye level (over a palace doorway, even), but facing us, with the bodies within the frame understood (meaning *felt*) as reiterating – amplifying, mobilizing, diverging from – our uprightness just underneath?

The longer I look, the more I think 'just underneath' most probable. The four canvases, as Veronese made them, were presumably upright – large-scale unwieldy surfaces, fastened to an easel or a studio scaffold. Their space was premised on the vertical. It was fitting (here is my sense of Veronese's intention) that in the end they floated high in relation to us, but not too high. They had to be at a level where the powerful (and wonderfully varied) grounding of the four paintings – the stone platform, the scrollwork pedestal, the fallen section of cornice, the grassed-over ledge – could register as *our* grounding. The pictures begin with *terrazzi*, to use the period phrase:[8] steps and footings built into the earth, some solid, some littered and crumbling, but all of them inviting us upwards into the imagined world. From not far below.

Infidelity, to take an example, seems to me immensely more powerful if the final teetering obliquity of the woman is prepared for

from the bottom up – if we get to her elusiveness over the grassy ledge, the slope of ruined brickwork, the man at right bracing one foot on the grass and letting his other heel rest lightly on the bricks' sharp corners. And the same is true, even more strongly, of *Disinganno*. We feel the man's abjection – his lowness – because we get to it from somewhere tangible (heavy and full of matter) lower down.[9] The slab of cornice supporting the man ought to be high in the air, maybe on the roof of the garden temple. Everything upright is where it should not be. The ground is a ruinous stoneyard. Woman is decidedly on top.

Disinganno, I should say in passing, is the one of the four traditional titles that is hardest to translate. The English *Scorn*, which has come to be attached to it, is surely wrong, both visually and philologically. *Disinganno* is a strong Baroque term. It is the moment of being robbed of one's illusions and seeing the actual sad state of things. There is an element of chastisement and self-chastisement to it, and certainly an element of stripping to the bone. 'Disabuse' is as close as we can come to the idea in English, but the word is too weak, too awkward. In this case the Italian should stand.

I realize, of course, that no argument about whether or not these were ceiling paintings is ever going to be decisive. I could bring on pictures by Veronese that are for sure, or were, on ceilings – the work in the Doge's Palace in Venice, or the crowning scenes at San Sebastiano, or even the fabulous oval in Vienna of Marcus Curtius leaping into the abyss (fig. 64) – and try to show that, when Veronese was painting with this kind of viewpoint in mind, his whole sense of orientation and picture plane turned, unmistakably, through 180 degrees or very close. You could still contend that in the *Allegories* he experimented with a strange compromise formation. But the *Allegories*, for me, are Veronese's masterpiece; and masterpieces, I'm convinced, are fundamentally single- (not myriad-) minded. Space and bodies – seeing from below and spellbinding uprightness – are in sync in the four pictures of love;

63. Paolo Veronese, *Apotheosis of Venice* (detail),
1579-80, fresco. Palazzo Ducale, Venice

64. Paolo Veronese, *Marcus Curtius*,
*c.*1550, 221.5 cm (87¼ in.) in diameter.
Kunsthistorisches Museum, Vienna.

they are dimensions of Veronese's thought that exist in tension, not at odds. And this connects to my sense of Veronese's distinctive qualities as a painter, which I see the *Allegories* as summing up.

∽

'A good, stout, self-commanding, magnificent Animality,' writes Ruskin, 'is the make for poets and artists.'[10] Again he has Veronese in view. I would state the case slightly differently. What seems to me the central feature of Veronese's achievement – take the counterpoised bodies in *Respect*, for example, or the bride and naked goddess in *Happy Union* – is a unique completeness of empathy with the figures he paints, so that one feels him almost physically entering into them, male or female, and deploying their weight and balance as if from the inside. Even Titian cannot manage the business in quite the same way. The centre or anchor of Veronese's vision was this: an internal, material, comprehensive inhabiting of bodies, and therefore an ability to depict their glittering outsides as manifestations of their weight, their mechanics: the set of their skeletons, their centres of gravity, their muscle tone. I really do not see any other painter who can do this as well; so that time and again facts of deep structure and self-propulsion appear wholly on the outside of things, in the fall of a drape or the lustre of a fold of fat.

It seems strange that the gift is so rare. But it is rare, perhaps because human beings naturally (biologically) divide experience in two, the inhabiting of the body being something experienced from the inside, and 'appearances' being felt as detached from that lived totality. However we try to explain the norm, what Veronese does is extraordinary: he steps over the dualism as if the division of inside and outside did not occur to him. But of course he knows that outsides, if they are to manifest the whole feel of a complex solid in motion, will have to be somehow supercharged, almost hypertrophied. Hence the famous gaudiness of his surfaces – the shot silk, the rippling silver stripes, the impenetrable

brocade, the special acidity of his greens and yellows. His treatment of fabrics makes sense, I think, the moment one grasps it as a language – a specific high diction – in which internal mobilities and resistances are staged in two dimensions.

Veronese's sensuousness is grave – grave meaning subject to the force of gravity. Few painters put feet on the ground with more of an awareness – built into the brushwork, seemingly – of the feet as load-bearing. (One writer on the *Allegories* points out that several of the protagonists' feet disappear below frame, and this is no doubt one factor in the pictures' creation of 'above-ness'.[11] Yet the feet that Veronese shows us in three of the four paintings – I don't count Cupid's preposterous digits in *Disinganno* – often with their soles visible, braced or hanging in space, are entirely part of an earthbound world.) Damask in Veronese hits the floor with an inimitable soft thud. The weight and thickness of the material are somehow a function of its responsiveness to light. And what strikes me as unique about Veronese's sensibility is not so much his delight in lustre and texture for their own sake as his ability to see even a patterned fabric – the one in *Disinganno*, for example, or that central to *Happy Union* – as a distinctive, essentially singular colour (a specific note in a colour scale) possessing its own kind of heaviness or lightness. Not pink cloth with gold brocading, then, or white with silver stripes and a light purple surcoat, but an entirely palpable gold-rose or silver-grey: the first in inimitable dialogue with the separated gold-yellow and green next to it; the second shimmering exactly strongly enough to answer the folds of orange and gold wrapped around the naked man's groin.

That Veronese was aware of this gift of his, and capable of irony about it, is suggested by the conceit of the fig leaves silhouetted against the white fabric in *Infidelity*. Clearly it is meant to take us a moment or two to disentangle the leaves from their ground, and be sure we are looking at nature here, not culture. There is something scandalous to this, even leaving aside the erotic associations of the fruit. I dare say

Veronese disliked too much illusionism in embroidery. The fig-leaf gown is the strict antithesis of the bride's brocade in *Happy Union*. There, Cupid's hand can disappear into the folds of drapery without anyone getting the wrong idea.

These are particular beauties and shows of wit. But one senses immediately that the episodes are tightly controlled, part of a consistent vision; and this leads on to the hard question in Veronese's case (the Ruskin-type question) of what the inimitable contrasts and tonalities are *for* – what picture of the human they subtend. Not, anyway, a 'hedonism'. Animality, yes; but 'eat, drink and be merry', no. What chilled and bewildered Ruskin (but also had him cheering) was precisely the recognition that Veronese's colour was restrained in its very sumptuousness; that it articulated a heroic and pagan view of the human, in which Christianity had little place, but an extraordinarily tender and compassionate one, which contained within it a deep sense of human vulnerability. This is true, I think, of both the main female figures in *Happy Union* and *Respect*. The nude in *Respect* is protected – not just set off like a jewel – by the great carapace of purple above and white and gold-russet below. The bride's body in *Happy Union* is crystallized – epitomized – by the astonishing transparent purple-tinged lace at her breast: an image of the woman's tentativeness, in dialogue with her gesture and the faint shadow crossing her face.

Frailty – vulnerability – is part of the pageant. That idea is active throughout. The off-balance pose of the knight in *Respect* is one way of putting it; the fallen man in *Disinganno* a more dramatic one; the man on the right in *Infidelity* the idea's moment of comedy.

∽

I said previously that the world of the *Allegories* was built from the ground up, with its bottom few inches – the marble ledge, the grassed earth, the fallen cornice – solid as a rock. This means that, even looking upwards, into a realm meant to register as decisively 'higher', the

bodies Veronese offers seem always entirely substantial, subject to the force of gravity. The bent knee of the nude in *Respect*, and the spread of her breasts, and the planting of her foot, and the soft weight of her stomach – they sum up the artist's materialism.

Ruskin's word 'animality' seems wrong or insufficient, but at least it reminds one that Veronese's attitude to earthly existence did make for a special kind of sympathy and tenderness where four-legged animals were concerned. The dog in *Happy Union* is a case in point, though usually the humour is less broad. I take the bottom left corner of the *Adoration of the Magi* in Dresden to be typical. A dog there is in thoughtful dialogue with a marvellous woolly lamb; the ground they are standing on and sniffing seems to absorb their attention. Of course the pair is intended as a foil for the shepherd in rusty orange directly above, who knows what is truly important in the scene. His uprightness is triumphant, but also, as often in Veronese, somewhat precarious. He has a staff to support him, and two steadying hands, one grasping the end of a wooden balustrade, the other braced against a marble bracket. His sandal rocks on the angle of a stone step, with weight upon it (and shadow cast). And then one notices – this is the true Veronese moment – that in between the lamb and dog there is another planted foot. It is the foot of a second shepherd – and this one, even more than that of his neighbour in orange, shows signs of bipedal wear and tear. Veins flower on the skin round the anklebone. (And up above one sees a final detail. The shepherd with varicosed feet has a bag made of string hanging from his belt, with two or three birds inside it, their heads and beaks poking through the net.)

This kind of exchange between human and animal goes on repeatedly in Veronese. In the great *Christ in the House of Simon* in Turin (fig. 66), the Magdalene's washing of Christ's feet is compared to that of a dog attending to its paws nearby. And another dog in the foreground – dignity itself, four legs planted firmly, colour as solid as the column behind him – overlaps the feet of a beggar, whose partner in the dark-

65. Paolo Veronese, *Adoration of the Magi* (detail), *c.*1570-72,
206 × 455 cm (81⅛ × 179⅛ in.). Gemäldegalerie, Dresden.

66. Paolo Veronese, *Christ in the House of Simon* (detail), *c.*1559-60,
451 × 315 cm (177½ × 124⅛ in.). Galleria Sabauda, Turin.

ness has one foot in a dirty bandage, strapped to a stick. A monkey stares in horror (or is it pity?) at the beggar's stump.

I suppose Ruskin is right that in Veronese the stress ultimately falls on 'the pomp and majesty of humanity, [floating] in a marshalled glory'. But the world of meekness and simplicity and physical disability (as well as casual cruelty and inattentiveness) is unfailingly there at the story's edge.

∽

I have been setting out my view of Veronese's distinctive procedures as an artist, using specific episodes from the *Allegories* and elsewhere to show the procedures in action. But is pointing at random enough? Surely – to return to the *Allegories* – there is some kind of overall structure to the four paintings seen together. I say 'structure', not iconography, since the kind of patterning and mirroring that does real semantic work in the four seems to me formal and general rather than tied to identifiable texts or even typical Renaissance trains of thought. All the same, the iconographers have sometimes had useful things to say about form. In their efforts to imagine a specific layout for the panels on that long-ago ceiling, at least one of them has pointed to the fact that the crisscross of trees in *Infidelity* is continued (roughly) at the left of *Disinganno*, and that the shattered and denuded architecture top right in *Disinganno* paves the way for the great enclosure – the safety – of the palace in *Respect*.[12] The settings of *Respect* and *Happy Union* are linked; there is almost a continuity at ground level. It is possible to imagine Fortuna – the goddess on the sphere in *Happy Union*[13] – as a reappearance of the sleeping woman in *Respect*, sobered up (if that really is an empty flask of wine by the sleeper's bedside) and meeting petitioners on the outside of the building.

I may not believe that such repetitions add up to a narrative, but the idea of the four paintings being divided – into two groups of two – is reasonable. *Infidelity* and *Disinganno* are pictures of love happening in

an outside world, where nature has already largely overtaken a fallen order. How cunningly done the soft down of grasses on the front ledge of *Infidelity*! How hard on the feet *Disinganno*'s stones! And how total the change of key as one passes from *Disinganno* to *Respect*! The spatial disposition of the palace in *Respect* may be perplexing – I shall come to that – but the sense of grandeur and orderliness is overwhelming. The high arch with its mosaic and the grey sky far in the distance; the fall of the drapes; the man's hand as a cut-out against a black and gold brocaded screen; even the crisp profile of the front step – it is all architecture epitomized: architecture meaning permanence, decorum, hard-edged division of spaces. The round stone on its massive base in *Happy Union*, and the sea-green veining of the column behind the goddess, essentially continue the story.

Openness versus enclosure, then, or twisting tree trunks versus perfect sphere: this is one way Veronese envisages the contraries of love. But there are many others, which often cut across the nature/architecture division. The fallen man in *Disinganno* is the mirror image of the woman in *Respect*, and the two central cupids in the same pictures are likewise close cousins; *Disinganno* and *Happy Union* have the same set-up of female/female/male from left to right, though put to utterly different purposes. Three of the four paintings are essentially closed at their right sides, by architecture or drapery or both; even *Infidelity* is hemmed in at right by a great red hanging pinned to a tree. In this respect *Happy Union* seems deliberately the negative term, with an open grey sky supervening. *Disinganno*, looked at another way, is the opposite of *Happy Union* just as much as of *Respect*, with Fortuna's throne and aedicule, top left, replaced by the ruined Pan-temple, top right. Pan and Fortuna make an interesting duo. The head of the knight in gold in *Respect* is rhymed with that of the poet in pink in *Infidelity*; yet there is just as good a comparison, in terms of uninterrupted silhouetting of head against sky, between the knight in gold and *Infidelity*'s femme fatale. But surely the latter calls out to

the bride in *Happy Union* – clothed to naked, embedded to isolated, sacred to profane.

Isn't the groom in *Happy Union* the same figure as the knight in *Respect* (down to his strange flexed fingers), just with beard trimmed for the occasion? Doesn't the main woman protagonist in all four scenes (down to her hairdo and jewelry, almost) seem to move from episode to episode unchanged, taking clothes off and putting them on regardless – till finally she climbs on a sphere to be deified? Is the man on the fallen cornice in *Disinganno* the knight in *Infidelity* next door, stripped of his light-brown top? The drape round his midriff looks similar.

Questions accumulate. Veronese, like the rest of us, seems to begin thinking by means of binaries: male/female, nature/architecture, naked/clothed, upright/fallen, noble/base. But the opposites lead on to crossings, half-rhymes, echoes, borrowing of features. Equivocation – balancing between possibilities – is the key to the artist's ethics. We sense the woman in *Infidelity* still feeling for a balance she has lost. She is leading the men a dance, for certain (and sometimes I fancy the men, too, are holding hands, so the dance is really interminable), but she needs their support. The man at right appears to be holding her steady. The woman in silver-grey in *Disinganno* is not quite ready, by the look of it, to be led away by Chastity from the man's dazzling abjection.[14] And who can blame her? Her friend is a pallid ghost of a woman, whose profile is doubled, somewhat cruelly, by that of the stoat in her lap. The way of virtue has a washed-out feel. The man on the ruined cornice, by contrast, is the power of illusion personified. In a great working drawing for the *Allegories*, now in the Metropolitan Museum in New York (fig. 67), one sees Veronese experimenting with the figure – one, two, three, four, five times (remarkably for him) – till he hits exactly the right measure of foreshortening to trigger the viewer's empathetic participation.[15] And the angle he chooses is perfect. One feels the stone and the orange drapery under one's shoulder blades. And then finally one notices – typical Veronese – that the man's head

67. Paolo Veronese, studies for *Allegories of Love*,
c.1570-75, pen and ink, 32 × 22.2 cm (12⅝ × 8¾ in.).
Metropolitan Museum of Art, New York.

is casting a shadow across the last section of the cornice. Immediately his head moves closer to the picture plane. The trap of illusion – of presence, proximity – snaps shut.

You see that I cannot stop myself from moving again from discussion of structure – of possible overall patterning in the group – to particular episodes and exchanges. And this is right. Of course it makes a difference that we look at the woman in *Disinganno*, as she assesses what to do in the face of a fallen man's erotic agony (you will notice that the bow Eros is using to administer punishment is coloured pink, and the whiplash of bow-string is glittering gold) with an awareness that opposite, in *Respect*, roles and genders are reversed. But the foursome as a whole is very much not, in the end, a logical or topological transformation set. For the actual viewer, if my experience is anything to go by, it is not the 'positionality' of each encounter – its place in a grammar of doublings and reversals – that matters most. It is the particular materialization, the embodiment. The exact angle of the woman-in-silver's look downwards and across. The inimitable ambiguity of her expression. The way she is holding but not holding Chastity's hand. Her other hand disappearing into the light mauve mantle. The heaviness and resilience of her breast.

<center>∽</center>

Nonetheless, I would be doing Veronese an injustice if all this chapter managed was to chronicle local feats. For Veronese, like all great thinkers, moves in the end (from the beginning) towards totality: he sees the whole picture. In particular, he sees space. He does not conceive his particular bodies and interactions as separate from the space they move in. And that space has to be given a specific character: it has to be a main actor in the drama. It, if anything, will be what allegorizes Eros.

I go back to the question of viewpoint and divide it in two. I want to look first at viewpoints and orientations as they occur within each picture's fictive space, and then return to the way the space as a whole

in the picture – and the action within that space – connects to us as viewers on the ground. In practice I shan't be able to keep the two dimensions of the problem separate, but it is worth trying to.

Focus on *Infidelity*. Of the four *Allegories*, this is the one that takes most profound advantage of a basic fact of the paintings: that they are all almost perfect, and almost identical, squares, in this case 74¾ by 74¾ inches. A square encourages an equal, contrapuntal weighting of elements within the pictorial field, while also allowing each side of the picture to be dramatized or reiterated by forms close to it, making its presence felt. A square goes along with intricate balance, fourfoldness: the to-and-fro of evenly stressed, approximately rhyming shapes, perhaps around a central fulcrum. All of this happens here. The dialogue between the human limbs and the tree limbs has always been admired. It is beautiful, and produces ambiguity. Where any of the actors stands in relation to the forest clearing soon comes to matter, and to be a problem – maybe particularly the nature of the interval between the woman's hairdo and the leaves so close to it. And this uncertainty spreads. Writers on *Infidelity* have often been aware – Michael Podro most eloquently[16] – that Veronese's main way of conveying the uncertainty of 'positions' in the circuit of love is by drawing the viewer into a game of ungraspable orientations. The woman's back, shoulders and arms are at the heart of this: the little wingless boy holding his mistress's shin seems to be present mainly to reiterate the colour and modelling of her musculature, but his back is turned just a little more towards the picture plane, which makes the elusiveness of *her* back, higher up, all the more noticeable. In any case, the elusiveness is everywhere. The stump of ruined brickwork concentrates the enigma. At what angle does it recede from the picture plane? How does the woman sit on it? Is she sitting at all, or getting to her feet? But then what about the cherub hanging onto her calf? The man at the right *is* sitting, unmistakably, but how? How are we meant to read the lean of his upper body? Or the strange angles of his two lower

legs? Or the tilt of the sole of his boot? And we know already that the
pink poet won't help us. His swaying back and looking up are part of
a world off kilter.

The trees amplify the indecision. At one moment they twist grandly
back into space, providing the figures a stately canopy; at the next they
flatten into symmetries and repetitions of pattern. So the fig-leaf sapling
is really a miniature – an intensification – of the picture's whole either/
or. Even ground level participates in the dance. It is important that
the grassy bank in *Infidelity*'s foreground, which I have said is enticing,
is offered to us just slightly on a slope – in contrast to the hard and
sharp horizontals in *Respect* and *Happy Union*. Perhaps the side of the
clavichord at left was introduced – at the last minute, it seems[17] – to
give the viewer at least one right angle in a world of shifting obliques.
But the shape is too small to act as a spatial anchor. Cupid looks up
from his instrument in something very like alarm. (A frowning cherub
is a rarity.) When is anyone in this game of love going to straighten
up and find a rhythm?

Maybe an anti-Ruskinian would say that this elusiveness is simply
the result of *Infidelity* taking place out of doors, in the grand mobil-
ity of nature. Veronese is just being casual with his spatiality – lordly,
florid, free and easy. But much the same happens when we move inside.
Respect is a beautiful, trustworthy structure, but I defy anyone to draw
its elevation and ground plan. How far back is the grand arch with its
stucco and mosaics, and how are we to understand the angle of its cur-
vature and the depth of its recession? Does it connect with the cornice
below to the right? How is there room on top of the cornice for a flask
– maybe of wine – to rest?[18] Presumably the flask is within reach of an
upright human. How does that tally with the general sense we have of
the architecture's scale? Why did Veronese mask the stonework below
the cornice with a second, hyper-elusive surface – a screen, by the look
of it, since the thing's edges are too hard and straight to belong to a
hanging – covered in a pattern of gold and black? The knight's hand,

picked out dryly, electrifies this dark field. Down below, on the outmost edge of visibility, the screen is interrupted by one of the cupid's wings. (Maybe the gold and black are meant to be a bed-screen, which the woman has forgotten to erect – or which the cupid has pulled aside.) And how – finally, quintessentially – is the knight in gold meant to be moving from level to level within the building? Where is he standing, exactly, and how does he steady himself? (Compare the invisibility of his feet with cupid's peek-a-boo toes.) The knight is one of Veronese's triumphs: we shall return to him. Suffice it to say, for the time being, that the figure participates fully in the strangeness of the space he has just entered.

Here is the moment to step back – and, above all, to step down. For it matters profoundly, to repeat, that we are looking *up* into the worlds of *Respect* and *Infidelity*, and that this angle of vision tempers and complicates our whole response. The viewpoint does not cancel the uncertainties of orientation I have been pointing to – part of what produces the elusiveness of the naked woman's back and shoulders in *Infidelity* is the angle at which we approach them – but it gives them a different weight. It asks us to accept grandeur and precariousness simultaneously. Not as aspects of a world we can never hope to enter – everything I have been saying about Veronese's physicality makes such lack of involvement unthinkable – but of one just out of reach. Familiar and tangible, but also superhuman. This is the pagan balance to be struck.

There is obviously something wonderful in general, and appealing to all sorts of painters, about showing a scene from below its ground level. The view up intensifies and makes strange. The great formal idea of the *Allegories* is to take that angle of vision, with all its potential of magnification and estrangement, and put it at the service of a completely earthbound view of life.

Always in the *Allegories* we are looking from low down, not into an utterly sublimated, superior space of the gods, but into a great construction: a clearing or a portico whose scale and logic are slightly (meaning decisively) beyond us. Sometimes, as in *Disinganno*, the construction has toppled or crumbled, and kinds of unruliness have taken over; but even they are to be experienced in relation to the rule and balance implicit in the fragments. Rule and balance; but not a rule and balance we shall ever quite understand – that the pictures will spell out to us. We are not meant to know what the knight in gold or the woman in silver are about. Our viewpoint is our not knowing.

But again, it does not follow from this that the *Allegories* put us out of touch with the world above. It is just above us, not floating in the void. We have stumbled into the world of love in a way not unlike the knight in *Respect* halfway up the palace steps. What is his stance towards the woman whose nakedness he has happened upon? Attracted, obviously, but at the same time stepping back, resisting Eros's encouragement, taking a distance, holding a balance, *seeing enough*. His pose is a set of instructions, as it were – a template for the kind of viewing we are meant to undertake from our place below stairs.

Veronese offers us almost nothing in the *Allegories* by way of perspective clues. No ground planes, no graspable orthogonals. For a moment *Respect* might seem to, but its space is a house of cards. And yet the *Allegories* are profoundly perspectival paintings, in the wider sense of the word. They are projections, from a viewpoint – our viewpoint – that is felt to be discontinuous from (non-identical to) the lived spatial world of the scenes' inhabitants.[19] The lowness of our vantage point means we shall never be able to claim imaginary authority over the worlds above us, even though they are projected from where we are standing; but nonetheless the oblique perspective means – and isn't this at the heart of the pictures' strangeness? – that the world up there (the spatial container) does not simply belong to the actors within it, steadying themselves in relation to its coordinates. Space

is absolute. Not even heroes possess it. Not even goddesses perched high on stone.

Seeing from below, then, in Veronese's hands, is seeing as if from outside. It is not the outside of detachment, and certainly not of awed inferiority. Perhaps we could just describe it as the outside of unfamiliarity. We look up at the human comedy and are aware, above all, of its physical, spatial dimensions. Standing and falling, balancing and unbalancing, the brick stump and the marble sphere. Familiar and tangible, to repeat, but also transfigured. Only a painter who had made it his life's work to set up worlds that would register as fully and naturally equivalent to ours – worlds of mass and proximity – could have put things at a distance in just this way.

∽つ

Viewpoint and orientation, to sum up, are two main modes of a great artist's thinking of space. But they are far from being the only ones. Light, so painting in general never tires of telling us, is just as important a conjurer of spatiality. And shadow, too – especially cast shadow, which seems to point immediately to light's trajectory, light's strength. Painters do not make space primarily with lines, or even containers. They make it by showing bodies intercepting photons. We are back in the world of the *femme-colonne*.

Veronese in the *Allegories* is a master of cast shadow – but the mastery is of a very special kind. The shadows in question, for all their beauty (as part of their beauty), take some seeing. They are very unlike, say, the show-stopping crux at the centre of Rembrandt's *Night Watch*. Veronese's shadows tend to emerge unexpectedly from the warp and weft of his colour. Once we have seen them, however, we understand that many things depend on them. We can hardly believe there was a time when they were invisible.

One example of this has already been noted in *Disinganno*: the strange inspiration of the fallen man's shadow on the cornice, and all

68. Rembrandt, *The Night Watch* (detail), 1642,
379.5 × 453.5 cm (149⅜ × 178½ in.). Rijksmuseum, Amsterdam.

that this patch of shade then does to our sense of the man's proximity. Of course the shadow works so powerfully on the viewer here partly because Veronese, in the rest of the picture, has given us such strong, abbreviated clues to the intensity of the sunlight – on the agonized fingers of both the man's hands, for example, or his upturned face and the folds of his orange cloak. There are other analogous instances. Look at the face of the bride in *Happy Union*, and notice again the smudge of shadow passing across it – perhaps cast by Fortuna's forearm, or even the bridal wreath she is holding out. And then come to realize that what one first unthinkingly takes as *attached* shadow on Fortuna's stone sphere, coming in from the sphere's outer edge, is actually a discrete shape of *cast* shadow, with the sphere re-entering the light

Detail from fig. 61: Paolo Veronese, *Respect*, c.1570-75,
186.1 × 194.3 cm (73¼ × 76½ in.). National Gallery, London.

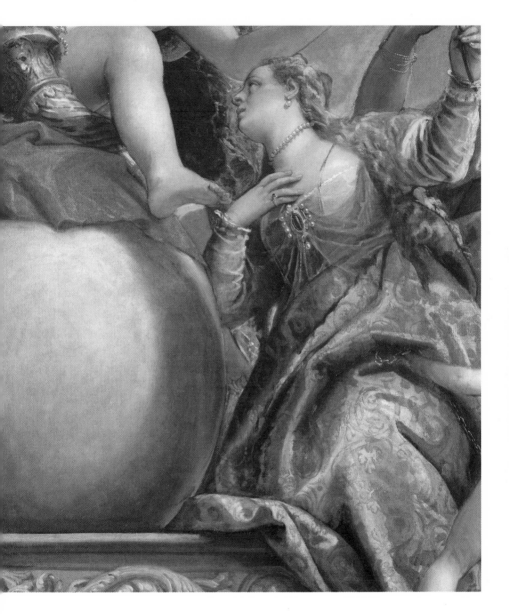

Detail from fig. 62: Paolo Veronese, *Happy Union*, c.1570-75,
187.4 × 186.7 cm (73¾ × 73½ in.). National Gallery, London.

on the other side of it, top right. It must be – gentle anamorphosis, this – the shadow of the bride's body.[20] We turn back to *Respect*, and our eyes go immediately to the knight's arm and hand against the grey sky and the dark brocade. Notice the line of dry white drawn in one movement along the arm's upper edge. Not for the first time we ask ourselves how the arm is hinged at the elbow, and how far forward in space – forward as well as laterally – the hand is reaching. Then we see the anti-*Night Watch* moment. The arm is there, as cast shadow, moving back across the knight's gold stomacher; one edge of its soft negative almost touches the navel. It is a ghostly apparition.

These are tours de force of painting; but in contrast to Rembrandt's they are strong exactly in their lack of emphasis, their refusal to point and dramatize. Here is where I feel a touch of Ruskin vertigo coming on. I know, with the shadows on the sphere and the gold stomacher, that I am being asked to attend to some daunting pictorial thought. I am moved by the thought. I believe a whole view of the human is being proposed by it. But what view is it, and why is the view so moving? At this point I clutch at straws.

Light in the *Allegories* – straw number one – gives the impression of being fairly bright and informative (*Infidelity* is a little flat and faded, as if its surface has suffered over the years), but this does not mean that the source and direction of the light are clear. It appears in all four paintings to be coming from the right and above, but whether from in front of the picture plane or from the side is a delicate question. Perhaps the light in *Infidelity* is imagined as passing through the picture plane from high up. In *Disinganno*, by contrast, it seems to enter from the rear, but fitfully, inconsistently, picking things out at random: fingers, a nipple, Eros's forearm, the satyr's smashed thigh. Where the light comes from in *Respect* is a mystery, which the cast shadow on the stomacher only deepens. The same for *Happy Union*. Putting together the grey on the sphere and the grey passing over the bride's face, or for that matter the light and shade on Fortuna's cornucopia, or the gloom of shadow

on her torso, or even the fabulous grey sole of her hanging far foot, just glimpsed in the gap between sphere and bride's gown ... making these shadows all come from the same sun – well, I cannot do it. And I have the feeling this is my problem, not Veronese's. I cannot keep in mind all the possible variables – of location, orientation, topology, reflectiveness and so on.[21] But he could, I am sure. He knew how much complexity would serve his turn.

So the shadows themselves are elusive and emerge from the overall colour matrix in a very special way. And when they do, they tend to complicate our sense of how light is behaving, and how (or whether) it falls and crosses and totalizes space. Perhaps the best way to get a handle on this is to face directly the comparison with Rembrandt that has been haunting my discussion – specifically with the shadow of the hand in the *Night Watch* as interpreted by Merleau-Ponty.[22]

I did not mean to be condescending when I called the shadow in the *Night Watch* dramatic. Light and shade are often dramatic. Rembrandt's relish for them is understandable; it is Veronese's pushing them to the edge of the perceptible that needs explaining. Merleau-Ponty believed that the shadow of the captain's hand in the Rembrandt is a strong instance of what painters do habitually when they are good enough, which is to show us the actual process, the optical conditions, for a thing becoming tangible (or at least three-dimensional) in vision. According to the philosopher, the hand – any hand – as the retina registers it becomes a reality for the mind, with a felt location in space, only by means of an immediate, intuitive putting-together by each viewer of its foreshortened and profile aspects, or its shape and projection. Rembrandt's is no more than a striking case of the kind of triangulation that constitutes vision all the time. Painting is about showing the elements in the equation, but also about showing the result: having the hand materialize out of its manifold appearances.

Is this what happens in Veronese? I don't think so. We go back, inevitably, to the shadow on the gold stomacher, which so much

anticipates Rembrandt's, but which perhaps, once we have got used
to it, makes Rembrandt's seem a little overwrought. Even the gilt
on the lieutenant's dress uniform comes to seem a bit bourgeois in
comparison. (Of course that was partly Rembrandt's point.) Does the
cast shadow on the armour call the knight's actual arm and hand into
being, à la Merleau-Ponty, giving them suddenly a spatial life, a specific
orientation? I doubt it. It seems rather to multiply the uncertainties we
already have – and they are at the heart of our response to the knight
and his movement – about the line of his arm, the forward dynamic of
his stride, the exact measure of pressure exerted against that forward
motion by the knight's shadowy companion, the backward lean of the
knight's body, his whole negotiation of the step. It matters, of course,
that in contrast to Rembrandt the shadow here is cast back onto the
knight's own body, not somebody else's. One might feel that, ultimately,
the shadow is a figure of the knight's self-restraint: the double of his
forward-pointing arm, but now pressing gently against his onward
motion. It is, as it were, the third arm of his restraining counsellor to
the left. The super-ego of the superman.

What the shadow materializes, then, is not the simple presence of
the body – the part of the knight that Eros is urging on – but the play
of inhibition and equivocation that lies at the heart of desire. The knight
is not merely remembering his duty as a gentleman. He has come on
the object of his desire too abruptly. He is recoiling from it: denying
it, disavowing it. Freud would have loved the glassy fixity of his eyes,
and the fact of their staring, like the pink poet's, off into space. Men
regularly stare into space, Freud thought, when women take off their
clothes. They'd rather not see the nothing that is there.

So the shadow in Veronese is not, as in Rembrandt, a guarantor – a
conjurer – of presence, but truly a shade of that presence, a double, an
undercurrent, a familiar. There is a sense in which the shadow on the
stomacher seems even to reach inside the knight's body and demateri-
alize his hard carapace. It is tragic and touching, this will-o'-the-wisp,

especially compared to the comedy of Eros's hand on the knight's sword, urging battle, or the frightful little frog's mouth and goggle eyes down at the knight's waist. Shadow is not negation here – there are no negations in Veronese's universe – but it is interception, distortion, almost disfigurement. None of which threatens the pageant: it serves to give it depth.

Can the same be said of the shadow on the sphere in *Happy Union*? Yes, partly. Certainly the shadow confirms, and intensifies, the three-dimensional presence of the form that casts it. We read back solidity from the shadow to the bride. (The bride is more firmly embedded in a mass of bodies than any other figure in the series.) But is 'intensifies' the right word? Couldn't the shadow as well be seen as a figure simply of the *strangeness* of three-dimensional being? It is and is not the shape of the woman. It is an indeterminate projection of her uprightness, her mere verticality, onto a surface that immediately conjures that uprightness away – though not dramatically, not wickedly or playfully, not with the force of an anamorphosis.

This is a fine balance. Certainly the shadow on the sphere is not belittling or paradoxical: it is not an episode from a fun house. But it does ask us, gently, not to equate the human body with the massiveness – the indubitability – of the regular stone volume. The sphere cannot lend the body its own material perfection.

Perhaps the dialectic goes further. The shadow seems, if anything, to confirm the form of the sphere, not of the body that casts it. This remains true even when one notices, as we have already, that the shadow marks out the shape of the stone deceptively, at least to first sight. It misleads us, for a second or two, about the sphere's actual curvature. The sphere and the shadow together do have effects, of course, on our apprehension of the bride: to repeat, they solidify her; they speak to her actual stopping of the light. But at the same time they move her away into a world where identities are only projections, intersections, shapes on surfaces we cannot always trust. We have again entered a world – as

with the arm on the armour – that is not quite like the world of fleshly positivities summed up, so naively, in the body of the goddess seated above. Between Fortuna and the shadow – Fortuna and the sphere as disturbed by the shadow – a great Veronese dialogue is taking place. (And, of course, the instability of spheres – their tendency to wobble and topple – is part of Fortuna's story.)

This is a Veronese dialogue, and therefore the negativity of the shadow is not dwelt on. One can imagine him reading 'A Lecture upon the Shadow' of his near contemporary Donne, and being happy with the poem's affirmative opening lines:

> These three hours that we have spent,
> Walking here, two shadows went
> Along with us, which we ourselves produced;
> But, now the sun is just above our head,
> We do these shadows tread;
> And to brave clearness all things are reduced.[23]

'Brave clearness' is the overall note in *Happy Union*. None of the alternative intuitions that follow from the recognition of the shadow as the woman's is at all stressed. Paradox is foreign to Veronese's frame of mind. This is the quietest – most blurred – of dialectics. But it is dialectics, and in it the sensuous presence of the body is put in play – gently, almost surreptitiously – with the shadowiness of its passing. Again, the *femme-colonne* is close.

There is one dimension of the *Allegories* that I should try, finally, to face head on, though really I have been talking about it from the beginning. It is the *Allegories'* view of gender. When love is at issue in Veronese, which sex has the upper hand? Who is the actor and whom the acted upon?

You will not be expecting a simple answer. Even at the level of mere 'positionality', it is clear that Veronese thinks dominance and submission, or uprightness and prostration (or being on top, to put the matter instrumentally), go constantly from male to female as the game of love proceeds. Nakedness does not necessarily mean subjection. Fortuna sits higher than any other actor in the plot; the picture rectangle can barely contain her. As for the woman in *Infidelity*, is there another naked woman in the history of art who so dictates – handles, balances, orchestrates, prestidigitates – the terms of her own exchange between men? This does not mean, as I see it, that Veronese falls back on the courtly love cliché of mistress as impassive ruler. The woman in *Infidelity* may be dominant, but she depends on the men she manipulates for support. Both her cherub companions seem worried about her ability to go on holding the pose. The woman in silver-grey and mauve in *Disinganno* does not seem to be gloating over the naked man's downfall. She has seen – or almost seen (the orange drape does a little concealing) – what, behind the flowery phrases, men always want. It is a sobering experience, but whether the conclusions Chastity has drawn from it are at all the right ones remains in doubt. In due course *Disinganno* may prove to have been part of growing up.

Veronese is a realist. He knows that the balance of power in sex, in the world he belongs to, lies ultimately with the male.[24] But exercising that power is a risky business. Sex is comedy. *Infidelity* speaks to that: the man on the right, so the costume historians tell us, has stripped down to his under-armour, and by the look of it he lacks trousers. Again, golden folds conceal his genitals. This is a scandalous scene in general; but even in *Happy Union* the man in the set-up seems to be slightly overdoing things. It is not for nothing that his profile is rhymed with that of Fido bottom right. The tilt of the bridegroom's head, and his look of devotion, and above all his hand gestures lack conviction: they are like bad stage-managed versions of those of the knight in *Respect*. And never has an artist taken more wicked advantage of the opportunity

cupids and putti offer to show the viewer miniature penises as comic substitutes for those kept under wraps. Penises, not phalluses: no male in the *Allegories*, we could say, is put in possession of the phallus, even metaphorically. The satyr's limbs are broken, the Pan pipes a cumbersome toy. Cupid's arrow, in *Respect*, is exquisite but far too small. He knows it: he seems to be urging the knight to take his sword out of its sheath. And that is just what the knight is deciding not to do.

Insofar as the four paintings allow themselves a moment in which the sheer glamour and fascination of the sex organs is celebrated, then surely it is in the bottom right corner of *Respect*. And the metaphor, when it comes, is wild, florid, flagrant; even Courbet is seldom so shameless.[25] The sleeping woman's fingers pressing the folds of drapery; the fig leaves in the appropriate position in *Infidelity*; even the cornucopia in *Happy Union* pouring its bounty from between Fortuna's legs … I have been saying Veronese was not a hedonist: that doesn't mean he lacked a vision of pleasure.

But again, to end on this note would be wrong. I still think the figure that crystallizes Veronese's world-view is that of the knight. I believe, as I have said, that the knight's extraordinary off-balance posture is the form the artist gave to his deepest thinking about human choices, human ethics and responsibilities. But of course built into these is a layer of reflex, appetite, recoil. Ethics and instincts are transforms of one another. Part of the knight's enormity and pathos derives from the fact that he is so palpably converting a somatic, automatic equivocation into something more human and discursive. He is, first of all, merely a male face to face with a woman's nakedness. And on one level he follows the Freudian script. He hesitates. He sees and does not see. He sways backward but reaches out to touch. He is the hand and the hand's shadow. The little Eros, with his pre-Freudian view of sexual dynamics, is not finding the right words to rouse the knight from his

trance. The grey counsellor at left seems to be offering consolation as much as good advice. Once or twice I have called the knight's stance on the steps off balance. But this isn't quite right. His movement is decentred, certainly – subject to many holds, pulls, impulsions. But of course in the end it steadies itself. The hand set off by the black and gold brocade – that tour de force of spatial suggestion, put at the picture's plumb centre – is an anchor, a fulcrum. Sex in the *Allegories* is always stopping itself in its tracks. Loss of nerve and *Disinganno* are written into its very fabric. But that exactly does not mean, for Veronese, that it lacks grandeur. It has grandeur enough. 'A good, stout, self-commanding, magnificent Animality', to quote Ruskin again. We could go on quarrelling about the adequacy of the final noun here: 'animality' and 'humanity', as applied to Veronese, seem to me names for much the same (exceeding) thing. Neither word quite touches what Veronese is proposing. But Ruskin's four adjectives, with their flavour of Homer's or even Shakespeare's paganism, are close to the mark.

I look for a voice to push Ruskin's argument further and come up with Nietzsche. Here is the passage from *The Will to Power* touched on in my Introduction, this time quoted in full:

Such an experimental philosophy as I live anticipates experimentally even the possibilities of the most fundamental nihilism; but this does not mean that it must halt at a negation, a No … It wants rather to cross over into the opposite of this – to a Dionysian affirmation of the world as it is, without subtraction, exception, or selection … the same things, the same logic and illogic of entanglements … So I have guessed to what extent a stronger type of human being would necessarily have to conceive the elevation and enhancement of the human as taking a different direction: higher beings, beyond good and evil, beyond those values which cannot deny their origin in the sphere of suffering, the herd, the majority – I sought in history the beginnings of

this construction of reverse ideals (the concepts 'pagan,' 'classical,' 'noble' newly discovered and expounded –).[26]

That there are dangers to Nietzsche's enhancement of the human we do not need reminding. The word 'herd' in this passage is unforgivable. 'Beyond good and evil' became a catchphrase for killers. And Nietzsche himself, we may think – leaving aside the grotesqueries of his worst readers – is still in the grip of a dream borrowed from the religions he wished to eradicate: he, too, with St John the Divine, cannot think the elevation and ennoblement of the human without imagining a humanity freed from 'the sphere of suffering'.

This is where the muteness of painting – its easy largeness, its obvious artificiality – may help release us from the spell. For Veronese in the *Allegories*, I've been arguing, provides us with a way to think heroism – think elevation – without the Nietzschean dangers necessarily overwhelming us. Look back – look up – at *Disinganno*. *We* are the ecstatic and foolish male on the smashed cornice; but also the woman on the hill, pivoting and rebalancing as she looks, one breast exposed by the movement, her face a study in inquisitiveness and calm. She takes the measure of the human comedy. The woman in *Infidelity* is her cousin. These are higher beings, we recognize, but 'higher' here means the opposite of pitiless or invulnerable. 'The same things, the same logic and illogic of entanglement'. 'More of Man, more of awful and inconceivable intellect'. 'The beginnings of this construction of reverse ideals'. I am with Nietzsche and Ruskin, those necessary madmen, in thinking such a construction more than ever what we need.

Picasso and the Fall

Two world wars in one generation, separated by an uninterrupted chain of local wars and revolutions, followed by no peace treaty for the vanquished and no respite for the victor, have ended in the anticipation of a third World War between the two remaining world powers. This moment of anticipation is like the calm that settles after all hopes have died. We no longer hope for an eventual restoration of the old world order with all its traditions, or for the reintegration of the masses of five continents who have been thrown into a chaos produced by the violence of wars and revolutions and the growing decay of all that has still been spared. Under the most diverse conditions ... we watch the development of the same phenomena – homelessness on an unprecedented scale, rootlessness to an unprecedented depth.

It is as though mankind had divided itself between those who believe in human omnipotence (who think that everything is possible if one knows how to organize masses for it) and those for whom powerlessness has become the major experience of their lives.

Hannah Arendt, Preface to *The Origins of Totalitarianism*, 1950[1]

When Hannah Arendt wrote a new preface to *The Origins of Totalitarianism* in 1966 and looked back at her original judgment of the state of Europe, she was a little apologetic. *The Origins* had been drafted between 1945 and 1949, and in retrospect it registered, she thought, as a first effort to understand what had happened in the opening half of the twentieth century, 'not yet *sine ira et studio*, still in grief and sorrow and, hence, with a tendency to lament, but no longer

in speechless outrage and impotent horror'. 'I left my original Preface in the present edition in order to indicate the mood of those years.'[2]

One understands her unease. Already by the mid-1960s, the moment of *The Origins of Totalitarianism*'s new edition, the tone and even the substance of her 1950 reckoning with fascism and Stalinism had a period flavour. The world – at least, the world of European and European-in-exile intellectuals – had decided that the twentieth century's long catastrophe was over. Many thought that 1962, the year of the Cuban Missile Crisis, had marked its ending. And whatever crisis of civilization had succeeded the earlier mass slaughter – Arendt and her friends were far from certain how to characterize the new situation, and certainly not inclined necessarily to see it as a respite from ongoing 'decay' and 'powerlessness' at the level of civil society – it could no longer be written about (or depicted) in epic terms. The fall of Europe had happened, tens of millions had perished; but the fall of Europe had not proved a new fall of Troy. After it had not come the Savage God. Maybe, as the preface goes on to say, 'the essential structure of civilization' had broken; but the breakage, in the years after 1950, had failed to give rise to a new holocaust or final nuclear funeral pyre. In place of the banality of evil had arrived the banality of Mutually Assured Destruction.

⌐⊃

'Two world wars in one generation, separated by an uninterrupted chain of local wars and revolutions': perhaps it goes without saying that, for Arendt's generation, the revolution that had summed up the previous horror – staging, as it had seemed to, the essential combat between fascism and Communism with special concentrated violence, and drawing into it Left and Right partisans from across the world – was the Civil War in Spain. It was, for them, the epic event of the mid-twentieth century. Picasso's *Guernica* had given it appropriate, unforgettable form.

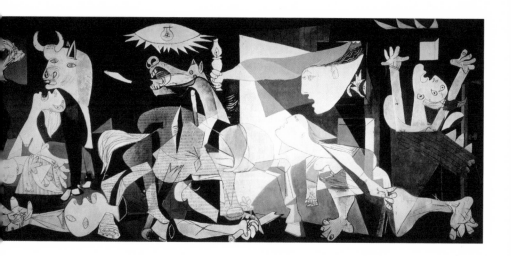

69. Pablo Picasso, *Guernica*, 1937, 349.3 × 776.6 cm (137½ × 305¾ in.).
Museo Nacional Centro de Arte Reina Sofia, Madrid.

The painting still does, of course. Arendt may have been right to feel a twinge of embarrassment at the tragic, exalted, 'catastrophist' tone of her 1950 description, and to have thought by 1966 that the fate of mass societies in the late twentieth century needed to be approached in a different key. But her rethinking has not carried the day. The late twentieth century, she argued, would truly confront itself in the mirror only if it recognized that the battle for heaven on earth (the classless society, the thousand years of the purified race) was over. It had given way (this is Arendt's implication) to a form of 'mock epic' or dismal comedy – still bloodstained and disoriented, but divested at last, by the evidence of Auschwitz and the Gulag, of the deadly dream that 'everything is possible'. And it is this post-epic reality we should now learn to live with, she believed – maybe even to oppose. We shall do this, says her second preface, only if we manage finally to look back on the hell of the totalitarian period with thorough bemused disillusion. We have to learn how *not* to allow the earlier twentieth century to stand for the human condition. We have to detach ourselves from its myth.

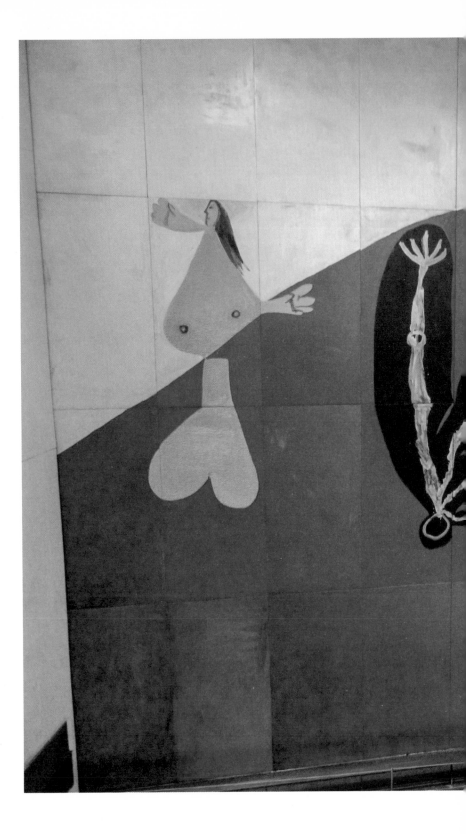

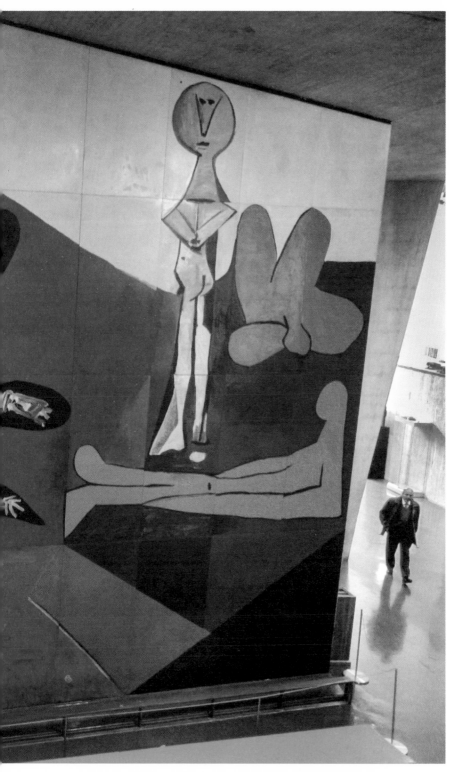

70. Pablo Picasso, *Fall of Icarus*, 1958, acrylic on forty wooden panels, 910 × 1060 cm (358¼ × 417⅜ in.). UNESCO Bâtiment des Conférences, Paris.

But detachment has proved impossible. *Guernica* lives on. Or, to put it more carefully: what is striking about so many twenty-first-century societies, especially those involved directly in the wars and revolutions Arendt had in mind, is the fact that they go on so stubbornly living – at the level of myth, of national self-consciousness, of imagined past and present – in the shadow of an already distant past. It is their fantasy relation to the struggle of fascism and Communism that continues to give them or rob them of their identity. Germany remains the prime example, in its interminable double attachment to (its guilt at and caricature of) the pasts of Nazism and the Stalinist 'East'. Russia – with its neo-Bolshevik hyper-nationalism – is the paranoid case of entrapment forever in the moment of Stalingrad. Britain's endless replaying of its 'finest hour' stands in the way (as it is meant to) of any real imaginative reckoning with the deeper, morally compromised, past of Empire.[3]

Picasso's *Fall of Icarus* (fig. 70), done in 1958, is a defining and appalling statement of Arendt's post-epic perspective. It aims to put the era of *Guernica* – that is, of heaven or hell on earth – behind it.[4] And it does so in a context that lies at the heart of the post-war, 'international community' reality of the 1950s: the just-finished headquarters of the United Nations Educational Scientific and Cultural Organization in Paris. *Icarus* was commissioned for the hallway of UNESCO's Bâtiment des Conférences, and first shown to the public there in November 1958, the moment of the new building's inauguration.

Picasso's proposal – his vision of the form to be taken by history painting in a post-*Guernica* age – has never been much liked or understood. The literature on the artist largely leaves it to one side: the Communist pantomime he did of *War in Korea*, or the exacerbated repeat of *Guernica* in the Temple of Peace at Vallauris (fig. 80), Picasso's hometown for most of the 1950s, are given more sympathetic attention.[5] No one – Picasso included – has ever had a firm idea of what the

71. Interior view of the UNESCO Bâtiment des Conférences, Paris, with Picasso, *Fall of Icarus* in place.

UNESCO mural was of. UNESCO itself, in the literature produced for the inauguration, said it showed 'the forces of life and the spirit triumphant over evil' ('les forces de la vie et de l'esprit triomphant du mal'). Maurice Thorez, leader of the French Communist Party in the 1950s and a regular visitor to his most famous party member – Picasso and he seem to have had a genuine friendship – noted in his diary that the mural showed 'the triumph of peace over the forces of war'.[6] Thorez had been present at the unveiling of *Icarus* in Vallauris in March (fig. 72) – the mural was shown outdoors, under a crude canopy in the school-yard – but it seems doubtful that his title conveyed Picasso's intention at all accurately. When Georges Salles – old friend of Picasso, scholar

72. Picasso, Cocteau and Thorez at the inaugura-
tion of the mural in Vallauris, March 1958.

of Asian art, and by 1958 head of the French museum establishment
– called the scene 'The Fall of Icarus' in his speech at the painting's
installation in Paris a few months later, it was unclear to his audience if
he was acting with Picasso's sanction or not. Salles, we know now, had
been at the earlier Vallauris launch and suggested a title then: 'Icarus
of the darkness' ('L'Icare des ténèbres'). A journalist for Radio Geneva
had asked Picasso directly at the time: 'Master, do you really think that
this is Icarus of the darkness?' To which Picasso replied:

Yes, I find that George Salles's thing is very exact, more or less
– because a painter paints and doesn't write – it's more or less
what I wanted to say ... It went on for months and months,
and little by little it was transformed without me even knowing
where I was going, d'you follow? – It began as a studio where
there were pictures, it was my studio where I was in the process
of painting, you understand? – And little by little the picture
ate up the studio, there was nothing left but the picture, which
said – which expressed – things I was master of but not acting
of my own free will [*des choses dont je suis le maître mais pas
volontairement l'acteur*].[7]

The interviewer then turned to the poet and filmmaker Jean Cocteau,
asking for his impressions. Cocteau's reply is indicative: he seems
immediately to struggle between the epic and post-epic frames of
reference that the new mural put in question – hanging onto the
possibility of history and tragedy, but glimpsing (his voice lapsing
into silence as he tries to articulate the thought) a future with no
such frame:

Well, for me, it's the curtain that rises on an epoch, or falls on
an epoch, that's for the public to decide. We have lived a tragic
epoch, we are going to live another, it's either the curtain that
falls on a tragic epoch, or the curtain that rises on the ... the
curtain for the prologue to another tragic epoch. But there is a
great tragedy in his fresco. It's a diplodocus, it's the last terrible
animal from an epoch we have just traversed, which moreover
was very great, but very terrible.[8]

Cocteau is followed by Georges Salles himself, whose reinterpretation
of his own Icarus suggestion is a masterpiece of 'international com-
munity' waffle:

On the wall, what did I see? I saw that UNESCO had at last found its symbol. At the heart of UNESCO, at the heart of the new building … we'll be able to see the forces of light defeat the forces of darkness. We shall see the forces of peace defeat the forces of death. We shall see all that accomplished, thanks to Picasso's utterly original creation, and alongside this combat, which is great like an antique myth, we see a peaceful humanity that is present on the shores of the infinite at the accomplishment of its destiny.[9]

We would do well, I think, to retreat from Salles's shameless *récupération* and put our trust in what he said before the microphones were switched on: the four-word title he seems to have first come up with in Vallauris, cobbled together from half-memories of Baudelaire's *Les Fleurs du mal*: 'L'Icare des ténèbres', as the interviewer called it. Both elements of the idea, if we put them back in their *Fleurs du mal* context, seem close – in tone and even intention – to Picasso's reworking. First, the two terrible lines from 'Au lecteur':

Chaque jour vers l'Enfer nous descendons d'un pas,
Sans horreur, à travers des ténèbres qui puent.[10]

It is the chilling 'sans horreur' that seems to catch Picasso's new tone. And second, the last lines of 'Les plaintes d'un Icare', with their vision of a future – an abyss – that refuses to be named:

Je n'aurai pas l'honneur sublime
De donner mon nom à l'abîme
Qui me servira de tombeau.[11]

The world of Arendt's second preface seems close.

It would be easy, after Salles, to paint a scathing picture of UNESCO. There were many such indictments at the time. As early as 1950 the philosopher Benedetto Croce could be found in the *Manchester Guardian* arguing seriously for the organization's disbandment, as a failed experiment stifled by Cold War duplicities.[12] Even those who (quite reasonably) celebrated the range of good works that UNESCO fostered in the world at large rarely failed to regret the great power politics creaking on at its centre.

In 1951 the question of Spanish membership came up, not for the first time.[13] The US and France were officially opposed; the Franco regime pretended to be indifferent. (That same year Spain refused to allow a UNESCO display on human rights to cross the Pyrenees.) Garroting of trade unionists in 1950–51 – the pace of executions quickened in the wake of a general strike in Barcelona in the spring of 1951 – 'aroused scattered headlines' in the world at large. Picasso, we know, had come to the attention of Franco's Dirección General de Seguridad as early as 1944 (he was supposed to have signed a letter to De Gaulle urging French support for the regime's opponents); he gave generously to Spanish refugee organizations then and later, and lent his name to various anti-Franco causes.[14] When Spanish membership was broached again in 1952, Albert Camus and others petitioned the director general to veto it. Pablo Casals and Salvador de Madariaga severed connections with UNESCO on the issue. Spain joined the body – on a 44 to 4 vote – in November.

By the time Picasso accepted the UNESCO commission, battle lines in the institution were immoveable. The Soviet bloc campaigned for Peace, the NATO powers for Freedom. Senator McCarthy sent staffers to investigate the loyalty of the US delegation.[15] Had any of them been heard to utter the dread word 'neo-colonialism' (about which UNESCO members droned on interminably)? 'Peace,' as a later participant put it, proved 'the issue which more than any other brought out humbug in UNESCO ... No other word generated so much loose

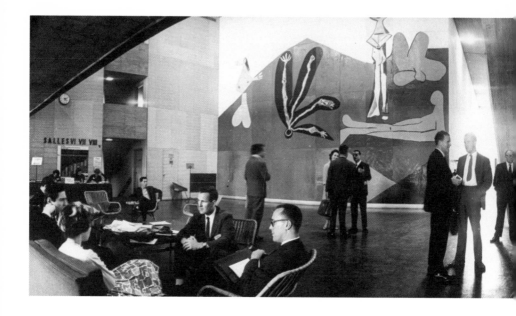

73. *Fall of Icarus* in the UNESCO building. Photograph by Loomis Dean
for *LIFE* Magazine, 1959.

speech or vague suggestions for projects. One of its later variants was
the argument that UNESCO should promote a movement toward a
"universal humanism" – [a project harking back to] arguments for "a
UNESCO philosophy" in the early days.'[16] The early days had been
guided by intellectuals of the stature of Julian Huxley and Joseph
Needham. They were long gone.

The writer just quoted is Richard Hoggart, whose memories of
his time as assistant director general are mostly not fond. The picture
he paints of a UNESCO general conference – the kind taking place
through the door just to the left of Picasso's mural – seems relevant:

Meetings usually start late. There is no effective time limit on
speeches. Delegates are frequently told that time is short and the
list of speakers long, that unless each speaker restricts himself
to fifteen minutes there will have to be a night session; and that

even then some people may not be able to speak. All this usually has little effect ... Meanwhile, delegates are moving in and out continually, going for coffee, to telephone, to do business in the corridors or simply to stretch their legs. It is a swirling parade of important people, or of people who were once important, or of people who think they are important.[17]

There is much more in the same vein.

These are the reminiscences of a disappointed insider, and I do not mean them to represent Picasso's view. How much the painter knew or cared about UNESCO's on-the-ground reality is impossible to guess. Probably rather little: the building, after all, was still under construction as he worked. But artists (some artists) are canaries in the mineshaft: they smell the atmosphere of disappointed hopes – 'the growing decay of all that has been spared' – before the full form of *Disinganno* has crystallized.

The details of UNESCO's evolution, that is, doubtless do not matter in assessing Picasso's mural, though often they make for tragic-comic reading. (In the 1960s the Secretariat was instructed to produce anthologies on tolerance and the horrors of war. The first could be printed, after long delays, only by an outside publisher, and UNESCO refused to put copies on sale; parts of it had not been 'cleared'. The second never materialized.[18]) But perhaps what is striking, looking back at materials from the time, is how dramatic the disappointment of the intellectuals continued to be for so long. UNESCO, we might say – just because of the urgency and nobility of its aims – was the theatre in which the disintegration of the 'international community' could still bring on a shudder. It is this wider disintegration, I think, that the *Fall of Icarus* tries to represent. And the mural's stylistic bizarrerie – the tragicomic strip-cartoon idiom Picasso devised for it – could not be more apt.

The painting as finally realized is trapezoidal in shape – that is, a vast rectangle with a sloping top edge. It is close on 35 feet wide at the base, and 30 feet high at the left, growing steadily shorter towards the right as it follows the ceiling line. The painting spreads over 970 square feet, built out of forty (clearly visible) separate mahogany panels and weighing around 79 stone. Both size and shape were dictated by the difficult site, on a wall just outside a main auditorium in the UNESCO building. The long ground-floor hallway leading towards the wall is crisscrossed, Le Corbusier-fashion, by concrete pilotis and walkways, which half-hide the mural till the spectator is almost on top of it. Roland Penrose may be right (he is by far the most sympathetic of the mural's historians) when he says of the viewer's approach:

His movement round these obstacles seems to give movement to the composition itself, in particular to the sinister black shape near the center of the painting, like the shadow of a man head downwards on which his blanched bones are traced ... Our own movement as we emerge from behind the rough concrete pillars creates a new and dramatic relationship between the painting and ourselves.[19]

Penrose may be right. Or he may be struggling, as Cocteau did, to bring the mural back into the realm of *Guernica*. I think we'd do best to put aside for the moment the Englishman's characterization of the central Icarus shape – 'sinister', he calls it, shadowy, skeletal (all the adjectives are reasonable but disputable) – and concentrate on his wish for movement and 'dramatic relationship'.

In front of the mural itself, and moving towards it through the pilotis, I for one experience no such animation. And I doubt Picasso meant me to. We know that the process of making the *Icarus* was difficult for him: everything, in the realization of such a public object (he told friends), depended on an evolving understanding of the overall shape and size

of the pictorial field, and he seems to have been worried that in the process of piecemeal assembly – the forty panels, worked on with the help of assistants – he would end up losing his sense of both parameters and fail to make his eventual handling of form (moving from sketch to full scale) respond to the reality of the vast empty surface.[20] (One suspects that the memory of *Guernica*, emerging from nothing in the room at the Grands-Augustins, worked at alone, changing constantly through the days of its making, every element attuned to the canvas's gigantism, was on Picasso's mind.) I am with Penrose in thinking that Picasso, 'relying on his ability to imagine [the field] as a whole', did pull off the final scaling-up for the wall in UNESCO. But as for what the artist intended the shape and size and setting to *do* to his picture's 'composition' – here Penrose and I part company.

A trapezoid – especially one intersected and hemmed in, as *Icarus* was to be, by great grey concrete horizontals and verticals – is something fundamentally different from a picture rectangle. A picture rectangle, even one hung high on a wall or blown up to *Guernica* proportions, brings with it – enforces in the viewer – the protocols of pictorial looking and feeling. It creates a viewpoint: not necessarily a literal, privileged place to take position in front of the painting, but a virtual standpoint from which the picture's array of things will best come to make sense and fall into Penrose's 'dramatic relationship' with us. A picture rectangle suggests a perspective on the events depicted, whether the space in which the events unfold is plotted explicitly in geometric terms or implied elliptically (even ironically). 'Perspective' here, returning to the viewer's experience in front of Veronese, means several things: a painted depth into which the onlooker is invited to enter imaginatively; a picture plane through which the imaginative entry can take place; and, finally, a pondered hierarchy of pictorial incident (a foreground and background, an 'action' and a 'setting', a centre and periphery) that proposes an order or meaning for the scene portrayed.

A trapezoid – or, rather, a trapezoid as Picasso reluctantly came to terms with it – is a picture without a viewpoint. It takes up the normal clues and mechanics of perspective and has them disperse and disintegrate – float back absurdly onto the surface – before our eyes. The orthogonal brown slab of 'beach' or 'diving board' slicing in, unconvincingly, from the bottom edge of Icarus is a signature of this – of perspective's powerlessness against the trapezoid's flat lack of direction. And compare, more grandly and structurally, the sea's unstable blue horizon in the mural, going off towards a vanishing point in summer haze; and the inability of that 'horizon' to become, perceptually, any such thing. In this sense, one could say that Picasso finally took advantage of his panel-by-panel procedure. He came to see that its additive, discontinuous, de-totalizing 'feel' was what his understanding of the subject demanded. Or maybe the piecemeal nature of the process reshaped the understanding.[21] Discontinuity across edges became one main carrier of the mural's strange suspension, or annihilation, of feeling in general – of 'attitude', of discernible tone, even of a salving irony. The take-it-or-leave-it sliced toes of the bather at right are a signature of the new style; and the nowhereness of the bather at left – the lack of perceivable relation between her body parts and the sea they are supposedly floating in – its weirdest achievement.

The photograph of the mural I favour – the one that strikes me as giving us the best sense of the thing as it functions in UNESCO space – is taken from above. We are looking down from one of the concrete walkways, and if we try to get back far enough from the mural to see it all in one piece (well, almost ... the eye or camera lens constantly loses hold of one or another corner) we have to accept an oblique, off-centre viewpoint. And this seems appropriate to the trapezoid itself – to the absence of totality (of Penrose-type drama, of epic or tragic depth) that the shape allowed Picasso to reckon with.

'Absence of totality' is, for Picasso, a thing hard won. We know from surviving sketches that, as usual, the painter's first ideas for UNESCO, jotted down in December 1957, were indoor ones – pictures of a studio, as he explained to the Vallauris interviewer, with a model reclining on a couch, confined by four walls and ceiling.[22] (The *Guernica* commission had begun the same way: the painter-and-model set-up was what Picasso painted while he waited for the world to occur to him.[23] During the latter part of 1957 he had done more than forty variations on Velázquez's *Las Meniñas*: the last of them were being finished as the UNESCO sketches began.) The world of the beach, which eventually came to dominate *Icarus*, was already present in Picasso's first sketches, but as a picture within a picture: next to the model in the studio stood a canvas on an easel, filled with bather totem-figures, and the bathers themselves were doubly mediated, since they were essentially painted

74. Pablo Picasso, *Studio with reclining woman and painting*, 2 January 1958, pen and ink, 32 × 24 cm (15⅝ × 9½ in.). Musée Picasso, Paris.

75. Pablo Picasso, study for *Studio with reclining woman and painting*, 25 December 1957, crayon on paper, 25 × 32.6 cm (9⅞ × 12⅞ in.). Whereabouts unknown.

equivalents of a set of bronze sculptures the artist had done earlier in the year. The sketchbook went back and back to the studio notion all through December and early January (fig. 74), trying out ways to put model and painting in tighter and tighter Cubist contact. The scene stayed firmly bounded – very much an interior – for several weeks.[24] On Christmas Day 1957 Picasso did a set of small blue-and-black thumbnails that still insisted on the old Cubist framework: triangles and quadrilaterals interlocking, solid and void, table, easel, skylight, corner of the room. In some of the sketches done in early January bathers (in the plural) were replaced by a single male on a diving board, but what continued to matter, pictorially, was the to-and-fro between studio space and picture space – between two kinds of foursquare containment. (The diver motif in the picture on the easel was no doubt the original

76. Anon, *Tomb of the Diver*, *c*.470 BCE. Museo Nazionale, Paestum.

'common-sense' idea that gave rise to the plunging Icarus in the mural – so that at one level we might read Picasso's UNESCO painting as a premonition of the Tomb of the Diver discovered at Paestum in 1968.)

It was only after a month and more of experiments that the walls of the room in Picasso's sketches began to dissolve; and even when they did – by late January the seaside is decided on – the sketches seem determined, for a week or so, to bring some kind of studio structure out into the open air (fig. 77). In Picasso's first crude try-outs of the beach scene, the sea's horizon line and vanishing point are mobilized so as to tie the jagged array of shapes together: orthogonals radiate from a vanishing point, and a further pattern of triangles is brought on to lock the various elements in place. For a while Icarus seems to be heading for a neat, triangular hole in the ocean. Segments of coloured paper, hard-edged and crisply discriminated – fragments of Cubist collage – are pinned in changing positions on top of the beach bottom right. The diving board is decided on, and its wedge form is

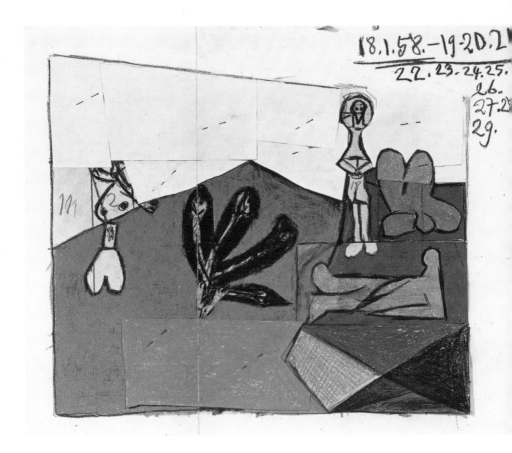

77. Pablo Picasso, *Fall of Icarus* study, 18-29 January 1958, mixed media,
50.5 × 65.5 cm (19⅞ × 25¾ in.). Whereabouts unknown.

part of a Cubist honeycomb of reversible cubes. The mural might well
have ended, by the look of it, as a variant on the kind of nervously
ingenious 'perspectival' beach scene Picasso had painted on camera
for Clouzot's *Mystère de Picasso* – the kind he can be heard describing,
not unreasonably, on the soundtrack as 'très mauvais … extrêmement
mauvais' – or the *Baie de Cannes* he did in April, immediately after the
UNESCO job was finished.

My argument, then, is that it was only in the actual-size, forty-piece
Fall of Icarus that Picasso escaped from Cubism – from the studio,

from 'viewpoint', from interlock and paradox, from the whole spatial and figurative world of *Guernica* – and showed us the world after epic. Two things seem decisive. First, to repeat, there was the effect of the non-square shape of the field itself, coming into being panel by panel, on the picture's deployment of surface and depth. 'Flatness' of a new kind emerges, peculiarly piecemeal and lacking in structure, floating the scene's absurd protagonists apart. (The sloping top edge of the wall at UNESCO had been registered from the start in Picasso's sketch-book try-outs, sometimes emphatically, with light and dark triangles pinned to it; but only very late in the day did the slope begin to infect – disperse, disassemble – the joinery of forms below.) It is impossible to be certain how much Picasso knew or cared, at this point in the 1950s, about 'American-type' painting. But the *Fall of Icarus* does have the look, especially from ground level, of a burlesque Barnett Newman with figures supplied by Matisse.

And then secondly – inescapably – there is the figure of Icarus itself. Where did Icarus come from? Or, rather, what was it that provoked the figure's final transformation from plunging bather (still easily recognizable as such in the sketches) into a free-fall, spider-limbed, semi-transparent ghost – made out of cursory scribbles and slack trails of paint, silhouetted in a black air pocket? The final ghost has nothing to do with the other four figures in the scene: he is, in handling and orientation, the strict opposite of their pinned-on hard-edged flatness.

Where did Icarus come from? Well, from at least two places. Matisse's *Fall of Icarus*, done in the dreadful year 1943 (fig. 78), had been assembled from pinned, cut papers touched with gouache. It was as close as the artist ever came to an acknowledgment of the world of bomb blast and airborne terror.[25] Picasso could have seen the collage reproduced in *Verve* in 1945 or encountered the real thing in Tériade's collection – presumably at the time in 1948 when he worked with Tériade on the book *Le chant des morts*.[26] Put together the bomb-blast stars in Matisse (which may themselves have carried the trace of the

78. Henri Matisse, *Icarus (Icare)* from *Jazz*, 1947,
pochoir printed in colour [original cut-paper, 1943],
42.2 × 32.5 cm (16⅝ × 12¹³⁄₁₆ in.).

exploding lightbulb-incendiary in *Guernica*) and Icarus's white-on-
black falling body, and you have the bare elements of Picasso's idea.
To these add Bruegel.

I have no doubt that long before Salles produced his *Icarus* title in
March these two versions of the legend – Matisse's and Bruegel's – had
coalesced in Picasso's mind. Matisse had been the presiding deity of
the UNESCO project from the moment (in late January) when the
action had shifted from studio to seaside. The tanned figure top right
in the mural – pebble, flower, polyp, pin-up, extravagant Saint Tropez
sunbather – is a compound and parody of Matisse motifs. The Icarus

79 Pieter Bruegel The Elder, *Fall of Icarus*, *c*.1555,
73.5 × 112 cm (28⅞ × 44⅛ in.). Musée Royaux des Beaux-Arts, Brussels.

idea emerged from the Matisse matrix. And once it had appeared,
naturally Bruegel came with it: Picasso burrowed into his library and
dreamed over the unavoidable source. What he responded to most
deeply, it seems, and set himself the task of repeating, was Bruegel's
(entirely characteristic) sense that the tragedy of Icarus had made
no difference to the universe it took place in – that in the real world
tragedy is an incident, a brief interruption, an agony in a vacuum, to
which the idiot onlooker in Picasso's mural, staring out at us from his
position top right, will never pay heed. Characteristically, the response
to Bruegel's idea seems to have hinged on a single visual incident that
Picasso saw he could fasten on: Icarus's splayed limbs in the mural (and
in the sketch where the figure first materializes) are direct variations
on the famous 'unnoticeable' flailing legs of the Bruegel prototype.

Picasso's Icarus is sinister, says Penrose – a 'tattered apparition', 'the shadow of a man head downward'. But Icarus is also shapeless, weightless, insubstantial, silly, not really present in his black container – not really part of the scene. He may be sinister, he may be a figure of fun. He may stand for disaster, he may stand for some passing evil (or absurdity) averted. Even the Salles/Thorez reading may be right. 'Peace' – in all its UNESCO blandness – may indeed be basking by the Mediterranean, watching War shot down. We may even be meant to identify (groaning) with Salles's 'pacified humanity, which is present on the shores of the infinite at the accomplishment of its destiny'. It is worth recalling that in 1958 Picasso was putting the finishing touches

80. Pablo Picasso, Temple of Peace, 1958,
end wall. Musée Picasso, Vallauris.

to his Vallauris Temple of Peace, painting the temple's pure-Stalinist end wall, with its cardboard apotheosis of the peace dove.[27] Picasso had intended the temple to have a grand opening ceremony in 1958, but the Vallauris authorities had decided at the last minute that the space was too small for the expected crowd; so the schoolyard unveiling of the UNESCO mural may have been a kind of substitute.[28] No doubt Picasso's painting anticipated the worst that officialdom would make of it. And no doubt that officialdom, for Picasso in 1958, included the French Communist Party.

Naturally, *Les lettres françaises*, the party's magazine of art and literature, was given privileged access to the Vallauris debut.[29] In the article

81. *Les lettres françaises*, no. 716
(3–9 April 1958).

accompanying the first photographs of the mural, its correspondent gathered readings from selected members of the audience. Salles's Icarus idea was already solidly in place: the mural was 'like an antique tragedy in which an "Icarus of the shadows" will fall vanquished by the forces of light, by the human forces of peace'.[30] 'As for the building workers who put up the metal carcass [the scaffold proscenium visible in news photos], this painting made them think "of the H bomb that makes its way around our skies, carried by American planes".' Enter a stock figure of Communist pastoral: 'A white-haired schoolteacher, come to look at Picasso's work over the Easter holiday, went still further: "I think of Algeria – she said – when I look at that woman torn to pieces, who cries from the other side of the sea."' Given the state of Communist Party policy towards the Algerian War in 1958, it is not clear which 'Algeria' – FLN or *pied noir* – the schoolteacher thinks we should sympathize with.

'Picasso smiles joyfully when I report these commentaries to him,' the correspondent goes on. I wonder if 'joyeusement' quite captured Picasso's feelings.

Scholars are divided on the question of whether the *Fall of Icarus* now in Brussels (fig. 79) is the picture Bruegel painted or a copy. In any case the conception, and many details of its realization, can hardly be anyone else's. I even go along with Max Friedländer in thinking the original to have been a product of the artist's last years:[31] it seems in many ways analogous to the Darmstadt *Magpie on the Gallows* (fig. 38). And in both pictures the real challenge – the interest, beyond the fascination of particulars – is to grasp Bruegel's tone. The polarities of optimism and pessimism do not seem to apply. What the gallows stand for, absorbing the sun in *Magpie*, is as hard to put a name to as Icarus's soft splash. In Bruegel's final accountings of life and death, what seems to matter most is the sweep and depth of the natural world – the world

of farming and trade winds – and the quality of the light. The sun may be what has put an end to Icarus's attempt at victory over it, but that does not make the sunshine any the less tender – whether glittering in the firmament or (this being Bruegel) unfolding imperturbably under foot, shaping and smoothing each furrow. The pace of the ploughman and his horse – surely the key to the scene's whole vision – goes in time with the sun's slow progress.

Whether or not the first state of *Icarus* found room for Daedalus in the sky, looking down on his son's disappearance (there is another early copy in which Daedalus is visible), the overall picture of the world Bruegel offers is one from which the gods have departed. The proverbial displaces the mythological, as usual with the artist. Off to the left in *Icarus*'s middle distance, where the ploughed field stops at the edge of a wood, an old man's bald head rests on the final furrow. 'The plough passes over corpses' is the Flemish proverb ('De ploeg gaat over lijken').[32] The time of generation – cyclical time, accumulative, 'man comes and tills the earth and lies beneath' – is Bruegel's reality, miniaturizing any one man's death. The head on the furrow counts for more than the legs in the waves.

Picasso agrees with Bruegel about very little beyond this basic proposal. The world of work in the Brussels picture – ships, cities, elaborate harbours, flocks, fishing rods, bags of seed – gives way to an empty seaside, with only a graceless diving board for furniture. The soft dazzle of light in the sky in Bruegel is replaced in Picasso by ceramic non-colour – the endless summer of the travel brochure. Icarus is pulled from the water and sealed from the idyll in a space suit of black. He may be a skeleton surrounded by charred flesh. His terrible weightless downward velocity is the scene's only sign of life. Even Marcel Duchamp's *Network of Stoppages* (fig. 82) looks animate in comparison.

82. Marcel Duchamp, *Network of Stoppages*, 1914,
148.9 × 197.7 cm (58⅝ × 77⅝ in.). MoMA, New York.

The reader will be asking, finally, if Picasso's *Icarus* is really a conclusion to the story I have been telling. The answer is no. I admire the painting's nerveless absurdity more than I can say, and see it as a necessary moment – a tremendous negative – in the process of rethinking (demythologizing) the twentieth century. But even that exorcism, if and when it happens, will put an end to nothing. On the other side of Picasso's tattered parachutist remains Giotto's angel. Echoing and annihilating the fatuous bathers in *Icarus* will always be (for me) the woman in *Disinganno* – taking her distance from the Fall, smiling at it, seeing how low a man can go, but not for a moment

dreaming that she can escape (or would want to) from the elation and ludicrousness of desire.

There is a tiny engraving by Blake, published in 1793 as part of a book called *For Children: The Gates of Paradise*, that bears the caption 'I want! I want!' (fig. 83). This is, if you will, Blake's emblem of the 'heaven on earth' imperative. The plate immediately following in the book is a variant of *Icarus*: a bather in a stormy sea (perhaps the child has fallen from his ladder to the moon) calling for help as the waves overwhelm him (fig. 84).

But 'Help! Help!' and 'I want! I want!' – if we consider the two plates in the whole *Gates of Paradise* sequence and as part of Blake's wider work of prophecy – are terms, again, of a dialogue that will never cease. That seems to me the message of all the images I have looked at. Icarus goes down to darkness, yes, but Joachim shakes off despair. The *Land of Cockaigne* may be pie in the sky, but this does not mean that the *Triumph of Death* is the truth. Picasso's bleak gaiety in the face of catastrophe is the product of a specific moment in history (the photograph of him and Maurice Thorez in front of *Icarus* speaks to the moment's ironies as few other images can) and has to be corrected by Blake's nursery-rhyme simplicity and Veronese's complex optimism. 'You never enjoy the world aright, till the sea itself floweth in your veins, till you are clothed with the heavens, and crowned with the stars.' 'The world as it is, without subtraction, exception, or selection ... the same things, the same logic and illogic of entanglements.' For children, these antinomies. Till time stops.

83. William Blake, *For Children, The Gates of Paradise*, plate 11, 1793,
etching and line engraving, 13.7 × 11.4 cm (5⅜ × 4½ in.).
Yale Center for British Art, New Haven.

84. William Blake, *For Children, The Gates of Paradise*, plate 12, 1793, etching and engraving, (13.7 × 11.4 cm (5⅜ × 4½ in.). Yale Center for British Art, New Haven.

The text that follows was first published in Oslo as 'The Experience of Defeat', then in New Left Review *in April 2012, and later as a booklet in Brazil in 2013.[1] Inevitably, some aspects of it have dated. It was written, for example, before the rise of Syriza in Greece, and its brief reference to Greek politics betrays my ignorance of the complex movements that were bringing a new Left into being there from 2010 on; though what then transpired, as Syriza was forced to decide if it could as a party in power 'present a program outlining an actual, persuasive default economic policy, a year-by-year vision of what would be involved in taking "the Argentine road"', only serves to make the difficulties I was pointing to more vivid. (Much of Left commentary since on Syriza's fate in government – the familiar accusations of 'betrayal', the enthusiasm for default and currency-crash economics, etc. – seems to me once again to conjure away the real tentacular power of capitalism over any one nation-state, however politically recalcitrant. A comparison with Venezuela suggests itself.) I reprint the essay, lightly revised, as a coda to the book because in so many ways – not just the role played in it by Bruegel's* Land of Cockaigne[2] *– its themes anticipate those developed in my five previous chapters; and the events of the years since 2012 have, sadly, raised the stakes in the bitterest of ways. They have made it clear, perhaps – I think in particular of the rise and fall of a true 'eschatological state' in the Middle East (successor to many others), born of imperial chaos, exulting in the last days, full of the cruelties and certainties of apocalypse, seeing God's kingdom on the horizon – why any rethinking of human possibility has no choice, in response, but to re-imagine time itself.*

Coda:
For a Left with No Future

How deceiving are the contradictions of language! In this land without time the dialect was richer in words with which to measure time than any other language; beyond the motionless and everlasting *crai* [meaning 'tomorrow' but also 'never'] every day in the future had a name of its own ... The day after tomorrow was *prescrai* and the day after that *pescrille*; then came *pescruflo, maruflo, maruflone*; the seventh day was *maruflicchio*. But these precise terms had an undertone of irony. They were used less often to indicate this or that day than they were said all together in a string, one after another; their very sound was grotesque and they were like a reflection of the futility of trying to make anything clear out of the cloudiness of *crai*.

> Carlo Levi, *Christ Stopped at Eboli*[3]

I hope sincerely it will be all the age does not want ... I have omitted nothing I could think of to obstruct the onward march of the world ... I have done all I can to impede progress ... having put my hand to the plough I invariably look back.

> Burne-Jones on the *Kelmscott Chaucer*[4]

Left intellectuals, like most intellectuals, are not good at politics; especially if we mean by the latter, as I shall argue we should, the everyday detail, drudgery and charm of performance. Intellectuals most often get the fingering wrong. Up on stage they play too many wrong notes. But one thing they may be good for: sticking to the symphony

hall analogy, they are sometimes the bassists in the back row whose groaning establishes the key of politics for a moment, and even points to a possible new one. And it can happen, though occasionally, that the survival of a tradition of thought and action depends on this – on politics being transposed to a new key. This seems to me true of the Left in our time.

These notes are addressed essentially (regrettably) to the Left in the old capitalist heartland – the Left in Europe. Perhaps they will resonate elsewhere. They have nothing to say about capitalism's long-term invulnerability, and pass no judgment – what fool would try to in present circumstances? – on the sureness of its management of its global dependencies, or the effectiveness of its military humanism. The only verdict presupposed in what follows is a negative one on the capacity of the Left – the actually existing Left, as we used to say – to offer a perspective in which capitalism's failures, and its own, might make sense. By 'perspective' I mean a rhetoric, a tonality, an imagery, an argument, and a temporality.

By 'Left' I mean a root and branch opposition to capitalism. But such an opposition has nothing to gain, I reckon, from a series of overweening and fantastical predictions about capitalism's coming to an end. Roots and branches are things in the present. The deeper a political movement's spadework, the more complete its focus on the here and now. No doubt there is an alternative to the present order of things. Yet nothing follows from this – nothing deserving the name political. Left politics is immobilized, it seems to me, at the level of theory and therefore of practice, by the idea that it should spend its time turning over the entrails of the present for signs of catastrophe and salvation. Better an infinite irony at *prescrai* and *maruflicchio* – a peasant irony, with an earned contempt for futurity – than a politics premised, yet again, on some terracotta multitude waiting to march out of the emperor's tomb.

Is this pessimism? Well, yes. But what other tonality seems possible in the face of the past ten years? How are we meant to understand the arrival of real ruination in the order of global finance ('This sucker could go down', as George Bush told his cabinet in September 2008), and the almost complete failure of Left responses to it to resonate beyond the ranks of the faithful? Or to put the question another way: If the past decade is not proof that there are *no* circumstances capable of reviving the Left in its nineteenth and twentieth-century form, then what would proof be like?

It is a bitter moment. Politics, in much of the old previously immovable centre, seems to be taking on a more and more 'total' form – an all-or-nothing character for those living through it – with each successive month. And in reality (as opposed to the fantasy world of Marxist conferences) this is as unnerving for Left politics as for any other kind. The Left is just as unprepared for it. The silence of the Left in Greece, for example – its inability to present a programme outlining an actual, persuasive default economic policy, a year-by-year vision of what would be involved in taking 'the Argentine road' – is indicative. And in no way is this meant as a sneer. When and if a national economy enters into crisis in the present interlocking global order, what has *anyone* to say – in any non-laughable detail – about 'socialism in one country' or even 'partly detached pseudo-nation-state non-finance-capital-driven capitalism'? (Is the Left going to join the Eurosceptics on their long march? Or put its faith in the proletariat of Guangdong?)

The question of capitalism – precisely because the system itself is once again posing (agonizing over) the question, and therefore its true enormity emerges from behind the shadow play of parties – has to be bracketed. It cannot be made political. The Left should turn its attention to what can.

∽

It is difficult to think historically about the present crisis, even in general terms – comparisons with 1929 seem not to help – and therefore to get the measure of its mixture of chaos and *rappel à l'ordre*. Tear gas refreshes the army of bondholders; the Greek for General Strike is on everyone's lips; Goldman Sachs rules the world. Maybe the years since 1989 could be likened to the moment after Waterloo in Europe: the moment of Restoration and Holy Alliance, of apparent world-historical immobility (though vigorous reconstellation of the productive forces) in the interim between 1815 and 1848.

In terms of a thinking of the project of Enlightenment – my subject remains the response of political thought to apparent comprehensive defeat – these years were a pause between paradigms. The long arc of rational and philosophical critique – the arc from Hobbes to Descartes to Diderot to Jefferson to Kant – had ended. Looking with hindsight, we can see that beneath the polished surface of Restoration the elements of a new vision of history were assembling: peculiar mutations of utilitarianism and political economy, the speculations of Saint-Simon, Fourier's counterfactuals, the intellectual energies of the Young Hegelians. But it was, at the time (in the shadow of Metternich, Ingres, the later Coleridge), extremely difficult to see these elements for what they were, let alone as capable of coalescing into a form of opposition – a fresh conception of what it was that had to be opposed, and an intuition of a new standpoint from which opposition might go forward. This is the way Castlereagh's Europe resembles our own: in its sense that a previous language and set of presuppositions for emancipation have run into the sand, and its realistic uncertainty as to whether the elements of a different language are to be found at all in the general spectacle of frozen politics, ruthless economy, and enthusiasm (as always) for the latest dim gadget.

The question for the Left at present, in other words, is how deep does its reconstruction of the project of enlightenment have to go? 'How far down?'

Some of us think, 'Seven levels of the world'. The book we need to be reading – in preference to *The Coming Insurrection*, I feel – is Christopher Hill's *The Experience of Defeat*. That is: the various unlikely and no doubt dangerous voices I find myself drawing on in these notes – Nietzsche in spite of everything, Bradley on tragedy, Burkert's terrifying *Homo Necans*, Hazlitt and Bruegel at their most implacable, Moses Wall in the darkness of 1659, Benjamin in 1940 – come up as resources for the Left only at a moment of true historical failure. We read them only when events oblige us to ask ourselves what it was, in our previous stagings of transfiguration, led to the present debacle.

The word 'Left' in my usage refers, of course, to a tradition of politics hardly represented any longer in the governments and oppositions we have. (It seems quaint now to dwell on the kinds of difference within that tradition once pointed to by the prefix 'ultra'. After sundown all cats look grey.) Left, then, is a term denoting an absence; and this near non-existence ought to be explicit in a new thinking of politics. But it does not follow that the Left should go on exalting its marginality, in the way it is constantly tempted to – exulting in the glamour of the great refusal, and consigning to outer darkness the rest of an unre-generate world. That way literariness lies. The only Left politics worth the name is, as always, the one that looks its insignificance in the face, but whose whole interest is in what it might be that could turn the vestige, slowly or suddenly, into the beginning of a 'movement'. Many and bitter will be the things sacrificed – the big ideas, the revolutionary stylistics – in the process.

∽

This leads me to two kinds of question, which structure the rest of these notes. First, what would it be like for Left politics not to look

forward – to be truly present-centred, non-prophetic, disenchanted, continually 'mocking its own presage'? A movement that left behind, that is, in the whole grain and frame of its self-conception, the last afterthoughts and images of the avant-garde (figs. 85 and 86). And a second, connected question: could Left politics be transposed into a tragic key? Is a tragic sense of life possible for the Left – for a movement that aims to stay in touch with the tradition of Marx, Raspail, Morris, Kropotkin, Luxemburg, Gramsci, Platonov, Sorel, Pasolini? Isn't that tradition rightly – indelibly – unwilling to dwell on the experience of defeat?

~

What do I mean, then, by tragedy, or the tragic conception of life? The idea applied to politics is strange, maybe unwelcome, and therefore my treatment of it will be plain; which need not, in this instance, mean banal. Bradley is a tremendous late-Victorian guide; better, I think, because more political, than all the great theorists and classicists who followed him; and he exemplifies the kind of middle wisdom – the rejected high style – that the Left will have to rediscover in its bourgeois past. He addresses his students (colonial servants in the making) mainly about Shakespeare, but almost everything in his general presentation of the subject resonates with politics more widely.

Tragedy, we know, is pessimistic about the human condition. Its subject is suffering and calamity, the constant presence of violence in human affairs, the extraordinary difficulty of reconciling that violence with a rule of law or a pattern of agreed social sanction. It turns on failure and self-misunderstanding, and above all on a fall from a great height – a fall that frightens and awes those who witness it because it seems to speak to a powerlessness in man, and a general subjection to a Force or Totality derived from the very character of things. Tragedy is about greatness come to nothing. But that is why it is not depressing. '[Man] may be wretched and he may be awful,' says Bradley, 'but he is

ABOVE 85. Pieter Bruegel the Elder, *Small Tower of Babel*,
c.1563, 59.9 × 74.6 cm (23⅝ × 29⅜ in.).
Musée Boymans-van Beuningen, Rotterdam.

BELOW 86. Vladimir Tatlin, *Monument to the Third International*,
in the studio of the former Academy of Arts, Petrograd, 1920.

not small. His lot may be heart-rending and mysterious, but it is not contemptible.'⁵ 'It is necessary that [the tragic project] should have so much of greatness that in its error and fall we may be vividly conscious of the possibilities of human nature.'⁶ Those last two words have traditionally made the Left wince, and I understand why. But they may be reclaimable: notice that for Bradley nature and possibility go together.

Bradley has a great passage on 'what [he] ventures to describe as the centre of the tragic impression'. I quote it in full:

> This central feeling is the impression of waste. With Shakespeare, at any rate, the pity and fear which are stirred by the tragic story seem to unite with, and even merge in, a profound sense of sadness and mystery, which is due to this impression of waste … We seem to have before us a type of the mystery of the whole world, the tragic fact which extends far beyond the limits of tragedy. Everywhere, from the crushed rocks beneath our feet to the soul of man, we see power, intelligence, life and glory, which astound us and seem to call for our worship. And everywhere we see them perishing, devouring one another and destroying themselves, often with dreadful pain, as though they came into being for no other end. Tragedy is the typical form of this mystery, because that greatness of soul which it exhibits oppressed, conflicting and destroyed, is the highest existence in our view. It forces the mystery upon us, and it makes us realize so vividly the worth of that which is wasted that we cannot possibly seek comfort in the reflection that all is vanity.⁷

One thing to be said in passing about this paragraph – but I mean it as more than an aside – is that it can serve as a model of the tone of politics in a tragic key. The tone is grown up. And maybe that is why it inevitably will register as remote, even a trifle outlandish, in a political culture as devoted as ours to a ventriloquism of 'youth'. The present

language of politics, Left and Right, participates fully in the general infantilization of human needs and purposes that has proved integral to consumer capitalism. (There is a wonderful counter-factual desperation to the phenomenon. For consumer society is, by nature – by reason of its real improvement in 'living standards' – grey-haired. The older the average age of its population, we might say, the more slavishly is its cultural apparatus geared to the wishes of fifteen-year-olds.) And this too the Left must escape from. Gone are the days when 'infantile disorder' was a slur – an insult from Lenin, no less – that one part of the Left could hope to reclaim and transfigure. A tragic voice is obliged to put adolescence behind it. No more Rimbaud, in other words – no more apodictic inside-out, no more elated denunciation.

Here again is Bradley. 'The tragic world is a world of action,' he tells us,

> and action is the translation of thought into reality. We see men and women confidently attempting it. They strike into the exist-ing order of things in pursuance of their ideas. But what they achieve is not what they intended; it is terribly unlike it. They understand nothing, we say to ourselves, of the world on which they operate. They fight blindly in the dark, and the power that works through them makes them the instrument of a design that is not theirs. They act freely, and yet their action binds them hand and foot. And it makes no difference whether they meant well or ill.[8]

Politics in a tragic key, then, will operate always with a sense of the horror and danger built into human affairs. 'And everywhere we see them perishing, devouring one another and destroying themselves.' This is a mystery. But (again quoting Bradley, this time pushing him specifically in our direction) 'tragedy is the … form of this mystery [that best allows us to think politically], because the greatness of soul

87. Collectivization campaign, *c.*1930. ('We kolkhozniks are liquidating the kulaks as a class, on the basis of complete collectivization'). Photographer unknown.

which it exhibits oppressed, conflicting and destroyed, is the highest existence in our view. It forces the mystery upon us.' And it localizes the mystery, it stops it from being an immobilizing phantom – it turns from the hopelessness of 'human nature' and tries to look one catastrophe in the face.[9]

Our catastrophe – our Thebes – is the seventy years from 1914 to 1989. And of course to say that the central decades of the twentieth century, at least as lived out in Europe and its empires, were a kind of charnel house is to do no more than repeat common wisdom. Anyone casting an eye over a serious historical treatment of the period – the one I

never seem to recover from is Mark Mazower's terrible conspectus, *Dark Continent: Europe's Twentieth Century*[10] – is likely to settle for much the same terms. *The Era of Violence*, I remember an old textbook calling it.[11] The time of human smoke.

The political question is this, however. Did the century's horrors have a shape? Did they obey a logic or follow from a central determination – however much the contingencies of history (Hitler's charisma, Lenin's surviving the anarchist's bullet, the psychology of Bomber Harris) intervened? Here is where the tragic perspective helps. It allows us *not* to see a shape or logic – a development from past to future – to the last hundred years. It opens us, I think rightly, to a vision of the period as catastrophe in the strict sense: unfolding pell-mell from Sarajevo on, certainly until the 1950s (and if we widen our focus to Mao's appalling 'Proletarian Cultural Revolution' – in a sense the last paroxysm of a European fantasy of politics – well on into the 1970s). A false future is suddenly dominant, overtaking the certainties of Edwardian London and Vienna; a chaos formed from an unstoppable, unmappable crisscross of forces: the imagined communities of nationalism, the pseudo-religions of class and race, the dream of an ultimate subject of History, the new technologies of mass destruction, the death-throes of the 'white man's burden', the dismal realities of inflation and mass unemployment, the haphazard (but then accelerating) construction of mass parties, mass entertainments, mass gadgets and accessories, standardized everyday life.

The list is familiar. And I suppose that anyone trying to write the history that goes with it is bound to opt, consciously or by default, for one among the various forces at work as predominant. There must be a heart of the matter.

∽

Which leads to the question of Marxism. Marxism, it now comes clear, was most productively a theory – a set of descriptions – of bourgeois society and the way it would come to grief. It had many other aspects

and ambitions, but this was the one that ended up least vitiated by chiliasm or scientism, the diseases of the cultural formation Marxism came out of. At its best (in Marx himself, in Lukács during the 1920s, in Gramsci, in Benjamin and Adorno, in Brecht, in Bakhtin, in Attila József, in the Sartre of 'La conscience de classe chez Flaubert'), Marxism went deeper into the texture of bourgeois beliefs and practices than any other description save the novel. But about bourgeois society's ending it was notoriously wrong. It believed that the grand positivity of the nineteenth-century order would end in revolution – meaning a final acceleration (but also disintegration) of capitalism's productive powers, the recalibration of economics and politics, and breakthrough to an achieved modernity. This was not to be. Certainly bourgeois society – the cultural world that Malevich and Gramsci took for granted – fell into dissolution. But it was destroyed, so it transpired, not by a fusion and fission of the long-assembled potentials of capitalist industry, and the emergence of a transfigured class community, but by the vilest imaginable parody of both. Socialism became National Socialism, Communism became Stalinism, modernity morphed into crisis and crash, new religions of *Volk* and *Gemeinschaft* took advantage of the technics of mass slaughter. Franco, Dzerzhinsky, Earl Haig, Eichmann, Von Braun, Mussolini, Teller and Oppenheimer, Jiang Qing, Kissinger, Pinochet, Pol Pot, Ayman al-Zawahiri. This is the past that our politics has as its matrix. It is our Thebes.

But again, be careful. Tragedy is a mystery, not a chamber of horrors. It is ordinary and endemic. Thebes is not something we can put behind us. No one looking into the eyes of the poor peasants in the 1930 photograph, lined up with their pikes and Stalinist catch phrases, off to bludgeon a few kulaks down by the railway station – looking into the eyes of these dupes and murderers, dogs fighting over a bone, and remembering, perhaps with Platonov's help, the long desperation the camera does not see – no one who takes a look at the real history of the twentieth century, in other words, can fail to experience the 'sense

of sadness and mystery' Bradley points to, 'which is due to the impression of waste ... And everywhere we see them perishing, devouring one another and destroying themselves ... as though they came into being for no other end.'

∽

However much we may disagree on the detail of the history the kolkhozniks in the photo are living, let us at least do them the justice not to pretend it was epic. 'Historical materialism must renounce the epic element in history. It blasts the epoch [it studies] out of the reified "movement of history". But it also explodes the epoch's homogeneity, and intersperses it with ruins – that is, with the present.'[12] The shed on the right in the photo might as well be a *Lager*, and the banner read *Arbeit macht frei*.

∽

'The world is now very dark and barren; and if a little light should break forth, it would mightily refresh it. But alas: man would be lifted up above himself and distempered by it at present, and afterwards he would die again and become more miserable': thus the Puritan revolutionary Isaac Penington in 1654, confronting the decline of the Kingdom of Saints.[13] Penington thinks of the situation in terms of the Fall, naturally, but his attitude to humanity can be sustained, and I think ought to be, without the theological background. His speaking to the future remains relevant. And it can coexist fully with the most modest, most moderate, of materialisms – the kind we need. Here for example is Moses Wall, writing to John Milton in 1659 – when the days of the English republic were numbered:

> You complain of the Non-proficiency of the Nation, and of its retrograde motion of late, in liberty and spiritual truths. It is much to be bewailed; but yet let us pity human frailty. When

those who made deep protestations of their zeal for our Liberty, being instated in power, shall betray the good thing committed to them, and lead us back to Egypt, and by that force which we gave them to win us Liberty, hold us fast in chains; what can poor people do? You know who they were that watched our Saviour's Sepulchre to keep him from rising.

(Wall means soldiers. He knows about standing armies.)

Besides, whilst people are not free but straitened in accommodations for life, their Spirits will be dejected and servile: and conducing to [reverse this], there should be an improving of our native commodities, as our Manufactures, our Fishery, our Fens, Forests, and Commons, and our Trade at Sea, &c. which would give the body of the nation a comfortable Subsistence.[14]

Still a maximalist programme.

A tragic perspective on politics is inevitably linked, as Wall's letter suggests, to the question of war and its place in the history of the species. Or perhaps we should say: to the interleaved questions of armed conflict, organized annihilation, human psychology and sociality, the city- and then the nation-state, and the particular form in which that something we call 'the economy' came into being. I take seriously the idea of the ancient historians that the key element in the transition to a monetized economy may not have been so much the generalization of trade between cultures (where kinds of barter went on functioning adequately) as the spread of endemic warfare, the rise of large professional armies, and the need for transportable, believable, on-the-spot payment for same.[15] And with money and mass killing came a social imaginary – a picture of human nature – to match.

'When, in a battle between cities,' says Nietzsche,

the victor, according to the *rights* of war, puts the whole male population to the sword and sells all the women and children into slavery, we see, in the sanctioning of such a right, that the Greek regarded a full release of his hatred as a serious necessity; at such moments pent-up, swollen sensation found relief: the tiger charged out, wanton cruelty flickering in its terrible eyes. Why did the Greek sculptor again and again have to represent war and battles, endlessly repeated, human bodies stretched out, their sinews taut with hatred or the arrogance of triumph, the wounded doubled up in pain, the dying in agony? Why did the whole Greek world exult in the pictures of fighting in the *Iliad*? I fear we do not understand these things in enough of a Greek fashion ... and we would shudder if we did.[16]

Nietzsche is vehement; some would say exultant. But much the same point can be made with proper ethnological drabness:

Many prehistoric bone fractures [Josephine Flood, summarizing the Australian aboriginal material] resulted from violence; many forearms appear to have been broken deflecting blows from clubs [fig. 88]. Most parrying fractures are on the left forearm held up to block blows to the left side of the body from a right-hander. Parrying fractures were detected on 10% of desert men and 19% of east coast women; for both groups they were the most common type of upper-limb fractures ... Fractured skulls were twice to four times as common among women as men. The fractures are typically oval, thumb-sized depressions caused by blows with a blunt instrument. Most are on the left side of the head, suggesting frontal attack by a right-hander. Most head injuries are thus the result of interpersonal violence, probably inflicted by men on women.[17]

88. Baldwin Spencer, Men quarrelling after accusations over disobedience of social laws, Alice Springs, 1901. Museums Victoria, Melbourne.

Do not think, by the way, that dwelling in this way on human ferocity leads necessarily in a Nietzschean direction. Listen to Hazlitt, speaking from the ironic heart of the English radical tradition:

> Nature seems (the more we look into it) made up of antipathies: without something to hate, we should lose the very spring of thought and action. Life would turn to a stagnant pool, were it not ruffled by the jarring interests, the unruly passions of men. The white streak in our own fortunes is brightened (or just rendered visible) by making all around it as dark as possible; so the rainbow paints its form upon the cloud. Is it pride? Is it envy? Is it the force of contrast? Is it weakness or malice? But so it is, that there is a secret affinity, a *hankering* after evil in the human mind … Protestants and Papists do not now burn one another at the stake: but we subscribe to new editions of *Fox's Book of Martyrs* [a contemporary equivalent might be *The Gulag Archipelago*];

and the secret of the success of the Scotch Novels is much the same – they carry us back to the feuds, the heart-burnings, the havoc, the dismay, the wrongs and the revenge of a barbarous age and people – to the rooted prejudices and deadly animosities of sects and parties in politics and religion, and of contending chiefs and clans in war and intrigue. We feel the full force of the spirit of hatred with all of them in turn … The wild beast resumes its sway within us, we feel like hunting-animals, and as the hound starts in its sleep and rushes on the chase in fancy, the heart rouses itself in its native lair, and utters a wild cry of joy.[18]

This has more to say about Homs and Abbottabad, or Anders Breivik and Geert Wilders, than most things written since.

It is a logical error of the Left, further, to assume that a full recognition of the human propensity to violence – to blood-soaked conformity – closes off the idea of a radical reworking of politics. The question is: what root is it we need to get down to? And even a Hazlitt-type honesty about 'a hankering after evil in the human mind' can perfectly well coexist (as it did in Hazlitt's post-Augustan generation) with a 'By our own spirits are we deified'. Human capacities may well be infinite; they have certainly been hardly explored, hardly been given their chance of flowering; but the tragic sense starts from an acknowledgment that the infinity (the unplumbable) is for bad as much as good.

It likewise is wrong to assume that moderacy in politics, if we mean by this a politics of small steps, bleak wisdom, concrete proposals, disdain for grand promises, a sense of the hardness of even the least 'improvement', is not *revolutionary* – assuming this last word has any descriptive force left. It depends on what the small steps are aimed at changing. It depends on the picture of human possibility in the case. A politics actually directed, step by step, failure by failure, to preventing the tiger from charging out would be the most moderate and revolutionary there has ever been.

Nietzsche again is our (Janus-faced) guide, in a famous glimpse of the future in *The Will to Power*. As a view of what the politics of catastrophe might actually be like it remains unique. He begins with an overall diagnosis that will be familiar to anyone who has read him; but then, less typically, he moves on. The diagnosis first:

> To put it briefly … What will never again be built any more, cannot be built any more, is – a society, in the old sense of that word; to build such, everything is lacking, above all the material. All of us [Nietzsche means us 'moderns'] are no longer material for a society; this is a truth for which the time has come![19]

We moderns no longer provide the stuff from which a society might be constructed; and in the sense that Enlightenment was premised on, perhaps we never did. The political unfolding of this reversal of the 'social' will be long and horrific, Nietzsche believes, and his vision of the century to come is characteristically venomous (which does not mean inaccurate): the passage just quoted devolves into a sneer at 'good socialists' and their dream of a free society built from wooden iron – or maybe, Nietzsche prophesies, from just iron on its own. After 'socialism' of this sort will come chaos, necessarily, but out of the chaos a new form of politics may still emerge. 'A crisis that … purifies, that … pushes together related elements to perish of each other, that … assigns common tasks to men who have opposite ways of thinking … Of course, outside every existing social order'.

And the upshot is the following:

> Who will prove to be the strongest in the course of this? The most moderate; those who do not require any extreme articles of faith; those who not only concede but actually love a fair amount of contingency and nonsense; those who can think of man with a considerable reduction of his value without becoming small

and weak themselves on that account ... human beings who are sure of their power and who represent, with conscious pride, the strength that humanity has [actually] achieved.[20]

Of course I am not inviting assent to the detail (such as it is) of Nietzsche's post-socialism. His thought on the subject is entangled with a series of naive, not to say nauseating, remarks on 'rank order' as the most precious fruit of the new movement. But as a sketch of what moderation might mean to revolutionaries, his note goes on resonating.

∽

Utopianism, on the other hand – that invention of early modern civil servants – is what the landlords have time for. It is everything Carlo Levi's peasants have learnt to distrust. Bruegel spells this out. His *Cockaigne* is above all a de-sublimation of the idea of heaven – an un-Divine Comedy, which only fully makes sense in relation to all the other offers of otherworldliness (ordinary and fabulous, instituted and heretical) circulating as Christendom fell apart. What the painting most deeply makes fun of is the religious impulse, or one main form that impulse takes (all the more strongly once the hold of religion on the detail of life is lost): the wish for escape from mortal existence, the dream of immortality, the idea of Life to Come. 'And God shall wipe away all tears from their eyes; and there shall be no more death, neither sorrow, nor crying, neither shall there be any more pain: for the former things are passed away.' What Bruegel says back to the Book of Revelation – and surely his voice was that of peasant culture itself, in one of its ineradicable modes – is that all visions of escape and perfectibility are haunted by the worldly realities they pretend to transfigure. Every Eden is the here and now intensified; immortality is mortality continuing; every vision of bliss is bodily and appetitive, heavy and ordinary and present-centred. The man emerging from the mountain of gruel in the background is the

'modern' personified. He has eaten his way through to the community of saints.

The young man on the ground at right, with the pens at his belt and the Bible by his side, we might see as none other than St Thomas More, awake but comatose in his own creation. And the lad gone to sleep on top of his flail? Who but Ned Ludd himself?

Utopias reassure modernity as to its infinite potential. But why? It should learn – be taught – to look failure in the face.

About modernity in general – about what it is that has made us moderns no longer 'social material' – I doubt there is anything new to say. The topic, like the thing itself, is exhausted: not over (never over), just tired to death.

All that needs restating here – and Baldwin Spencer's great photos of the longest continuing human culture are the proper accompaniment (figs. 88, 89) – is that the arrival of societies oriented towards the

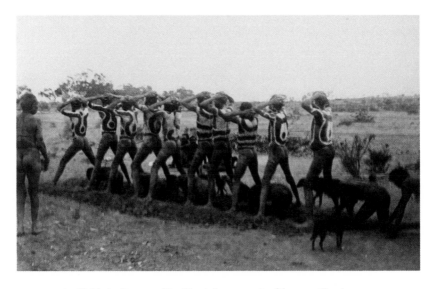

89. Baldwin Spencer, Final burial ceremonies, Tennant Creek, 1901.
Museums Victoria, Melbourne.

future, as opposed to a past of origins, heroisms, established ways, is a fact of History, not Nature, happening in one place and time, with complex, contingent causes; personal religion (that strange mutation) and double-entry bookkeeping being two of them. And by 'modernity' is meant very much more than a set of techniques or a pattern of residence and consumption: the word intends an ethos, a *habitus*, a way of being a human subject. I go back to the sketch given in a previous book:

'Modernity' means contingency. It points to a social order which has turned from the worship of ancestors and past authorities to the pursuit of a projected future – of goods, pleasures, freedoms, forms of control over nature, new worlds of information. The process was accompanied by a terrible emptying and sanitizing of the imagination. For without the anchorage of tradition, without the imagined and vivid intricacies of kinship, without the past living on (most often monstrously) in the detail of everyday life, meaning became a scarce social commodity – if by 'meaning' we have in mind agreed-on and instituted forms of value and understanding, orders implicit in things, stories and images in which a culture is able to crystallize its sense of the struggle with the realm of necessity and the realities of pain and death. The phrase Max Weber borrowed from Schiller, 'the disenchantment of the world' – gloomy yet in my view exultant, with its promise of a disabused dwelling in the world as it is – still sums up this side of modernity best ...

'Secularization' is a nice technical word for this blankness. It means specialization and abstraction, as part of the texture of ordinary doings; social life driven by a calculus of large-scale statistical chances, with everyone accepting or resenting a high level of risk; time and space turned into variables in that same calculus, both of them saturated by 'information' and played with endlessly, monotonously, on nets and screens; the de-skilling

of everyday life (deference to experts and technicians in more and more of the microstructure of the self); available, invasive, haunting expertise; the chronic revision of everything in the light of 'studies'.[21]

This does no more than block in the outlines: descriptively, there would be many things to add. But from the present point of view only two things need developing. First, that the essence of modernity, from the scripture-reading spice merchant to the Harvard iPod banker sweating in the gym, is a new kind of isolate obedient 'individual' with technical support to match. The printed book, the spiritual exercise, coffee and *Le Figaro*, *Time Out*, Twitter, tobacco (or its renunciation), the heaven of infinite apps. Second, that all this apparatus is a kind or extension of clockwork. Individuality is held together by a fiction of full existence to come. *Time Out* is always just round the corner. And while the deepest function of this new chronology is to do work on what used to be called 'subject positions' – keeping the citizen-subject in a state of perpetual anticipation (and thus accepting the pittance of subjectivity actually on offer) – it is at the level of politics that the Great Look Forward is most a given.

∽

What, in the trajectory of Enlightenment – from Hobbes to Nietzsche, say, or De Maistre to Kojève – were the distinctive strengths of the Right? A disabused view of human potential – no doubt always on the verge of tipping over into a rehearsal of original sin. And (deriving from the first) an abstention from futurity. Nietzsche as usual is the possible exception here, but the interest of his occasional glimpses of a politics to come is, as I have said, precisely their ironic moderacy.

Does the Right still possess these strengths? I think not. It dare not propose a view of human nature any longer (or if it does, it is merely Augustinian, betraying the legacy of Hume, Vico, even Freud

and Heidegger); and slowly, inexorably, it too has given in to the great modern instruction not to be backward-looking. The Right has vacated the places, or tonalities, that previously allowed it – to the Left's shame – to monopolize the real detailed description and critique of modernity, and find language for the proximity of nothing. The Left has no option but to try to take the empty seats.

<div style="text-align:center">∽</div>

Pessimism of the intellect, optimism of the will? Not any more: because optimism is now a political tonality indissociable from the promises of consumption. 'Future' exists only in the stock-exchange plural. Hope is no longer given us for the sake of the hopeless: it has mutated into an endless political and economic Micawberism.

<div style="text-align:center">∽</div>

The tragic key makes many things possible and impossible. But perhaps what is central for the Left is that tragedy does not expect something – something transfiguring – to turn up.

The modern infantilization of politics goes along with, and perhaps depends on, a constant orientation of politics towards the future. Of course the orientation has become weak and formulaic, and the patter of programmers and gene-splicers more inane. Walter Benjamin would recoil in horror at the form his 'weak messianism' has taken, now that the strong messiahs of the twentieth century have gone away. The Twitter utopia joins hands with the Tea Party. But the *direction* of politics resists anything the reality of economics – even outright immiseration making a comeback – can throw at it. Politics, in the form we have it, is nothing without a modernity constantly in the offing, at last about to realize itself: it has no other *telos*, no other way to imagine things otherwise. The task of the Left is to provide one.

<div style="text-align:center">∽</div>

'Presence of mind as a political category,' says Benjamin,

> comes magnificently to life in these words of Turgot: 'Before we
> have learned to deal with things in a given state, they have already
> changed several times. Thus, we always find out too late about
> what has happened. And therefore it can be said that politics is
> obliged to foresee the present.'[22]

You may ask, finally, what is the difference between the kind of anti-
utopian politics I am advocating and 'reformism' pure and simple. The
label does not scare me. The trouble with the great reformists within the
Internationals was that they shared, with the revolutionaries, a belief
in the essentially progressive, purgative, reconstructive destiny of the
forces of production. They thought the economy had it in it to remake
the phenotype. Therefore they thought reform was a modest proposal,
a pragmatic one. They were wrong. (The essential and noblest form of
socialist reformism – Bernstein's – came juddering to a halt in 1914, as
the cycle of twentieth-century atavisms began. As a *socialist* project, it
proved unrevivable.)

Reform, it transpires, is a revolutionary demand. To move even
the least distance out of the cycle of horror and failure – to leave the
kolkhozniks and water-boarders just a little way behind – will entail a
piece-by-piece, assumption-by-assumption dismantling of the politics
we have.

To end by rephrasing the question posed earlier: the Left in the heart-
lands of capitalism has still to confront the fact that the astonishing
– statistically unprecedented, mind-boggling – great leap forward in
all measures of raw social and economic inequality over the past forty
years has led most polities, especially lately, to the Right. The present
form of the politics of *ressentiment* – the egalitarianism of our time – is

the Tea Party. In what framework, then, *could* inequality and injustice be made again the object of a politics? This is a question that, seriously posed, brings on vertigo.

Maybe the beginning of an answer is to think of inequality and injustice, as Moses Wall seems to, as epiphenomena above all of permanent warfare – of the permanent warfare state. And to frame a politics that says, unequivocally: 'Peace will never happen.' It is not in the nature of (human) things that it should. But that recognition, for the Left, only makes it the more essential – the more revolutionary a programme – that the focal point, the always recurring centre of politics, should be to contain the effects and extent of warfare, and to try (the deepest revolutionary demand) to prise aggressivity and territoriality apart from their nation-state form. Piece by piece; against the tide; interminably. In the same spirit as that of a Left which might focus again on the problem of poverty – for of course there is no Left without such a prime commitment – all the more fiercely for having Jesus's words about its permanence ringing in their ears.

~

The question of reformism versus revolution, to take it up again, seems to me to have died the death as a genuine political dilemma, as opposed to a rhetorical flourish. To adapt Randolph Bourne's great dictum, extremisms – the extremisms we have – are now the health of the state.

The important fact in the core territories of capitalism at present (and this at least applies to Asia and Latin America just as much as Europe) is that no established political party or movement any longer even pretends to offer a programme of 'reform'. Reforming capitalism is tacitly assumed to be impossible; what politicians agree on instead is revival, resuscitation. Re-regulating the banks, perhaps – returning, if we are lucky, to the age of Nixon and Jean Monnet.

It surely goes without saying that a movement of opposition of the kind I have been advocating, the moment it began to register even

limited successes, would call down the full crude fury of the state on its head. The boundaries between political organizing and armed resistance would break down – not of the Left's choosing, but as a simple matter of self-defence. Imagine if a movement really began to put the question of permanent war economy back on the table – in however limited a way, with however symbolic a set of victories. Be assured that the brutality of the 'kettle' would be generalized. The public order helicopters would be on their way back from Bahrain. Jean Charles de Menezes would have many brothers. But the question that follows seems to me this: What are the circumstances in which the predictable to-and-fro of state repression and Left response could begin, however tentatively, to de-legitimize the state's preponderance of armed force? Not, for sure, when the state can show itself collecting severed and shattered body parts from the wreckage of tube trains. Extremism, to repeat, is the state's ticket to ride.

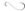

There will be no future, I am saying finally, without war, poverty, Malthusian panic, tyranny, cruelty, classes, dead time, and all the ills the flesh is heir to, because *there will be no future*; only a present in which the Left (always embattled and marginalized, always – proudly – a thing of the past) struggles to assemble the 'material for a society' Nietzsche thought had vanished from the earth. And this is a recipe for politics, not quietism – a Left that can look the world in the face.

Notes

Introduction

1 Joan Evans and John H. Whitehouse (eds.), *The Diaries of John Ruskin*, 3 vols. (Oxford, 1956), vol. 2, p. 437, entry from 1845, quoted in Robert Hewison, *John Ruskin: The Argument of the Eye* (Princeton, 1976), pp. 195–96.

2 See Terisio Pignatti and Filippo Pedrocco, *Veronese* (Milan, 1995), vol. 2, pp. 558–59 ('Nui pittori [hauemo la] si pigliamo licentia, che si pigliano i poeti e i matti').

3 Thomas Traherne, *Centuries of Meditations* [*c.*1669–74] (London, 1908), p. 19.

4 Compare Erich Auerbach, *Dante: Poet of the Secular World* [1929], trans. Ralph Manheim (Chicago, 1961), pp. 172–73: 'The *Comedy*, as we have repeatedly said, treats of earthly reality in its true and definitive form; but palpable and concrete as this reality is, it takes on a dreamlike quality in the Other World … Not that the reality of life has vanished; it has grown doubly plain and tangible. But the light is different and the eyes must grow accustomed to it … Dante transports his listeners into a strange world so permeated by the memory of reality that it seems real while life itself becomes a fragmentary dream; and that unity of reality and remoteness is the source of his psychological power.'

5 The last term is borrowed from Jean-Paul Sartre, *Critique de la raison dialectique*, vol. 1 (Paris, 1960), p. 391: 'le groupe en fusion'. Compare p. 383: 'le groupe comme *passion*'. Discussing the storming of the Bastille, his chosen example of the (fleeting) emergence of the fused group, Sartre cites Malraux's novel *L'Espoir*, in which such a moment of fusion is linked explicitly to the notion of apocalypse – unveiling, revelation, expectation of the end. I leave aside Sartre's further analysis of the steps leading, in his view necessarily, from fused group to Party.

6 Friedrich Nietzsche, *The Will to Power*, trans. Walter Kaufman and Reginald Hollingdale (New York, 1967), p. 537, translation modified.

7 Ibid., p. 536.

8 Revelation, 21: 4.

9 Lactantius Firmianus, *Epitome Divinarum Institutionum*, written in the fourth century, quoted in Norman Cohn, *The Pursuit of the Millennium* (London, 1957; revised edition 2004), p. 28.

10 William Blake, 'The Marriage of Heaven and Hell', in David Erdman (ed.), *The Complete Poetry and Prose of William Blake* (New York, 1988), p. 36.

11 Leszek Kolakowski, *Main Currents of Marxism*, 3 vols. (Oxford, 1978), vol. 3, pp. 526, 530.

12 Compare Traherne, *Centuries of Meditations*, pp. 130–31: 'Objective treasures are always delightful: and though we travail endlessly, to see them all our own is infinitely pleasant: and the further we go the more delightful. If they are all ours wholly and solely, and yet nevertheless every one's too, it is the most delightful accident

that is imaginable, for thereby …
two inclinations, that are both in our
natures, yet seem contradictory, are
at once satisfied': namely, possessive
individualism, 'whereby we refer all
unto ourselves and naturally desire to
have all alone in our private possession',
and 'the communicative humour …
whereby we desire to have companions
in our enjoyments to tell our joys, and
to spread abroad our delights, and to
be ourselves the joy and delight of
other persons.' It goes without saying
that the ground of such commonality
for Traherne is our being-together
in Christ.

Chapter 1: Giotto and the Angel

1 Jan Gijsel (ed.), *Libri de Navitate
Mariae* (Turnhout, 1997), the most
authoritative modern edition, says it was
compiled in the late seventh century.
The oldest surviving manuscript is from
four centuries later. Scholars think that
both *The Book of Mary* (now known to
experts, unfortunately, as *The Gospel of
Pseudo-Matthew*) and *The Gospel of the
Book of Mary*, which seem Giotto's
most important sources, may draw
on earlier material, perhaps going back
to the fifth century. See J. K. Elliott,
The Apocryphal New Testament
(Oxford, 1993), pp. 84–86, 120.

2 Claudio Bellinati, *Giotto: Atlante
iconografico della Cappella di Giotto*
(Treviso, 1997), p. 72, points out that
the inscription on the scroll held by the
prophetess Anna in the *Presentation of
Christ in the Temple* appears to be taken
directly from *The Book of Mary*, with
one word altered.

3 A. Walker, *Apocryphal Gospels, Acts and
Revelations* (Edinburgh, 1870), p. 18.

4 See Paul Hills, *The Light of Early Italian
Painting* (New Haven and London,
1987), pp. 11–16 for a brief summary,

building on G. F. Vescovini, *Studi sulla
prospettiva medievale* (Turin, 1965).

5 Walker, *Apocryphal Gospels*, p. 21;
Latin text in Constantin Tischendorf,
Evangelia Apocrypha (Leipzig, 1866), p.
58.

6 T. S. Eliot, *Collected Poems 1909–1962*
(London, 1963), p. 105.

7 See Anne Derbes and Mark Sandona,
*The Usurer's Heart: Giotto, Enrico
Scrovegni, and the Arena Chapel in Padua*
(University Park, Pennsylvania, 2008),
pp. 126–27, 200, for discussion of the
Pisan panel and the previous and later
history of the Joachim and Anna cycle
in art. The Pisan panel is usually dated
1270–90 and ascribed to the Master of
San Martino (sometimes called Rainieri
di Ugolino).

8 Walker, *Apocryphal Gospels*, p. 54.

9 Ibid.

10 Ibid. The Latin text in Tischendorf,
Evangelia Apocrypha, reads: 'Si ergo ratio
verbis meis tibi non persuadet'.

11 John Ruskin, *Giotto and his Works in
Padua*, in *The Works of John Ruskin*,
Edward T. Cook and Alexander
Wedderburn (eds.) (London, 1903–12),
vol. 24, p. 28. (Though serious and
informative, this essay is by no means
the strongest of Ruskin's statements on
Giotto: the material on Assisi in *Fors
Clavigera* and on the Bardi Chapel
and the Campanile reliefs in *Mornings
in Florence* is more impassioned and
characteristic.)

12 John Ruskin, *Fors Clavigera*, in *The
Works of John Ruskin*, Edward T. Cook
and Alexander Wedderburn (eds.)
(London, 1903–12), vol. 29, p. 91 (letter
76, April 1877). Compare an earlier
letter on the cult of Mary, which Ruskin
knows will be a sticking point for many
of his Protestant readers: 'I do not enter
into any question as to the truth or
fallacy of the idea … but I am certain

that to the habit of reverent belief in, and contemplation of, the character ascribed to the heavenly hierarchies, we must ascribe the highest results yet achieved in human nature … and every brightest and loftiest achievement of the arts … has been the fulfilment of the assured prophecy of the poor Israelite maiden, "He that is mighty hath magnified me, and Holy is His name.'" See ibid., vol. 28, p. 82 (letter 41, April 1874).

13 Benvenuto da Imola, *Comentum super Dantis Aligherii comoediam*, written in the 1270s, quoted in Derbes and Sandona, *The Usurer's Heart*, p. 17 ('No one subtler than [Giotto] has yet appeared').

14 On Giotto's workshop organization, see Bruno Zanardi, 'Giotto and the St. Francis Cycle at Assisi', in Anne Derbes and Mark Sandona, *The Cambridge Companion to Giotto* (Cambridge, 2004), pp. 32–62, building on much previous material, notably Bruno Zanardi, *Il cantiere di Giotto* (Milan, 1996). On the Arena Chapel specifically, see Giuseppe Basile, 'Giotto's Pictorial Cycle', in Giuseppe Basile (ed.), *Giotto, The Frescoes of the Scrovegni Chapel in Padua* (Milan, 2002), pp. 21–39, and Laura Jacobus, 'Giotto's Workshop', in Laura Jacobus, *Giotto and the Arena Chapel: Art, Architecture and Experience* (Turnhout, 2008), pp. 133–52.

15 Eliot, *Collected Poems*, pp. 76 ('The Waste Land'), 104 ('Ash Wednesday'), 91 ('The Hollow Men').

16 Marcel Proust, *Albertine disparue* (Paris, 2009 [1925]), pp. 351–52.

17 Ibid.: 'la même impression d'action effective, littéralement réelle'.

18 Tischendorf, *Evangelia Apocrypha*, pp. 108–9: 'Ne timeas, Anna, neque phantasma esse putes quod vides.'

19 Jacobus de Voragine, *The Golden Legend: Readings on the Saints*, trans. William Granger Ryan (Princeton, 2012), p. 538: 'Then one day an angel appeared with great brilliance to him when he was alone. He was disturbed by the apparition, but the angel told him not to be afraid.' Compare *The Gospel of the Nativity of Mary* in Walker, *Apocryphal Gospels*, p. 54: 'Now, when he had been there for some time, on a certain day when he was alone, an angel of the Lord stood by him in a great light. And when he was disturbed at his appearance, the angel who had appeared to him restrained his fear, saying: Fear not, Joachim, nor be disturbed by my appearing; for I am the angel of the Lord.' Here, as elsewhere, the *Golden Legend* lacks the apocryphal gospels' intensity.

20 Ruskin, *Giotto and His Works in Padua*, in *The Works of John Ruskin*, vol. 24, pp. 38–39.

21 John Ruskin, *Mornings in Florence*, in *The Works of John Ruskin*, vol. 23, p. 348.

22 Ibid., p. 349.

23 Many writers on Giotto have made the same point, or something like it, before. See, for example, Roger Fry, 'Giotto', in Roger Fry, *Vision and Design* (London, 1928), pp. 174–76: 'Giotto was one of the greatest masters of line that the world has seen, and the fact that his knowledge of the forms of the figure was comparatively elementary in no way interferes with his greatness. It is not how many facts about an object an artist can record, but how incisive and how harmonious with itself the record is, that constitutes the essence of draughtsmanship.' Compare Richard Offner, 'Giotto, Non-Giotto', in James Stubblebine (ed.), *Giotto: The Arena Chapel Frescoes* (New York, 1969),

pp. 135–55: 'The composition being conceived as a system of interdependent elements, each figure is accommodated to the whole by being contoured and modeled large in order not to draw too much attention to itself by individualization or description of its physical character. To the same end it needs must be immobilized. The composition thus subjugates the individual form to a corporate order and equilibrium, which it brings into predominating evidence. This implies a non-naturalistic treatment of the figure' (p. 139).

24 Dante Alighieri, *Paradiso*, ed. and trans. C. S. Singleton (Princeton, 1982), p. 268: 'Però salta la penna e non lo scrivo:/ chè l'imagine nostra a cotai pieghe,/ non che 'l parlare, è troppo color vivo.' A closer translation would be: 'For our imagination, not to say our speech, is of too vivid colour for such folds', i.e. it is too crude and bright for heaven's gradations. Charles Singleton quotes C. H. Grandgent, *La Divina Commedia* (Cambridge, MA, 1972), on the metaphor's debt to painting: ibid., p. 386.

25 See Giuseppe Basile (ed.), *Il Restauro della Cappella degli Scrovegni: Indagini, progetto, risultati* (Rome and Milan, 2003), especially pp. 433–37, for details on the 2001–02 restoration's decisions relating to colour.

26 See Hilary Spurling, *The Unknown Matisse* (New York, 1998), p. 395.

27 See Fry, 'Giotto', pp. 131–77. His paragraphs on the Joachim series largely dismiss the distinction between 'illustration' and 'pictorial art', which in another mood he was fond of insisting on. 'In every incident of his sojourn in the wilderness … his appearance indicates exactly his mental condition … It is true that in speaking of [this] one is led inevitably to talk of elements in the work which modern criticism is apt to regard as lying outside the domain of pictorial art. It is customary to dismiss all that concerns the dramatic presentation of the subject as literature or illustration, which is to be sharply distinguished from the qualities of design. But can this clear distinction be drawn, in fact?' (pp. 168–69).

28 Walter Benjamin, *The Arcades Project*, trans. Howard Eiland and Kevin McLaughlin (Cambridge, MA, 1999), p. 846 (First Sketches, I, 2): 'The anecdote brings things near to us spatially, lets them enter our life. It represents the strict antithesis to the sort of history that demands "empathy," which makes everything abstract. *"Empathy": this is what newspaper reading terminates in.* The true method of making things present is: to represent them in our space (not to represent ourselves in their space) … Thus represented, the things allow no mediating construction from out of "large contexts." – It is, in essence, the same with the aspect of great things from the past – the cathedral of Chartres, the temple of Paestum: to receive them into our space (not to feel empathy with their builders or their priests). We don't displace our being into theirs: they step into our life.' This is an early and bald statement of an argument that permeates *The Arcades Project* and the late 'Theses on the Philosophy of History'.

29 Ruskin, *Giotto and his Works in Padua*, in *The Works of John Ruskin*, vol. 24, pp. 56–57.

30 Andrew Ladis, *Giotto's O: Narrative, Figuration, and Pictorial Ingenuity in the Arena Chapel* (University Park, PA, 2008), p. 67, says that the narrative prescribes a nocturnal setting. I doubt this: the sources make no mention of night and day, and the idea of Joachim's

being 'overpowered' by sleep while thinking things over may suggest some kind of daytime visitation. But in any case Ladis responds beautifully to the *Dream*'s 'cool, intense light, markedly brighter than in the preceding scene' of *Joachim's Sacrifice*. 'A world as eerie as this confers an added strangeness to the unexpected.'

31 The most serious recent account of *Dream* is Ladis's, ibid., pp. 67–70. It gives great weight to the branch sprouting from the rock face just above Joachim's hut, seeing it ('in retrospect', once we are alerted to *Dream*'s place in the Marian sequence) as 'not merely a symbol of fertility but also an image of the Virgin herself'. For Ladis, even the fissure in the earth and the central grazing sheep are figures of fertility to come. I agree that the moment shown in *Dream* is a turning point, but barrenness seems to me still the dominant note. Nancy Locke (personal communication) points out that Giotto's stress on Joachim's uncertainty is fully compatible with the saint's place in the legend of Mary – a pious Jew, not yet privy to Christian revelation, though perhaps dimly aware of its imminence.

32 *The Book of Mary*, in Walker, *Apocryphal Gospels*, p. 18.

33 British Library MS Harl. 3571, 'History of the Most Holy Family', quoted in Ruskin, *Giotto and his Works in Padua*, in *Works of John Ruskin*, vol. 24, p. 49. (Ruskin believes this is a North Italian retelling from the mid-fourteenth century. He makes no claim for it as a direct source, but thinks it gives a glimpse of further treatments of the legend to which Giotto and his advisers may have had access.)

34 Ruskin's translation, in ibid. Compare Walker, *Apocryphal Gospels*, p. 54. Ruskin despises the apocryphal gospels, 'which are as wretched in style as

untrustworthy in matter' (p. 44, n.), but he recognizes that they, rather than the *Golden Legend*, may constitute 'the exact words in which the scenes represented by Giotto were recorded to him'.

35 Whether or not the Arena Chapel's decorations respond to, and in some sense try to make amends for, the Scrovegni family's ill-gotten gains continues to be debated. Compare the arguments in Derbes and Sandona, *The Usurer's Heart*, with those in Jacobus, *Giotto and the Arena Chapel*. Jacobus presents new material on the chapel's changing layout and function in its early years, stresses the splendour and self-confidence of Scrovegni's position in Padua, and questions whether the association of Judas specifically with usury (which Derbes and Sandona make much of) was in fact strong in the later Middle Ages; but to my mind she does not entirely extract the commission from the traditional 'restitution for usury' frame. Some of Derbes and Sandona's arguments remain suggestive: in particular their insistence on the specialness of the juxtaposition of the *Pact of Judas* and the *Visitation* over the chancel arch; their account of the chapel's overall imagery of barrenness and fertility, and the connection of such imagery to late-medieval notions of usury; and even, though here the evidence is open to challenge, their pointing to the stress on penitence (humiliation and abnegation) followed by redemption in several of the chapel's key scenes, notably the Joachim story.

36 Anthony of Padua, quoted in Derbes and Sandona, *The Usurer's Heart*, p. 128.

37 Tischendorf, *Evangelia Apocrypha*, p. 59: 'Cum autem Ioachim evigilasset a somno, omnes gregarios ad se vocavit eisque somnium indicavit. Illi vero adoraverunt dominum et dixerunt ei Vide ne ultra angeli dicta contemnas.'

38 Erich Auerbach, *Mimesis: The Representation of Reality in Western Literature* (Princeton, 1953), pp. 43, 44.

39 Compare Fry, *Vision and Design*, p. 168: 'The sad figure of Joachim is one never to be forgotten … When he first comes to the sheepfold, he gazes with such set melancholy on the ground that the greeting of his dog and his shepherds cannot arouse his attention.'

Chapter 2: Bruegel in Paradise

1 Fragment preserved in St Irenaeus, *Adversus haereses*, quoted in Norman Cohn, *The Pursuit of the Millennium* (London, 1957; revised edition 2004), p. 27. Papias wrote around AD 100, collecting (genuine and spurious) first-hand accounts of Christ.

2 See the most recent studies: Hermann Pleij, *Dreaming of Cockaigne: Medieval Fantasies of the Perfect Life*, trans. Diane Webb (New York, 2001 [first Dutch edition 1997]), and Hilario Junior, *Cocagne: Histoire d'un pays imaginaire* (Paris, 2013 [first Brazilian edition 1998]).

3 See Jean Delumeau (ed.), *La mort des pays de Cocagne: Comportements collectifs de la Renaissance à l'âge classique* (Paris, 1976).

4 See Timothy Clark, 'Painting at Ground Level', in *The Tanner Lectures on Human Values*, vol. 24 (Salt Lake City, 2004), pp. 131–72.

5 Alfred Tennyson, 'Tithonus', in Christopher Ricks (ed.), *Tennyson: A Selected Edition* (Berkeley and Los Angeles, 1978), pp. 584, 992. (The word 'earth' is used in the first two versions of the poem; the third opts for 'field'.)

6 See Roger Marijnissen, *Bruegel: Tout l'oeuvre peint et dessiné* (Paris, 1988), pp. 242–43. (Marijnissen notes, with an irony that does not invalidate the

judgment, that personnel and poses in *Spring* 'se prêtent à merveille à une exégèse marxiste'.)

7 Edward Snow, *Inside Bruegel: The Play of Images in Children's Games* (New York, 1997), p. 120. Snow's book, scrupulous in its representation of the art-historicist scholarship it is arguing with, devastating in its arguments and endlessly suggestive in its readings of Bruegel's imagery, is conspicuous by its absence from almost all recent art-historical literature.

8 For a judgment on Snow (as opposed to lofty silence), see Keith Moxey, 'Pieter Bruegel and Popular Culture', in David Freedberg, *The Prints of Pieter Bruegel the Elder* (Tokyo, 1989), pp. 45–46. Moxey gets Snow's point about the ambiguity of Bruegel's 'signifying structures' wrong. Snow's argument is that sixteenth-century culture itself (not 'the evidence' we have of it), insofar as we can reconstruct its full range, is ambiguous in its attitudes to and evaluation of childhood (as are most cultures). Compare sixteenth-century attitudes to the 'low', the 'earthy', the peasant and the 'folk'. On the accusation of undue subjectivity regularly levelled at Snow, see the always-to-be-reread 'Unfair Intimidation', in Theodor Adorno, *Minima Moralia*, trans. Edward Jephcott (London, 1974), pp. 69–70: 'The notions of subjective and objective have been completely reversed. Objective [now] means the non-controversial aspect of things, their unquestioned impression, the façade made up of classified data, that is, the subjective; and they call subjective anything that breaches that façade, engages the specific experience of a matter, casts off ready-made judgments and substitutes relatedness to the object for the majority consensus of those who do not even look at it, let alone think about it – that is, the objective.'

9 From a large literature, see, for
example, Moxey, 'Bruegel and Popular
Culture', and Moxey, 'Sebald Beham's
church anniversary holidays: festive
peasants as an instrument of repressive
humor', *Simiolus*, 12 (1982), pp. 107–30
(the clearest statement of Moxey's
background assumptions). Compare
Hans-Joachim Raupp, *Bauernsatiren:
Entstehung und Entwicklung des
bäuerlichen Genres in der deutschen und
niederländischen Kunst ca. 1470–1570*
(Niederzier, 1986); Margaret Sullivan,
*Bruegel's Peasants: Art and Audience in
the Northern Renaissance* (Cambridge,
1994); Ethan Matt Kavaler, *Pieter
Bruegel: Parables of Order and Enterprise*
(Cambridge, 1999). For contrary views,
see Svetlana Alpers, 'Bruegel's Festive
Peasants', *Simiolus*, 6 (1972–73),
pp. 163–76; Margaret Carroll, 'Peasant
Festivity and Political Identity in the
Sixteenth Century', *Art History*, 10
(1987), pp. 289–314. The debate about
Bruegel's peasants may now be escaping
from this previous frame: see Stephanie
Porras, *Pieter Bruegel's Historical
Imagination* (University Park, PA, 2016);
and Joseph Koerner, *Bosch and Bruegel:
From Enemy Painting to Everyday Life*
(Princeton and Oxford, 2016), especially
pp. 13–20, 268–74.

10 Hans Sedlmayr, 'Bruegel's *Macchia*',
trans. Frederic Schwartz, in Christopher
Wood (ed.), *The Vienna School Reader:
Politics and Art Historical Method in the
1930s* (New York, 2000), p. 336.

11 See Pleij, *Dreaming of Cockaigne, passim*;
Junior, *Cocagne, passim*; Marijnissen,
Bruegel, pp. 333–34 (citing a Dutch
description of *Luye-leckerlandt* from
1546); Delumeau, *La mort du pays de
Cocagne, passim*; and, from a large
literature, Louis Lebeer, 'Le Pays de
Cocagne (Het Luilekkerland)', *Musées
Royaux des Beaux-Arts de Belgique,
Bulletin*, 4 (1955), pp. 199–214, and
Lebeer's entry on the *Cockaigne* print

in *Catalogue raisonné des estampes de
Pierre Bruegel l'Ancien* (Brussels, 1969);
Jacques Le Goff, 'L'utopie mediévale: le
pays de Cocagne', *Revue européenne des
sciences sociales*, 27 (1989), pp. 271–86; and
Hans Gilomen, 'Das Schlaraffenland
und andere Utopien im Mittelalter',
*Basler Zeitschrift für Geschichte und
Altertumskunde*, 104 (2004), pp. 213–48.

12 Some of Junior's interpretations of
the *fabliau* are unconvincing, but
he establishes that the text plays on
multiple and often enigmatic registers:
see Junior, *Cocagne*, pp. 25–78 and *passim*.
On the oral basis of the legend, see
Pleij, *Dreaming of Cockaigne*, pp. 3–4, 28;
and Junior, *Cocagne*, pp. 18–19, 59–60,
76, discussing the uses made of it by
different classes.

13 See Junior, *Cocagne*, pp. 312–30: pushing
the argument too far, but pointing to
an unmistakable evolution.

14 First reproduced in Ross Frank, 'An
Interpretation of *Land of Cockaigne*
(1567) by Pieter Bruegel the Elder',
Sixteenth Century Journal, 22 (1991),
p. 303.

15 See Pleij, *Dreaming of Cockaigne*,
pp. 431, 434 (with the sentences cited
below), and discussion on pp. 301–3.
On the Free Spirit heresy, see R. Lerner,
*The Heresy of the Free Spirit in the Later
Middle Ages* (Berkeley, 1972); Cohn,
Pursuit of the Millennium, pp. 148–86;
Pleij, *Dreaming of Cockaigne*, pp. 311–34.

16 Quoted from Lebeer in the Brussels
Catalogue raisonné, p. 156. See also
Manfred Sellinck's entry in Nadine
Orenstein (ed.), *Pieter Bruegel, Drawings
and Prints* (New York, 2001), pp. 256–57.

17 On Bruegel's inwardness with the
calendar and key figures of Carnival,
see Claude Gaignebet, 'Le combat de
Carnaval et de Carême de P. Bruegel
(1559)', *Annales: Economies, Sociétés,
Civilisations*, 27 (1972), pp. 313–45.

18 See Pleij, *Dreaming of Cockaigne*, pp. 89–162 (the 'ritual surfeit' quote is on p. 130); and Junior, *Cocagne*, pp. 79–95, 312–13.

19 Max J. Friedländer, *Early Netherlandish Painting*, vol. 14 (Leyden and Brussels, 1976), p. 16.

20 Ibid., p. 34.

21 Ibid., p. 33.

22 For recent discussion of the Bosch–Bruegel relationship, see Tine Luk Meganck, *Pieter Bruegel the Elder, Fall of the Rebel Angels: Art, Knowledge and Politics on the Eve of the Dutch Revolt* (Milan and Brussels, 2014), pp. 35–63; and, pre-eminently, Koerner, *Bosch and Bruegel*, pp. 77–94 and *passim*. (The present chapter's view of the 'everyday', the allegorical and the theological in Bruegel ends up largely disagreeing with Koerner's. His culminating account of the Brussels *Winter Landscape with Bird Trap* is powerful, but my dissent from it can be summed up as follows: what seems to me most spellbinding about the bird trap in the scene is its ordinariness, its carefully plotted unobtrusiveness, its improvised homeliness, its integration into the picture's whole patterning of nature and culture. Koerner believes that the trap presents us with a 'terrifying perspective' on the world. I'd like to know more about the contribution of pigeon pie to a Netherlander's winter diet.)

23 Early versions of the moralizing interpretation could be eloquent: see Louis Maeterlinck, *Le genre satirique dans la peinture flamande* (Ghent, 2nd edn 1907): 'The painter may have wished to satirize his fellow-countrymen, who were too ready to indulge in the pleasures of the table and idleness, and to show that – as coming events were to prove – an excessive preoccupation with physical well-being would undermine their moral courage and make them

ready to accept oppression and tyranny', quoted in Piero Bianconi, *The Complete Paintings of Bruegel* (London, 1969), p. 108. By the time of Fritz Grossmann, *Bruegel: The Paintings* (London, 1966 [first published 1955]), p. 202, the picture 'is obviously intended as a condemnation of the sins of gluttony and sloth'; compare Kavaler, *Pieter Bruegel*, pp. 8–9 and no. 124, for a recent statement of the case; and Marijnissen, *Bruegel*, pp. 333–34, for a selection of arguments. Most art-historical treatments (not all) recognize that the picture was also meant to be funny.

24 For the Dutch text, see Freedberg, *Prints of Pieter Bruegel*, p. 169. I have preferred the translation in Marijnissen, *Bruegel*, p. 337.

25 See Sellinck in Orenstein, *Bruegel, Drawings and Prints*, pp. 256–57, building on Stephen Kostyshyn, 'A Reintroduction to the Life and Work of Peeter Baltens', PhD dissertation, Case Western Reserve University (Cleveland, 1994). On the altarpiece, see Marijnissen, *Bruegel*, p. 11.

26 The question of Bruegel's relation to the 'Boschian' recurs; and *Cockaigne* may indeed be partly an answer to *The Garden of Earthly Delights*. By 1567 the *Garden* was a coveted trophy: it belonged to William of Orange, and in December 1567 was still on display in his Nassau palace. Tine Meganck, *Fall of the Rebel Angels*, pp. 41–48, 148–51, makes the case for Bruegel's earlier knowledge of William's triptych. *Cockaigne* reverses many of the *Garden's* key terms: the chosen few are preferred to the multitude, closeness displaces panorama, gluttony trumps *voluptas*, and insensibility nude acrobatics.

27 Porras, *Pieter Bruegel's Historical Imagination*, pp. 49–50, sees *Cockaigne* as deliberately nostalgic in its picture of a world still organized around the 'three

estates', for all the presence of a modern city – maybe even Antwerp – on the other side of the mountain.

28 Peter Sahlins, personal communication. The idea that *Cockaigne*, as well as other pictures from around 1567, in some sense responded to contemporary horrors begins fairly early in the literature. See, for example, René van Bastelaer and Georges Hulin de Loo, *Peter Bruegel l'Ancien, son oeuvre et son temps* (Brussels, 1907), p. 134: 'Les premiers combats, les troubles et l'occupation d'Anvers par les troupes des Gueux, l'arrivée du duc d'Albe le 16 août, l'arrestation d'Egmont et de Horne, et l'érection du Conseil des troubles marquent l'année suivante, et, par ironie évidente, c'est le moment que Bruegel choisit pour executer sa peinture du Luilekkerland … L'idée de peindre le Luilekkerland dans les circonstances présentes était ironique au suprême degré.' Frank, 'An Interpretation', the most thoroughgoing attempt to read *Cockaigne* as politically coded, is unconvincing: individual readings and claims are farfetched (for instance, most of the analogies made between *Cockaigne*'s imagery and proverbs), and the argument as a whole built on non sequiturs. David Kunzle, 'Spanish Herod, Dutch Innocents: Bruegel's *Massacres of the Innocents* in their sixteenth-century political contexts', *Art History*, 24 (February 2001), pp. 51–82, seems to me the most scrupulous recent discussion of politics in Bruegel's late work: he makes a case for contemporary allusion in the *Massacre* and *Census in Bethlehem*, as well as the *Conversion of Saint Paul*, *Sermon of Saint John the Baptist* and perhaps even *Magpie on the Gallows*, but passes over Frank's reading of *Cockaigne* in charitable silence.

29 Collect, Fourth Sunday after Epiphany.

30 See Friedländer, *Early Netherlandish Painting*, p. 37: 'Since the body, in function and configuration, determined the fall of drapery, it was deemed urgent and indispensable to acquire an intimate knowledge of the organism in its cocoon. Only Bruegel took in the appearance as a whole … He rejoiced in its many manifestations. There was but one body, but many forms of dress and countless silhouettes adopted by the moving body in its swathings.'

31 On Bruegel's relation to the world of proverbs, see especially David Kunzle, 'Bruegel's Proverb Painting and the World Upside Down', *Art Bulletin*, 59 (June 1977), pp. 197–202; Alan Dundes and Claudia Stibbe, *The Art of Mixing Metaphors: A Folkloristic Interpretation of the 'Netherlandish Proverbs' by Pieter Bruegel the Elder* (Helsinki, 1981); Rainald Grosshans, *Pieter Bruegel d. Ä: Die niederländischen Sprichwörter* (Berlin, 2003), pp. 20–31; and Margaret Carroll, *Painting and Politics in Northern Europe: Van Eyck, Bruegel, Rubens, and their Contemporaries* (University Park, PA, 2008), pp. 33–46.

32 How much or what kind of 'folly' the tower may be is a question the Vienna picture leaves open. As a feat of building Babel is lovingly described. Compare, for a reading inspired by Hegel's rewriting of the story of the tower in his *Lectures on Aesthetics*, Catharina Kahane, 'Der Fall Babel. Volksbildung im Pieter Bruegels d. Ä Turmbau', in Beate Fricke et al. (eds.), *Bilder und Gemeinschaften* (Munich, 2010), pp. 141–68.

33 For arguments about cooking and civilization, see Claude Lévi-Strauss, *The Raw and the Cooked*, trans. John and Doreen Weightman (London, 1970); Marcel Detienne and Jean-Pierre Vernant, *The Cuisine of Sacrifice among the Greeks*, trans. Paula Wissing (Chicago, 1989); and compare Walter

Burkert, *Homo Necans: The Anthropology of Ancient Greek Sacrificial Ritual and Myth*, trans. Peter Bing (Berkeley and Los Angeles, 1983).

34 Genesis 3: 19.

35 From the more recent literature, see Walter Gibson, *Peter Bruegel the Elder: Two Studies* (Lawrence, KS, 1991), pp. 53–86. Compare the typical verdict in Grossmann, *Bruegel, The Paintings*, p. 192: 'It is the idea of Last Judgment closely connected with death which for Bruegel the Christian makes physical death so frightening.'

36 On this topic see Pleij, *Dreaming of Cockaigne*, pp. 165–81, 191–206, 281–97 (this last section pointing to the possibility that Cockaigne and *Luilekkerland* sometimes consciously poked fun at ideas of paradise).

37 Svetlana Alpers, oral response to my 'Painting at Ground Level' lectures, Princeton University, 2002.

38 See *The Catholic Encyclopedia*, ed. Charles Herbermann et al. (New York, 1912), vol. 13, p. 551.

39 From the large literature, see Fernand Braudel, *Capitalism and Material Life 1400–1800*, trans. Miriam Kochan (New York, 1973); Neil McKendrick et al., *The Birth of a Consumer Society: The Commercialization of Eighteenth-Century England* (London, 1982); Ben Fine and Ellen Leopold, *The World of Consumption* (London and New York, 1993); John Brewer and Roy Porter (eds.), *Consumption and the World of Goods* (London, 1993).

40 The art-historical literature – for instance, the majority of items indicated in note 9 – presents us with a Bruegel whose art equivocated constantly between moral disapproval of the excesses and naiveties it showed and nostalgia for the simplicities of a vanishing 'folk'. It is true that some such

mixture of censure and sentimentality soon became a standard ingredient of modern consciousness: whether Bruegel pioneered it remains questionable.

41 Hessel Miedema, 'Realism and comic mode: the peasant', *Simiolus*, 9 (1977), pp. 205–19; the quoted passage is on p. 211. Compare on the same page: 'If I am correct about this, it is out of the question that anyone of erudition (and erudition is something that Bruegel and print publishers clearly had in abundance) could ever have laughed uninhibitedly at peasant scenes in Bruegel's day.' For less joyless views of Bruegel's world, see Johan Verberckmoes, *Laughter, Jestbooks and Society in the Spanish Netherlands* (Basingstoke, 1999); and Walter Gibson, *Pieter Bruegel and the Art of Laughter* (Berkeley and Los Angeles, 2006).

42 Scholars have doubted that the words were present in the picture originally, though it seems that the picture made room for some such inscription: see Koerner, *Bosch and Bruegel*, p. 26.

43 'I shit on the world': a saying illustrated in Bruegel's *Netherlandish Proverbs*.

44 See discussion in Wilhelm Fraenger, *Das Bild der 'Niederländischen Sprichwörter' – Pieter Bruegels verkehrte Welt* (Amsterdam, 1999 [first published 1923]), p. 48. The verb *krommen* resists translation: 'stoop' or even 'grovel' are possible renderings.

45 Compare Koerner, *Bosch and Bruegel*, pp. 355–64, for a reading of *Magpie* that sees the picture as belonging to a cluster of works that respond to Alba's reign of terror – even reflecting a new consciousness of the gallows' (the Law's) arbitrariness. I feel the painting's overall atmosphere distinguishes it from the grimmer, bleaker, more 'political' works immediately preceding it, in which soldiers, and wintry barrenness, stand for the reality of present power.

46 See Kunzle, 'Spanish Herod', pp. 53–54, for a good brief survey. Numbers vary wildly; perceptions trumped statistics. Jonathan Israel, *The Dutch Republic: Its Rise, Greatness, and Fall* (Oxford, 1995), pp. 159–60, puts the number of executions under Alba at 'more than 5,000'. Contemporaries seem to have believed the figure, for the whole period of conflict, to be six or even ten times as large.

47 Henri Pirenne, *Histoire de Belgique* (Brussels, 1922), vol. 3, p. 428, cited by Kunzle, 'Spanish Herod', p. 53.

Chapter 3: Poussin and the Unbeliever

1 Robert Browning, *The Ring and the Book*, ed. Richard Altick (London, 1971), p. 375.

2 Nicolas Poussin, *Correspondance de Nicolas Poussin*, ed. Charles Jouanny (Paris, 1911), pp. 379–81. An earlier version of this chapter was published as Timothy Clark, 'Poussin's Sacrament of Marriage: An Interpretation', *New Literary History*, vol. 45, no. 2 (Spring 2014), pp. 221–52.

3 See e.g. Tony Green, *Nicolas Poussin Paints the Seven Sacraments Twice* (Watchet, 2000), p. 334: 'The entrance to the temple is the probable place of the marriage of the Virgin.' Green elsewhere reminds us that the scene is strictly, following the *Golden Legend*, Mary's betrothal, with the high priest of the Temple presiding: see ibid., p. 248.

4 See Abednego Seller, *Remarques Relating to the State of the Church of the First Christian Centuries* (London, 1680), p. 185. (The old source does not attribute the quotation.)

5 Paul Fréart de Chantelou, 'Voyage du Cavalier Bernin en France', manuscript first published by Ludovic Lalanne, *Gazette des Beaux-Arts*, 16 (1877), pp. 177–79; extracts reprinted in

Jacques Thuillier, *Nicolas Poussin* (Paris, 1994), pp. 175–78.

6 Ibid., p. 176: 'Ils [Bernini and his son Matthew] en ont admiré la grandeur et la majesté, ont considéré la totalité avec grande attention; puis venant au particulier, ont admiré la noblesse et l'attention de ces filles et femmes qu'il a introduites à la cérémonie, et entre les autres, celle qui est à moitié d'une colonne.'

7 Poussin to De Noyers, February 1639, *Correspondance de Poussin*, p. 16.

8 Poussin to Chantelou, 1647, ibid., p. 365.

9 Poussin to De Noyers, 1641, ibid., p. 54.

10 For further discussion, see Timothy Clark, 'Painting at Ground Level', in *The Tanner Lectures on Human Values*, vol. 24 (Salt Lake City, 2004).

11 The main sentence is from Bonaventure d'Argonne, *Mélanges d'histoire et de littérature* (Paris, 1700), quoted in *Actes du colloque Nicolas Poussin*, ed. André Chastel (Paris, 1960), vol. 2, pp. 237–38. For the phrase from Félibien, see Claire Pace, *Félibien's Life of Poussin* (London, 1981) p. 148, facsimile pp. 155–56.

12 1 Corinthians 15: 47.

13 Book of Common Prayer, 'Burial of the Dead'.

14 George Herbert, 'The Church-floore', *The Works of George Herbert*, ed. Francis Hutchinson (Oxford, 1941), pp. 66–67.

15 On Poussin's treatment of shadow projection in the *Eucharist*, and its links to seventeenth-century studies of the geometry of light and shade, see Elizabeth Cropper and Charles Dempsey, *Nicolas Poussin: Friendship and the Love of Painting* (Princeton, NJ, 1996), pp. 168–89 and Chapter 4. The book also contains a fine brief treatment of the brand of Counter-Reformation Catholicism underpinning Cassiano's commission: see pp. 109–27.

16 *The Catholic Encyclopedia*, ed. Charles Herbermann et al. (New York, 1912), vol. 13, p. 296, quoting the Catholic catechism's preferred formula.

17 Thomas Aquinas, 'De sacramentis', *Summa Theologica*, III, Q. lxi, a.1, summarized in ibid., p. 295.

18 *The Oxford Dictionary of the Christian Church*, ed. Frank L. Cross (Oxford, 1983), p. 1219.

19 Council of Trent, Canon I, Session XXIV, quoted in *Catholic Encyclopedia*, vol. 11, p. 707.

20 Martin Luther, 'Von den Ehesachen', p. 1, quoted in ibid.

21 John Calvin, *Institutions*, IV, xix, 34, quoted in ibid.

22 Jacques Thuillier, 'Poussin et Dieu', in *Nicolas Poussin 1594–1665*, exhibition catalogue, ed. Pierre Rosenberg and Louis-Antoine Prat (Paris, 1994), p. 34. The whole essay is fundamental. Compare the recent survey of the question by Nicolas Milanovic and Mickaël Szanto, 'Poussin et Dieu?', in *Poussin et Dieu* (Paris, 2015), pp. 17–31, which does not, I think, adequately confront Thuillier's point.

23 Peter Lombard [Master of the Sentences], *Fourth Book of Sentences*, IV Sent., d.1, n. 2, quoted in *Catholic Encyclopedia*, vol. 13, p. 296.

24 *Catholic Encyclopedia*, vol. 13, p. 303.

25 See Anthony Blunt, *Nicolas Poussin* (New York, 1967), p. 201. Blunt's Chapter 5, in which the discussion of the mysterious 'E' occurs, is to be compared with Thuillier. See Green, *Seven Sacraments*, pp. 301–10, for arguments in favour of the 'E''s Christian orthodoxy.

26 See the Paris exhibition catalogue *Nicolas Poussin 1594–1665*, p. 339, and Pierre Rosenberg and Louis-Antoine Prat, *Nicolas Poussin 1594–1665, Catalogue*

raisonné des dessins, 2 vols. (Geneva, 1994), vol. 1, p. 522. Rosenberg and Prat's opinion that the drawing was not 'preparatory' to the 1648 painting, though its style suggests it was done at much the same time, fails to convince some scholars: see Green, *Seven Sacraments*, pp. 282–85. Another connected Louvre drawing, my fig. 57, is sometimes considered a follow-up to the Cassiano *Marriage*, dating from the 1630s.

27 Council of Florence, 'Decree for the Armenians', quoted in *Catholic Encyclopedia*, vol. 9, p. 707.

28 Encyclical 'Arcanum' of Pope Leo XIII (1880), quoted in ibid., p. 710.

29 Ephesians, 5: 28–32.

30 *Oxford Dictionary of the Christian Church*, p. 889.

31 Petrus de Palude, 'Commentarium in IV Librum Sententiarum', dist. V, Q. ix, quoted in *Catholic Encyclopedia*, vol. 9, p. 711.

32 Chantelou, 'Voyage', in Thuillier, *Nicolas Poussin*, p. 176.

33 Richard Crashaw, 'The Himn O Gloriosa Domina', *The Poems English Latin and Greek of Richard Crashaw*, ed. Leonard C. Martin (Oxford, 1927), p. 303.

34 Pope Innocent IV, 'Profession of Faith for the Waldensians', quoted in *Catholic Encyclopedia*, vol. 9, p. 707.

35 'Cleave unto', which often reappears in citations, follows the Authorized Version's wording of Genesis 2: 24, which Paul is repeating.

36 1 Corinthians 10: 11. It is a passage that tests translators: the Authorized Version has 'for ensamples' instead of the Douay-Rheims Bible's 'in figure'.

37 John Donne, 'A Hymne to Christ, at the Authors last going into Germany',

The Poems of John Donne, ed. Herbert Grierson (Oxford, 1933), p. 322.

38 Walter Benjamin, 'On Some Motifs in Baudelaire', in Walter Benjamin, *Selected Writings*, ed. Howard Eiland and Michael Jennings (Cambridge, MA, 2003), vol. 4, p. 338.

39 Compare Bruegel's attitude to clothes. Poussin's treatment of 'drapery' may rest on a deeper optimism about the human condition – about the ground of commonality and the organizing power of shared norms. But the *femme-colonne* is also the figure of what such commonality excludes and may even fear.

40 Compare Paul de Man's exploration of the paradoxes of the aesthetic, in particular his 'Aesthetic Formalization: Kleist's *Über das Marionettentheater*', in de Man, *The Rhetoric of Romanticism* (New York, 1984); 'Hypogram and Inscription', in de Man, *The Resistance to Theory* (Minneapolis, 1986), especially pp. 34–37; and the three essays on Kant collected in de Man, *Aesthetic Ideology* (Minneapolis, 1996). De Man's challenge to more familiar (and comforting) versions of materialism remains fundamental.

41 Compare the tomb of Hamrath in Suweida (Syria), first century BC (known now only from Melchior de Vogüé's engraving), or the still-standing Gümüskesen tomb at Milas (Turkey), second century AD. Anthony Blunt points out that Roman tombs of various types were likely known to Poussin from engravings in books on the Holy Land: see Blunt, *Poussin*, pp. 204–5. On the possible symbolism of the sphere on the column, see Green, *Seven Sacraments*, pp. 338–39.

42 For further discussion, see Timothy Clark, *The Sight of Death: An Experiment in Art Writing* (New Haven and London, 2006), pp. 43–49, 67–72.

43 On the necessarily disguised form taken by religious doubt in the seventeenth century, Thuillier in 'Poussin et Dieu' recommends René Pintard's great study *Le libertinage érudit dans la première moitié du XVIIe siècle* (Paris, 1943; repr. Geneva, 1983) and sums up, in Empsonian vein, on p. 29: 'Cette époque, qui est celle des Bérulle et des Vincent de Paul, abonde en athées. Devant un personnage aussi complexe que Poussin, et dont l'existence comporte de grands pans d'ombre, le soupçon n'est pas seulement permis: il est en quelque sorte requis.'

Chapter 4: Veronese's Higher Beings

1 Edward T. Cook, *The Life of Ruskin* (London, 1911), vol. 1, pp. 519–20, quoting Ruskin's 1858 'Notes'. Compare the transcription in Wheeler, *Ruskin's God* (Cambridge, 1999), p. 138.

2 Edgar Wind, *Pagan Mysteries in the Renaissance* (revised edition, Harmondsworth, 1967), p. 275. Wind's essay 'A Cycle of Love by Veronese', pp. 272–75, is fundamental (and mostly implausible). Among other treatments, see Cecil Gould, *National Gallery Catalogues. The Sixteenth Century Venetian School* (London, 1959), pp. 149–53 [includes an early notice of Wind's interpretation]; Allan Braham, 'Veronese's Allegories of Love', *Burlington Magazine*, CXII, April 1970, pp. 205–10; Cecil Gould, *National Gallery Catalogues. The Sixteenth-Century Italian Schools* (London, 1975), pp. 326–30 [Wind's interpretation is dropped]; Roger Rearick, *The Art of Paolo Veronese 1528–1588* (Washington, DC, 1988), pp. 125–29; Terisio Pignatti and Filippo Pedrocco, *Veronese*, 2 vols. (Milan, 1995), pp. 360–64; Nicholas Penny, *National Gallery Catalogues. The Sixteenth Century Italian Paintings, Volume 2, Venice 1540–1600* (London,

2008), pp. 410–29; and Xavier Salomon, *Veronese* (London, 2014), pp. 180–91. An earlier version of this chapter was published as Timothy Clark, 'Veronese's *Allegories of Love*', *London Review of Books*, 3 April 2014.

3 Elise Goodman-Soellner, 'The Poetic Iconography of Veronese's Cycle of Love', *Artibus et historiae*, VII (1983), pp. 19–28. See Penny, *National Gallery Catalogues*, p. 417, for a summary of possible readings of the letter.

4 Evans and Whitehouse, *Diaries of John Ruskin*, vol. 2, p. 437.

5 Braham, 'Veronese's Allegories', p. 210.

6 The early mentions of the paintings in Italian provided no individual titles. For the French titles, *L'Infidélité, Le Dégoût, Le Respect, L'Amour Heureux*, see Louis-François Du Bois de Saint-Gelais, *Description des tableaux du Palais-Royal* (Paris, 1727), p. 377. Italian scholarship has opted for *Disinganno* as the most likely word lying behind the obviously crude *Le Dégoût*, and it does seem the concept most adequate to the picture itself. (My thanks to Franco Moretti for guidance here.)

7 Pierre-Jean Mariette, *Recueil d'estampes d'après les plus beaux tableaux* (Paris, 1729–42), vol. 2, p. 67. See Martin Royalton-Kisch, 'A New Arrangement for Veronese's Allegories in the National Gallery', *Burlington Magazine*, 120 (March 1978) pp. 158–62, for argument about the paintings' original layout on a ceiling, and Penny, *National Gallery Catalogues*, pp. 417–19, and Xavier Salomon, 'New Evidence for the Original Arrangement of Paolo Veronese's *Allegories of Love*', *Master Drawings*, 50 (2012), pp. 59–64, for recent statements of the ceiling painting hypothesis. The canvases are first recorded in an inventory of Rudolph II's collection in Prague drawn up after his death. This does not mean that Rudolph commissioned them (and Salomon, *Veronese*, pp. 186–89, marshals evidence to suggest he did not). The inventory makes no mention of their location or decorative function. Salomon points out that a ceiling big enough to hold all four paintings would have been a rarity in Venice, particularly in a private palace, and that the panels' regular square format hardly conforms to Venetian ceiling painting conventions.

8 For instance, Bernini in France confronting a Poussin *Bacchanal*, as recorded by Chantelou: 'il en loua les terrasses, les arbres et toute la composition': see Thuillier, *Nicolas Poussin*, p. 176. The context makes clear that the word 'terrasses' covers the whole treatment of the ground planes and objects resting on them.

9 The *Allegories* are 'ground-level' paintings, in other words; but they are also typical of the artist in their ability to reconcile a continual feeling for human balancing, gravity and grounding with a vision of a 'higher' world. It is this double emphasis that makes Veronese's worldliness unique. Nothing in my account of the paintings depends specifically on their having been designed originally as overdoors. It is Veronese's exploitation of 'above-ness' *and* proximity that matters, whether it involved rethinking the conventions of ceiling painting or, as I suspect, making new use of a set of paintings' actual (imposing) height on the wall.

10 Cook, *Life of Ruskin*, vol. 1, p. 519, again quoting Ruskin's 1858 'Notes'. Compare the transcription in Wheeler, *Ruskin's God*, p. 137.

11 Penny, *National Gallery Catalogues*, p. 417.

12 See Royalton-Kisch, 'A New Arrangement', p. 158.

13 The goddess on the sphere is not indisputably Fortuna: some think the nature of the scene calls for a less fickle deity. I think this misses Veronese's complex tone: *Happy Union* does not, for him, mean 'happy ever after'.

14 Wind, *Pagan Mysteries*, p. 272, sees both man and woman as torn by a 'fatal combination of passionate nature with chaste resolutions', since although Cupid 'is responsible for the [male] lover's plight, he is also the force that chastens his passion', and Chastity has clearly not put paid to the woman's 'general disarray'.

15 On the drawing, see J. Bordeaux, 'A Sheet of Studies for Veronese's Four Allegories of Love', *Burlington Magazine*, 107 (September 1975), pp. 600–03 (which first notes that the drawing suggests that the four pictures were developed simultaneously); Richard Cocke, *Veronese's Drawings* (Ithaca, NY, 1984), pp. 184–85; Rearick, *The Art of Paolo Veronese*, pp. 125–26; Penny, *National Gallery Catalogues*, p. 419. Salomon, 'New Evidence', alerts us to five faint capital letters written just above the drawing for *Respect* at the bottom of the sheet to the left, which may be a sketch plan of the pictures' arrangement, though the letters do not seem to correspond to possible titles.

16 See Michael Podro, *Depiction* (New Haven and London, 1998), p. 13: 'In the *Allegory of Deceit* we may remark separately on the qualities of the paint surface, on how the continuity of the line along the woman's arms and across her shoulder informs the whole gesture of her body, on the relation between the imagined low viewpoint in the painting and what we may assume was the low viewpoint of the original spectator, but none of these is offered as a discrete conceit, and remarking on them separately risks narrowing and simplifying attention – it interrupts their interdependence and their absorption in our synoptic view, our sense of the subject emerging within the painting.' In conversation, I remember Podro willing to talk at length about the viewer's uncertain orientation to the central nude, in ways that connected with his accounts of 'Orientation in Rembrandt' in the same book, pp. 61–85, and in Michael Podro, *The Critical Historians of Art* (New Haven and London, 1982), pp. 117–24.

17 So the paint surface suggests. But the clavichord is already present, twice, on the Metropolitan Museum sheet.

18 A 1742 engraving of *Respect* by Louis Desplaces shows the object resting on the cornice as a long-handled fan: see Penny, *National Gallery Catalogues*, p. 426.

19 See Erwin Panofsky, *Perspective as Symbolic Form*, trans. Christopher Wood (New York, 1991), p. 27: 'We shall speak of a fully "perspectival" view of space … only when the entire picture has been transformed … into a "window," and when we are meant to believe that we are looking through this window into a space.' On the paradoxes involved in the associated notions of 'projection' and 'viewpoint', the most searching discussion remains for me Hubert Damisch, *The Origin of Perspective*, trans. John Goodman (Cambridge, MA, 1994), especially Chapter 8, pp. 115–40, and the first half of Chapter 16, pp. 377–99.

20 It could be, at least partly, the shadow of Fortuna's front leg, but it seems too wide and too weighted towards the sphere's bottom to be cast by the leg alone.

21 I am setting aside the dialogue between the bride and the veined green marble column behind her, which in turn catches the light in elusive (but utterly convincing) ways. But the play of colour and shape here is fundamental to the bride's, and maybe the goddess's, humanity.

22 Maurice Merleau-Ponty, 'Eye and Mind', trans. Carleton Dallery, in Merleau-Ponty, *The Primacy of Perception* (Evanston, IL, 1964), especially p. 167: 'We see that the hand pointing to us in *The Nightwatch* is truly there only when we see that its shadow on the captain's body presents it simultaneously in profile … Everyone with eyes has at some time or other witnessed this play of shadows, or something like it, and has been made by it to see a space and the things included therein. But it works in us without us; it hides itself in making the object visible. To see the object, it is necessary *not* to see the play of shadows and light around it. The visible in the profane sense forgets its premises; it rests upon a total visibility … But the interrogation of painting … looks toward this secret and feverish genesis of things in our body.' In what follows I use the shorthand 'for the mind', but part of Merleau-Ponty's point is always that mind and body are one.

23 *The Poems of John Donne*, pp. 63–64.

24 In *Happy Union* the wingless boy, doing his master's bidding, has the bride on a gold chain, which seems to reach through her dress to her genitals.

25 Veronese thought hard about the degree of sprawling abandon appropriate to the nude in *Respect*. In the Metropolitan Museum drawing he tried out four, maybe five, positions for the woman, concentrating on her head and up-flung arm: memories of the Vatican *Cleopatra*, and even of Michelangelo's Medici Chapel, seem in evidence. The pose in the painting is decidedly less voluptuous: eroticism is displaced onto hand and drapery.

26 Friedrich Nietzsche, *The Will to Power*, trans. Walter Kaufman and Reginald Hollingdale (New York, 1967), pp. 536–37, translation modified.

Conclusion: Picasso and the Fall

1 Hannah Arendt, *The Origins of Totalitarianism* (New York, 1966 [first published 1951]), p. vii. The Preface is dated 1950.

2 Ibid., pp. xxiii–iv.

3 France is the apparent exception. We could say that its double experience of defeat and humiliation in the twentieth century, with all this entailed for the nation's founding myth of 'Napoleonic' centrality, had to be forgotten for the very idea of Frenchness to survive. It remains a painful question whether the myths of Revolutionary citizenship and *laïcité* to which the nation retreated (based as they were on a disavowal of French society's continual revolutionary dividedness) have done much more than exasperate and embitter the non-citizens of the *banlieues*. (About the reckoning of Japan, China and much of the rest of the world with the horrors experienced in the twentieth century I stay mute, from lack of knowledge.)

4 On *Guernica*'s continuing hold on the present, see Timothy Clark, 'Picasso and Tragedy', and Anne Wagner, '*Mater Dolorosa*: The Women of *Guernica*', in *Pity and Terror: Picasso's Path to Guernica* (Madrid, 2017).

5 See for instance, the brief treatment
 of the UNESCO mural in Gertje
 Utley, *Picasso: The Communist Years*
 (New Haven and London, 2000),
 p. 203, or the pages by Marie-Laure
 Bernadac in the exhibition catalogue
 Late Picasso (Paris and London, 1988),
 pp. 64–69. The best summary of the
 commission's history is Brigitte Léal's
 entry, 'Les carnets de l'Unesco', in
 Carnets: Catalogue des dessins, exhibition
 catalogue (Paris, 1996), vol. 2, pp. 269–71.
 Guernica itself had returned to Europe
 from New York for more than a year in
 1955–56 and been shown (to the disgust
 of Spanish ambassadors) in Oslo, Paris,
 Brussels and Amsterdam. See Genoveva
 García, 'Picasso, a political enemy of
 Francoist Spain', *Burlington Magazine*,
 CLV (March 2013),
 pp. 171–72.

6 See Annette Wievorka, 'Picasso and
 Stalin', in Lynda Morris and Christoph
 Grunenberg (eds.), *Picasso: Peace and
 Freedom* (London, 2010), p. 32.

7 For transcription of the interview, see
 'Picasso, 1958', *La Bergerie Céramique*
 [website]: www.labergerie-vallauris.
 com/photos/a-picasso-1958-rare-
 document (accessed 22 September
 2017): 'Maître, pensez-vous vraiment
 que ce soit l'Icare des ténèbres? Oui,
 je trouve que la chose de Georges
 Salles est très exacte, à peu près, parce
 qu'un peintre peint et n'écrit pas, c'est
 à peu près ce que j'ai voulu dire ... Ça
 a duré des mois et des mois où ça s'est
 transformé petit à petit sans savoir
 même où j'allais, n'est-ce pas, ça avait
 commencé à l'atelier où il y avait des
 tableaux, c'était mon atelier où j'étais en
 train de peindre, n'est-ce pas, et petit à
 petit le tableau a mangé tout l'atelier,
 il ne restait que lui-même en disant,
 en exprimant des choses dont je suis le
 maître mais pas volontairement l'acteur.'

8 Ibid.: 'Eh bien, selon moi, c'est le rideau
 qui se lève sur une époque ou qui se
 baisse sur une époque, ça à la volonté
 du public. Nous avons vécus une époque
 tragique, nous allons vivre une autre,
 c'est soit le rideau qui se baisse sur une
 époque tragique, soit le rideau qui se
 lève sur le ... le rideau du prologue
 d'une autre époque tragique. Mais il y
 a une grande tragédie dans sa fresque.
 C'est un diplodocus, c'est le dernier
 animal terrible d'une époque que nous
 venons [de] traverser qui est très grande
 d'ailleurs, mais très terrible.' Cocteau
 is among other things wrestling
 with his own past: his attitude to the
 German occupation of France had been
 ambiguous, and he had been arraigned
 on charges of collaboration immediately
 after the Liberation, though swiftly
 cleared of all charges.

9 Ibid.: 'Sur le mur, qu'est-ce que j'ai
 vu? J'ai vu que l'UNESCO avait enfin
 trouvé son symbole. Au coeur de
 l'UNESCO, au coeur de ce nouveau
 bâtiment ... on pourra voir les forces de
 lumière vaincre les forces de l'ombre. On
 verra les forces de paix vaincre les forces
 de mort. On verra tout cela s'accomplir
 grâce à la production géniale de Picasso,
 et à côté [de] ce combat, qui est grand
 comme un mythe antique, on voit une
 humanité pacifiée qui assiste sur la
 rive de l'infinie à l'accomplissement
 de son destin.' Compare Georges
 Salles, 'Une oeuvre significative de l'art
 contemporain', *Chronique de l'Unesco*,
 vol. IV, no. 10 (October 1958), pp.
 290–92 for the speech at the September
 installation.

10 Charles Baudelaire, *Les Fleurs du mal*
 [2nd edn, 1861], ed. Jacques Crépet et
 al. (Paris, 1968), p. 21: 'Each day we
 go another step down towards Hell,/
 Without horror, through the shadows
 that stink.'

11 Ibid., p. 355: 'I shall not have the sublime honour/Of giving my name to the abyss/That will serve as my tomb.'

12 See Richard Hoggart, *An Idea and Its Servants: UNESCO from Within* (new edn, New Brunswick, 2011 [first published 1978]), p. 160. I give weight in what follows to the disillusioned view of UNESCO Hoggart represents, not because it outweighed more hopeful ones at the time, but because it resonates with Picasso's mural.

13 See James Patrick Sewell, *UNESCO and World Politics* (Princeton, 1975), pp. 151–52.

14 For the Spanish police record, see García, 'Picasso, enemy of Francoist Spain', pp. 168–69. On the anti-Franco activities, see Utley, *Picasso: The Communist Years*, pp. 82–83, and Lynda Morris, 'Republicans in Exile: Spain, Hispanic America and the USA', in Morris and Grunenberg, *Peace and Freedom*, pp. 34–37.

15 Ibid., pp. 157–58. The American Luther Evans, director general from 1953 to 1958, is seen even in official histories as having failed to resist McCarthyite pressures: see J. P. Singh, *UNESCO: Creating Norms for a Complex World* (New York, 2011), pp. 16, 38.

16 Hoggart, *An Idea and Its Servants*, p. 95.

17 Ibid., p. 100.

18 Ibid., p. 97.

19 Roland Penrose, *Picasso: His Life and Work* (2nd edn, New York, 1962), p. 380.

20 See ibid., pp. 368–69, 379.

21 Information on *Icarus*'s means of production is scarce, so that how Picasso dealt with his team of assistants is unclear. But he seems in the end to have deliberately exploited the degrees of slight mismatch between panels: the

discontinuities, particularly in the blue, are striking when one stands in front of the mural itself.

22 See Gaëtan Picon, *La 'chute d'Icare' au Palais de l'UNESCO* (Geneva, 1971) for presentation of the sketchbook material, and compare Jean Leymarie, *La chute d'Icare: Décoration du Foyer des Délégués* (Geneva, 1972).

23 For recent discussion of the studio studies, see Wagner, '*Mater Dolorosa*', in *Pity and Terror*, especially pp. 110–17.

24 On the connection between Cubism and room-space, see Timothy Clark, *Picasso and Truth: From Cubism to Guernica* (Princeton, 2013), pp. 77–109.

25 See Louis Aragon, *Henri Matisse, Roman* (Paris, 1971), vol. 2, p. 35, claiming to relay 'Matisse's own confidential comments'.

26 See Stratis Eleftheriadis-Tériade Museum-Library, *Redisplaying the Collection*, ed. Annie Kontogiorgi et al. (Mytilene, 2014), pp. 136–39. Picasso would have also seen the reworking of *Icarus* Matisse did for his book *Jazz*. See Jack Cowart et al., *Henri Matisse: Paper Cut-Outs* (St. Louis and Detroit, 1977), pp. 100, 108.

27 See Pierre Daix, *Picasso: Life and Art*, trans. Olivia Emmett (New York, 1993), p. 338, for the date of the end wall's completion.

28 See *Late Picasso*, p. 293.

29 See Madeleine Riffaud, 'Voici la peinture murale que Picasso a composée pour l'UNESCO', *Les lettres françaises*, no. 716 (3–9 April 1958), p. 2.

30 'M. Georges Salles … l'a jugée simple et belle comme une tragédie antique où un "Icare des ténèbres" tomberait vaincu par les forces de la lumière, par les forces humaines de la paix. Quant aux ouvriers de bâtiment qui ont monté le carcasse métallique, ce tableau les

faisait songer "à la bombe H qui se promène dans notre ciel, portée par des avions américains". Une institutrice à cheveux blancs, venue faire connaissance avec l'oeuvre de Picasso pendant les vacances de Pâques, allait plus loin encore: "Je pense à l'Algérie – dit-elle – quand je regarde cette femme toute déchirée, qui appelle de l'autre côté de la mer.'"

31 Max Friedländer, *Pieter Bruegel die Ältere* (Berlin, 1921), p. 114, cited by Roger Marijnissen, *Bruegel: Tout l'oeuvre peint et dessiné* (Paris, 1988), p. 378.

32 Bob Claessens and Jean Rousseau, *Our Bruegel*, trans. Haakon Chevalier (Antwerp, 1969), p. 165.

Coda: For a Left with No Future

1 See Timothy Clark, 'The Experience of Defeat', in *The State of Things*, ed. Marta Kuzma et al. (Oslo and London, 2012), and Clark, 'For a Left with No Future', *New Left Review*, 74 (March–April 2012), pp. 53–75. Susan Watkins, the *Review*'s editor, published a full-length criticism of the essay, 'Presentism?: A Reply to T. J. Clark', in the same issue, pp. 77–102. See also Clark, *Por uma esquerda sem futuro*, trans. José Viegas (Sao Paulo, 2013), with a preface addressing the very different – stronger, but similarly disoriented – 'state of the Left' in Brazil.

2 I have not tried to disguise the fact that my verdict on *Cockaigne*'s relation to religion surfaces again, largely unchanged, in Chapter 2.

3 Carlo Levi, *Christ Stopped at Eboli*, trans. Frances Frenaye (London, 1982 [first published 1945]), p. 200. See also p. 178.

4 Quoted in William Peterson, *The Kelmscott Press: A History of William Morris's Typographical Adventure* (Oxford, 1991), p. 252 (a letter from December 1895).

5 A. C. Bradley, *Shakespearian Tragedy* (New York, 1968 [first published 1904]), pp. 28–29.

6 Ibid., p. 28.

7 Ibid., p. 29.

8 Ibid., p. 32.

9 Compare Pierre Vidal-Naquet, 'Aeschylus, the Past and the Present', in Jean-Pierre Vernant and Pierre Vidal-Naquet, *Myth and Tragedy in Ancient Greece*, trans. Janet Lloyd (New York, 1988), p. 257: 'Tragedy was one of the forms through which the new democratic city established its identity: Setting the actor in opposition to the chorus (it was Aeschylus who introduced a second actor), it took its prince-turned-tyrant from distant myth, set him on stage and assessed him, representing his errors and the mistaken choices that led him to catastrophe.'

10 Mark Mazower, *Dark Continent: Europe's Twentieth Century* (London, 1998).

11 See David Thomson (ed.), *The Era of Violence 1898–1945* (Cambridge, 1960). The overall editors of *The New Cambridge Modern History*, in which Thomson's volume appeared, quickly ordered a revised edition called *The Shifting Balance of World Forces*.

12 Walter Benjamin, *The Arcades Project*, trans. Howard Eiland and Kevin McLaughlin (Cambridge, MA, 1999), p. 474 (Convolute N9a, 6).

13 Isaac Penington, *Divine Essays* (London, 1654), quoted from Christopher Hill, *The Experience of Defeat* (New York, 1984), p. 120.

14 Moses Wall, letter to Milton, 25 May 1659, quoted in David Masson, *Life of Milton* (London, 1858-80), vol. 5, pp. 602–3; quoted in part and discussed in Hill, *Experience of Defeat*, pp. 53, 280–81, 327–28. Masson's great *Life* is a good companion to Bradley.

15 'Classical', I gather, is derived from the Latin word meaning 'first-class heavy infantry'. On a deeper level, Jean-Pierre Vernant's argument for a connection between the rise of 'de-individualized' hoplite warfare, the generalizing of a culture of competitiveness (*agon*), the move towards a conception of social 'equality' or *isonomia* (for the citizen few), and the drive towards a numerical valuation of more and more aspects of social life remains fundamental. See Jean-Pierre Vernant, *The Origins of Greek Thought* (Ithaca, NY, 1982 [first published 1962]).

16 Friedrich Nietzsche, 'Homer's Contest' (unpublished fragment from *c*.1872), in Friedrich Nietzsche, *On the Genealogy of Morality*, trans. Carol Diethe (Cambridge, 2007), pp. 174–75.

17 Josephine Flood, *The Original Australians: Story of the Aboriginal People* (Crows Nest, NSW, 2007), pp. 122–23, following Stephen Webb, *Palaeopathology of Aboriginal Australians: Health and Disease across a Hunter-Gatherer Continent* (Cambridge, 1995), pp. 188–216.

18 William Hazlitt, 'On the Pleasure of Hating' (from *The Plain Speaker*, 1826), in William Hazlitt, *Selected Writings* (Harmondsworth, 1970), pp. 397–98.

19 Friedrich Nietzsche, *The Gay Science*, trans. Walter Kaufmann (New York, 1974 [first published 1882]), p. 304 (translation slightly modified). I opt for the *Gay Science*'s formulation of a thought repeated constantly, but never so economically, in *The Will to Power*.

20 Nietzsche, *The Will To Power*, pp. 38–39 (translation slightly modified).

21 Timothy Clark, *Farewell to an Idea: Episodes from a History of Modernism* (New Haven and London, 1999), p. 7 (changed slightly).

22 Benjamin, *Arcades Project*, pp. 477–78 (Convolute N12a, 1).

Picture Credits

Index